CALIFORNIA MISSIONS

Photography **Londie Garcia Padelsky**
Text **Becky Prunty**
Editor **Carrie Lightner**
Art direction & design **T-Graphics**

Cover Photo - At the edge of the Santa Ynez mountains,
Mission Santa Bárbara glows from the clear ocean sunrise
Back Cover Photos - California's 21 Spanish missions

Stoecklein Publishing & Photography
Tenth Street Center, Suite A1
Post Office Box 856 • Ketchum, Idaho 83340
tel 208.726.5191 fax 208.726.9752 toll-free 800.727.5191
www.drsphoto.net

Printed in China
Copyright ©2005 by Londie Garcia Padelsky

ISBN 1-931153-88-4
Library of Congress Catalog number 2004097255

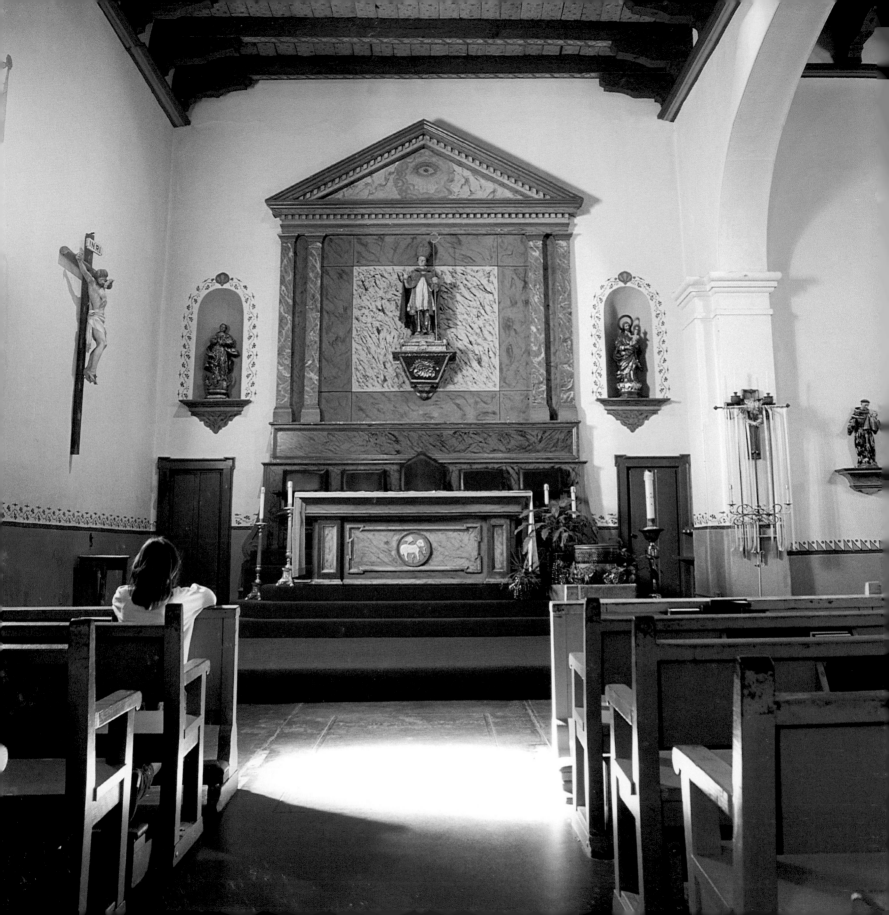

This book is dedicated to my dad and mom, Roy and Dolly Garcia,
for giving me roots and wings.

—Londie

To my youngest nieces and nephew, Amber, Madison and Bode,
I hope this book will be helpful to you
in your 4th grade California Mission studies.

Mission San Luis Obispo de Tolosa,
interior from 1947 to 2002.

ACKNOWLEDGMENTS

It has been an extraordinary journey photographing the California missions. Along the mission trail I have met a lot of interesting people who have openly shared their knowledge. I would especially like to acknowledge Ruben Mendoza, Professor of Archaeology at Monterey Bay State University, for the knowledge you have shared. Your dedication to uncovering and preserving the history of California Missions is invaluable.

Thank you to the mission Fathers and to the docents and volunteers who keep the doors open.

I am eternally grateful to my Mom and Dad for their never-ending support. To my brother and sisters, Ronnie, Heidi, Debbie and Janet, thank you for the times you have accompanied me on photography trips. Thank you to all my nieces and nephews, especially Kristy and her husband, Aaron Lazanoff. I appreciate your interest in early California vaquero history. Thanks for helping me to record the historic landmarks at Santa Margarita Ranch, and also for introducing me to Bruce Haener, who graciously shared his collection of mission era tack.

To friends who are like family, Jenny Harper Stevens, Leslie and Phil Teyssier, thank you for sharing your homes.

A special thanks to my best friend from junior high school, Leslie Silva Teyssier, for your relentless enthusiasm and help on this project.

I am most appreciative to David Stoecklein for this opportunity. This project has enriched my life.

INDEX

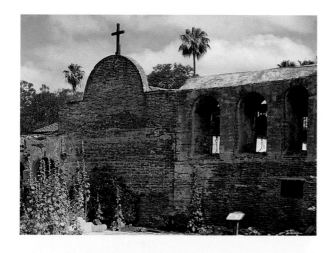

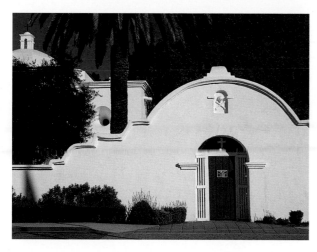

Mission San Juan Capistrano

Mission San Luis Rey de Francia

Introduction	7
History	11
San Diego de Alcalá	16
San Carlos Borromeo de Carmelo	24
San Antonio de Padua	32
San Gabriel Arcángel	38
San Luis Obispo de Tolosa	44
San Francisco de Asís	52
San Juan Capistrano	58
Santa Clara de Asís	66
San Buenaventura	72
Santa Bárbara	78
La Purísima Concepción	84
Santa Cruz	90
Nuestra Señora de la Soledad	96
San José	102
San Juan Bautista	106
San Miguel Arcángel	114
San Fernando Rey de España	122
San Luis Rey de Francia	128
Santa Inés	134
San Rafael Arcángel	142
San Francisco Solano	146

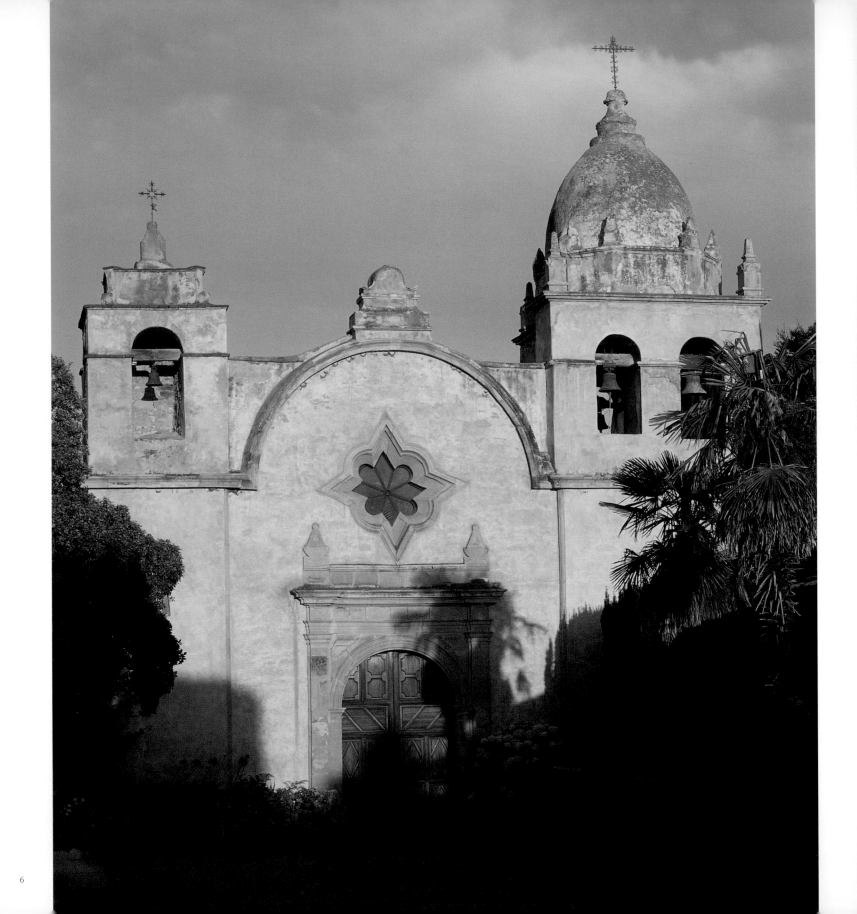

INTRODUCTION

My mission quest began when I was in fifth grade. Dad was my teacher and the subject was California missions. He immediately picked up on my enthusiasm to learn more about the history of the missions, and within weeks, he and Mom had us kids loaded in the blue stationwagon going south. Our vacation started at Mission San Diego de Alcala, the first permanent Spanish settlement in California. From there, we visited all 21 missions on the El Camino Real, The Royal Road.

A couple of years later, my family along with Dad's students, participated in a bicentennial event reenacting the De Anza Expedition. Participants wore authentic attire and either walked or rode horses on the De Anza Trail. For five days, dressed in a Native American costume that I made, carrying a tiny instamatic camera wrapped in a beaded leather pouch, I rode bareback on a deer-hide blanket from Guadalupe, California north to Monterey. We stopped at the missions for historic ceremonies along the way. The first three days we were pelted by rain and hailstones. On the morning we left Mission San Luis Obispo de Tolosa heading toward the Asistencia (assistant mission) at the Santa Margarita Ranch, we trod through fresh snow covering the ground on Cuesta Pass. We encountered some wicked weather, yet it was minor compared to what the settlers endured in 1776 when they followed Captain Juan Bautista de Anza for six months overland from Sonora, Mexico to Monterey, California to establish pueblos near the new mission at San Francisco de Asís.

One of the many highlights on the trip was when we went into the oak-studded valley near Mission San Antonio. We met with a local rancher, and to add authenticity to the 200-year celebration we herded his cattle onto the mission grounds. It was fiesta night, and there was a crowd of over 1,000 people gathered at the mission to watch us bring the cattle in. Waves of mariachi music could be heard between the hoopla and hollering. The sky was a cloud of dust, radiant-orange from the sunset. The cattle were spread as wide as the mission colonnades—a vignette in the distance. For a

fleeting moment it felt like life in the early days. The expedition had a lasting impression on me, and 30 years later, I am still following the mission trails.

I was born and raised in San Luis Obispo, California, home to the fifth mission on the Franciscan chain, founded by Father Junipero Serra in 1772. Less than ten minutes from Mission San Luis Obispo de Tolosa, our family ranch skirts this rapidly growing city, a region that Portola recorded in 1769 as being vastly populated by grizzly bears. We have never seen a bear on the ranch like some of the ranchers farther out, but we have found grinding holes, arrowheads, and the remnants of adobe mud walls.

Throughout history, artists and photographers have played a large role in the preservation of the missions. A painting from 1857 is the only record that shows the original interior at Mission Santa Cruz. It shows the ceiling with a colorful chevron pattern similar to the design at Mission Dolores. A sketch of Mission San Diego made in 1853 is the only drawing that recorded the shape of the bell tower. Today, the duplicated shape is a striking feature on a rather plain façade at the mission. The church and bell tower collapsed from earthquakes before professional photographers and artists recorded the missions.

The interior frescoes at Mission San Miguel are the best-preserved paintings of all the missions. Inside the church almost every surface is brightly colored with stenciled patterns and with scenes of archways, pillars, and huge scalloped shells. Decorations have remained unaltered by later restorers ever since Spanish artist Estevan Munras and his Native American apprentices first painted them in the 1820s. When an earthquake jolted the area on December 22, 2003, the mission doors were closed. Fortunately, the 183-year-old frescoes survived. It will take millions of dollars to retrofit the buildings and so for now, the only way for the public to enjoy the interior is through printed materials such as postcards and books.

Throughout my journey photographing the missions, many dif-

Mission San Carlos Borromeo de Carmelo

ferent aspects of mission history have opened up for me. This happened in a profound way at Mission Carmel. I arrived early so that I could photograph the front of the basilica in warm, morning light. Alongside a tent, there was a group of students in the midst of an archeology dig. A group of us gathered around while the professor used a laptop computer to show pictures from a summer and winter solstice phenomenon relating to the architectural alignment at the Carmel and San Juan Bautista missions. The pictures showed the sun coming up over a distant mountain, perfectly aligned with the window at the front of the church. From the window, light beamed down the center aisle all the way to the altar, and then lit up the tabernacle. It was believed that the church builders had designed the missions this way to teach Native Americans their new faith by using the light of the sun as a metaphor for the Light of Christ. Apparently, this tradition at the missions was rediscovered only ten years ago. The solstice, a powerful symbol of rebirth, has been celebrated by ancient cultures throughout the world.

Three months later, I made the trip back to the Carmel mission for the summer solstice. For four days I arrived before dawn and waited for the sun to break through the fog. On the fifth day I was rewarded with a clear morning. Dwarfed by an enormous arched ceiling, I stood near the altar in total darkness. Soon, there was a flicker at the window and then slowly a golden glow crept between the pews, flourishing the tiles on its path to the altar. By the time it reached the tabernacle, the light was brilliant. Following its normal course, the sun then passed by the window, and the brilliance subdued. Afterward, I walked on the beach, recounting the amazing experience of being touched by the light.

The winter solstice at Mission San Juan Bautista was a completely different experience. I stood at the very back of the church for a new perspective. At the altar, the pastor gave a brief pre-sunrise service before all lights were switched off. Then softly, a woman began to chant wordless prayers as she walked up the middle aisle. Her voice trailed to a whisper and then an echo as the rising sun crested the window. All of a sudden, a shaft of bright light followed in her footsteps. The crowd turned to face the rays, and from my view they were literally bathed in golden light. When the brightness struck the tabernacle it was radiant. The sun was so warm and brilliant that inhaling it even for a moment was nourishing to the soul.

Long before the Spaniards came to California, Native American shamans led sacred ceremonies in celebration of the solstices. The presence of Native Americans can be seen at grinding holes, petroglyphs, and cave painting sites along the coast and inland valleys.

One of the sites is located in the remote area near Mission San Antonio, which is bordered by the Los Padres National Forest. The wildness of the setting has drawn me back many times. It is home to bears, bobcats, coyotes, deer, and rattlesnakes. On a drizzly fall day, I visited one of my favorite places, a grinding hole site, some distance from the mission. Arriving at the site, I walked over huge granite slabs and found my meditative spot. The morning's rain flowed over the granite, creating small waterfalls all around me. In the distance the Santa Lucia Mountains were shrouded by fog. It is the kind of place, where, if you are quiet enough, the spirits come alive. I was alone and yet I felt the presence of others. I visualized several Native American women sitting between the rivulets of water, chatting happily as they ground acorns into a fine powder on the stone. I could hear children laughing as they splashed in the river below. The men passed through a far grassy meadow on their way to hunt.

As I reflect on the history of California, I feel it is important to honor and acknowledge the lives and traditions of the native people whose lives were forever changed.

My hope is that the images within these pages will inspire visitors to the missions to look more closely at the religious and historical artifacts. Every brick, brushstroke, statue, and altarpiece holds a valuable story about our past. The missions are not only a tourist destination, but they also provide a place for spiritual renewal and comfort as well as a place for worship. As the oldest buildings on the coast of California, the missions should forever be protected and revered for our future generations.

Londie Garcia Padelsky

Solstice glow on tabernacle
at Mission San Juan Bautista

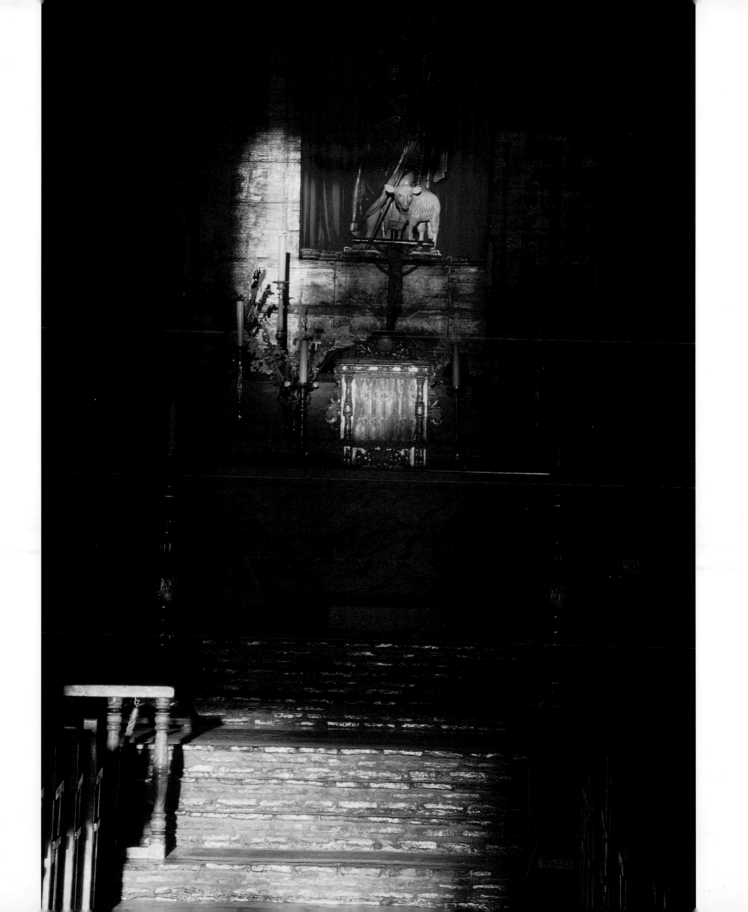

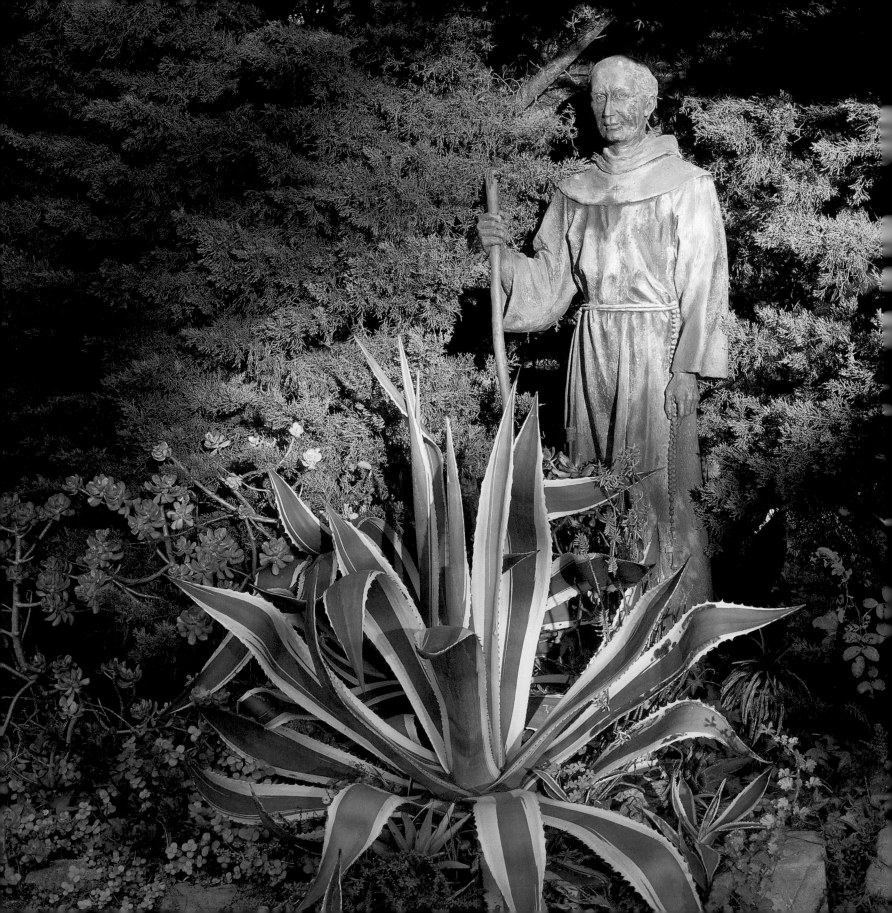

Driving through the Golden State, ensconced in the speeding metallic bumper-to-bumper trappings of the twenty-first century, one's eyes take in the vista of modern California: a landscape littered with thousands of square miles of concrete and asphalt, urban high-rises blurring into sprawling suburbs, a reality made merely tolerable by scarce, pristine enclaves of raw, unspoiled landscape. The relentless passing of time has rendered California an entirely different place than it was two centuries ago. Beneath a fool's gold façade of progress lies the genuine treasures of history and heritage, burnished by the triumphs and tragedies of generations past. Nowhere can this be sensed more strongly than within the holy adobe walls of California's 21 Spanish missions.

In 1493, Pope Alexander VI deemed Spain as owner of half of the world. The gargantuan territory encompassed all of what is now Mexico, Central America, and the Caribbean, as well as a sizeable portion of South America and today's United States. Spain's efforts toward colonization were born of the aristocracy's taste for the luxurious. With the tempting promise of exotic spices, silks, delicacies, and precious metals to be had in faraway lands, it took little to mobilize the Spaniards toward untold riches beyond the horizon. Bolstered by past successful conquests of the Moors, Spain ventured boldly into the New World, willing to do whatever was necessary to procure extravagant goods and annex territory to the already immense holdings of the Spanish crown.

Columbus' famous voyage of 1492 initiated the first phase of expansion. For approximately 25 years, the Spaniards focused their efforts to establish trade in the Caribbean Islands and surrounding mainland coastlines, sometimes utilizing brutal tactics in the name of the Catholic Church. The year 1519 saw Spain advancing into what is now Mexico, where the forces of Cortes acquired a motley army of thousands of natives unhappy with the rule of Chief Montezuma. With sheer manpower, Cortes' forces wreaked havoc upon the advanced and prosperous Aztec civilization.

The immense Aztec wealth of gold and crops commandeered by the Spaniards not only added to the material assets of the Crown, padding the coffers for further exploration of ordained Spanish territory, but also heightened the Europeans' morale and confidence with the potential for more magnificently successful conquests to be had in the unknown country of Baja California, which is today part of Mexico, and eventually, Alta California, which is today's American state.

While the hooves of Spanish horses did not meet with Baja California soil until 1533, the wild, bountiful dream of California had existed for over 20 years. A novel entitled The Labors of the Very Brave Knight Esplandian was published in 1510 by Garci Rodriguez de Montalvo. The last of five volumes in the set Amadis de Guala, the novel told the fanciful tale of the island of California, ruled by Queen Calafia, and populated only by women and mythical griffins. In the novel, California is repeatedly portrayed as a land of unrivaled riches and abundance, and in following the chivalric theme popular in the 16th century, the pagan Calafia falls in love with her European paladin, and then leads her people to convert to christianity.

Thus, it seems somewhat predestined that the Spanish pressed into California with such zeal, wielding their religious beliefs and superior weaponry. Following his success in Mexico, Cortes commissioned an exploratory venture to the California peninsula in 1533. Unsuccessful in almost every aspect, the voyage met first with mutiny, then with attack by natives that left the majority of the treacherous crew dead. In perhaps one of the defining moments in the history of the American West, the few survivors reported to Cortes that, while hostile, the natives had been in possession of a wealth of pearls.

A driven man, Cortes himself led the next expedition, which landed in May, 1535 near where La Paz is today. Cortes called it Santa Cruz—not to be confused with the Santa Cruz mission of Alta California, established over 250 years later. Suffering from short supplies and utter isolation, the Cortes settlement could not survive, and was abandoned within a year.

Following the initial enthusiasm and subsequent failures of Cortes, the eventual exploration and mapping of California spanned beyond a century, progressing one laborious expedition at a time. Voyages were fraught with sickness, starvation, storms, and potentially fatal interactions with indigenous peoples, with no guarantee of fresh water or supplies to be had. Burdened with difficulties, the explorers of land and sea did their best to create a coherent map of California, even while fighting to survive. With this in mind, it makes sense that California was mapped as an island as late as 1745, despite the fact that forays into the virgin land had proven otherwise.

Life-size statue of Franciscan Padre Junipero Serra (1713-1784)

Two events became instrumental in furthering the epic Spanish colonization effort. The port of San Diego was mapped in 1542 by Juan Rodriguez Cabrillo, and Monterey Bay was discovered and mapped in 1602 by Sebastian Vizcaino. Both were part of the newly-explored Alta California, and would eventually become the sites of the first two Spanish missions in the territory. In Baja California, missions had been established as early as 1697. The first real plans to establish missions in California were proposed in 1620 by Antonio de Ascencion, who had been on one of the many sea expeditions to the new land. He touted California's potential value to the Spanish Crown, as well as the religious community's willingness to establish missions in both Baja and Alta California.

While de Ascencion felt that the indigenous people could be eventually recruited to the Christian faith, he pragmatically realized the possible challenges and dangers of such a venture, recognizing that establishing missions would indeed require not only religious, but military personnel to keep peace while the missionaries pressed their foreign God upon the natives.

In general, the philosophy regarding settling new territory had shifted significantly toward converting rather than conquering, in part due to the sheer numbers of natives and vast, unknown landscape versus the undermanned military in the Californias. In addition, missions were, by their very nature, much less expensive for Spain to establish than maintaining a full-on military presence, requiring relatively few soldiers, several faith-bound padres, and a stake of supplies. Arguably, the effectiveness of the missions in their purpose would be substantially greater than military force; as it is said, "More flies are drawn by honey than by vinegar."

Historian Herbert E. Bolton observed, as quoted in The California Missions, that:

> "Spain laid claim to the lion's share of the two Americas, but her population was small and little of it could be spared to people in the New World. On the other hand, her colonial policy, equaled in humanitarian principles by that of no other country, perhaps, looked to the preservation of the Natives, and to their elevation to at least a limited citizenship. Lacking the Spaniards to colonize the frontier, she would colonize it with aborigines. Such an ideal called not only for the subjugation and control of the Natives, but their civilization as well. To bring this end about, the rulers of Spain made use of the religious and humanitarian zeal of the missionaries, choosing them to be to the Indians not only preachers, but also teachers and disciplinarians. To the extent that this work succeeded it became possible to people the frontier with civilized Natives, and thus to supply the lack of colonists. This desire was quite in harmony with the religious aims of the friars, who found temporal discipline indispensable to the best work in Christianization."

In de Ascencion's plan, he detailed various aspects of his concept for settling California, exhibiting an oxymoronic blend of insight and pious naivete. Among his ideas, he proposed that military personnel should themselves be of devout, unshakable faith in order to create a united, coherent front and that all necessary supplies and religious materials would be sent, along with a variety of simple trinkets to demonstrate magnanimity and goodwill to the natives. His plan stated, as quoted in Lands of Promise and Despair: Chronicles of Early California, that:

> "These items should be divided among the religious and the soldiers so that, wherever they land or choose to settle, they can distribute these pleasing gifts to the infidels they meet. With signs of love and goodwill, in the name of His Majesty, the gentile Indians will eventually feel love and affection for the Christians. They will also recognize that the Christians have come to their lands not to take away what the Indians have, but to give them what they have brought, and to save their souls. This is a matter of great importance, for it will enable the Indians to become calm, humane, and peaceful. Then they will obey the Spaniards without opposition or repugnance and receive willingly those who have come to preach the Holy Gospel and the mysteries of our Holy Catholic Faith."

While de Ascencion staked his faith in the success of the missions, he also unwittingly touched upon that which would play a role in the eventual decline and ultimate downfall of them. Seventy-some years after de Ascencion put his inked idea to paper, with missions successfully established in Baja California, the Spanish Viceroy (vice-king) was in no great hurry to press into Alta California. In fact, it would eventually be Russia's imminent encroachment that spurred Spain to action, when it became a priority to 'guard the dominion from insult and injury.'

For twenty-five years, Russian fur traders had been establishing

colonies along the shores of the Bering Sea, and had come as far south as the Farallon Islands off the coast of San Francisco in their quest for seals. The Spanish aristocracy's sudden realization that their future fortunes were at stake induced the renaissance of de Ascencion's concept over 150 years after it was originally penned.

While it took a century-and-a-half to realize the genuine merit of a plan to settle Alta California, it took a mere sixty-some years for Spanish California to become that by which it is today defined. The mission system's heyday began in 1769 with the founding of San Diego de Alcalá, and continued into the mid-1800s. In a historical context, the period is brief. However, considering the relatively brief span of time in which the padres nurtured their missions to success compared to the centuries that lay between the exploration and settling of California, the accomplishments of the missionaries are that much more impressive.

The immediate purpose of the missions was to convert and enlighten natives to the purportedly superior religion and civilization of Europe, a means to both religious and political ends—a fact that has stirred controversy over the years. One historian, Father Engelhardt, went so far as to state that "...men who presumed to guide the destinies of Spain cared not for the success of Religion or the welfare of its ministers except in so far as both could be used to promote political schemes."

Touted to be the epitome of progress and salvation by some, yet decried as holy-cloaked slavery by others, the long-term goal of the mission system was, of course, to broaden Spain's global influence, and the missionaries pursued the faith-based facet with fervor. Decreed under Spanish law, an established mission would have ten years to meet the underlying goal of civilizing, educating, and enlightening natives to the point of self-sufficiency.

Establishing a settlement was no simple process. In addition to myriad mortal dangers inherent to time and place, as well as interminable delays in correspondence and shipping, the missionaries faced a complicated bureaucratic process to secure funding, supplies, and personnel from the Spanish Viceroy.

Once the necessary authorization and documentation were in place, offering little consolation for the trials ahead, the founders of the first missions found themselves in a raw, wild land, devoid of the familiar, left to rely only upon their most primal survival skills, faith, and the few, infrequent supply ships sent across the fathomless azure mystery of the ocean—some of which disappeared en route, never to be heard from again.

The process of mission establishment followed a set of exacting rules, written in great detail in hopes of covering every eventuality. Since the voice of higher authority was a six-month sea voyage away, the documents provided precise procedures to follow regarding every conceivable aspect of mission establishment. It went so far, in fact, as to suggest what colors of fabric would be most appropriate to offer the natives.

Despite these well-laid plans, California presented a deluge of hardships. While Spain had planned in great detail how to deal with the predictably challenging and potentially dangerous encounters with California's native man, nothing could be done to prepare for the mayhem born of the earth itself. Claiming lives and destroying years of work, the notorious earthquakes of the early 1800s bore an ominous omen impossible to ignore, indiscriminately rattling the faith of even the most devout. Sporadic fires, floods, droughts, and plagues ravaged struggling missions, but in a stroke of bitter irony, it was the Spanish themselves who brought early disaster to their own settlements with European diseases. As the already daunting task of building faith and its accoutrements progressed, epidemics of measles, chickenpox, and venereal disease raged, filling mass graves with victims.

For natives already wary of the Spaniards and their ways, rampant disease cast the padres' best intentions in a suspicious, sinister light. For them, this new god had shown them little but regimented alien rituals and death. Only the faith and determination of the padres brought the missions through those times, which eventually allowed them to demonstrate to the natives all that a mission was intended to be.

The Spanish utilized three different entities when establishing a colony: the presidio (fort), the mission, and the pueblo (town). In California, the mission became the most common and was vastly successful. However, in many cases, a presidio, mission, and pueblo existed interdependently. A presidio established and maintained a military presence, offering protection for the padres as they went about the business of setting up a mission. In some instances, armed guards accompanied the padres at all times.

While the first two missions were founded a substantial distance apart, the chain soon filled in and new missions were strategically placed so that, upon completion of the string, it would be only about a day's ride between each station. The route that joined the missions was known as El Camino Real, or the Royal Road. As the chain of missions grew, it was able to, rather literally, feed upon itself. Established missions could supply manpower, livestock, and supplies to a fledgling colony, whereas in the beginning, all necessities had to be shipped from afar.

The missions' founding dates were traditionally the day that a cross was erected and a ceremony of prayer and blessing was held, thus consecrating the site. In most cases, missions were named for various religious icons, such as saints and angels, but La Purísima Concepcion of Maria Santisima was named to honor the Immaculate Conception of the Virgin Mary, and Nuestra Señora de la Soledad earned its moniker from the misunderstood name of a native guide.

In the months following the founding date, the missionaries worked on the spiritual, architectural, and industrial engineering required for a successful mission. Quite literally rising from the landscape, the missions began as little more than the crudest of brush huts, and as manpower increased through conversions, the structures gradually metamorphosed into log and adobe structures.

The architecture of the various missions offers an eclectic blend of design representative of two starkly different cultures melding—old-world simplicity and artistry accented with bright, primitive strokes of California's people. The bold, earthen tones and geometric patterns popular with the natives were mingled among the wrought metal, carved stone and wood elements of traditional Spanish architecture.

The missions were generally built in the form of a quadrangle, with a courtyard in the middle. The main building usually included not only the church, but also dormitories, workshops, and storerooms. Several components of the architecture became stereotypical of missions: the elaborate ornamented doorways and windows of Moorish influence; the espadaña, which was a false front to create an image of strength; the campanario, a wall with holes in which the bells hung; and the corridor, which was a covered but airy pillar-hemmed walkway common in Spain. Trained artisans were employed whenever possible to design the overall layout and to then facilitate the ensuing construction and decoration.

Surrounding the central mission building were housing units for the converts and structures inherent to the industries of the mission such as tanneries, grain mills, and forges, as well as myriad acres of crop and pastureland—the lifeblood of each mission. The industries made possible lively trade, supplying goods to barter for necessary manufactured items from overseas, and creating a hands-on vocational education for the natives. Each mission was its own thriving community, specializing in a variety of agricultural endeavors. The missions' livestock and fertile cropland not only fed the

chain, but also supported a number of related occupations. From their carefully nurtured bounty of nature, the missions and their neophytes brought forth grains, wines, tanned hides, tallow, leatherwork, and numerous handicrafts of great trading value.

To fully appreciate the productivity of the missions, one must realize the extraordinary, clever means through which their accomplishments were made. Examples exist throughout the mission chain. The necessity of irrigation water led to the construction of elaborate, inventive aqueduct systems at all the missions, sometimes channeling water for miles to the growing fields from a dammed river. Astoundingly, the water system at Santa Bárbara was so well crafted that portions of it are still in use today. At San Antonio de Padua, huge quantities of wheat were threshed by the hooves of wild horses driven through piles of the grain spread across a stone courtyard. A burro-powered mill modeled after an ore-crusher milked oil from olives at La Purísima Concepción.

The functional ingenuity and achievements of the missionaries do not overshadow the finer, aesthetic attributes of the missions. Like the rugged shell of an oyster housing a pearl, the stout, utilitarian walls of the missions embrace rare, stark beauty within. Along the cool, cobbled corridors, among the intricate works of art and painstakingly

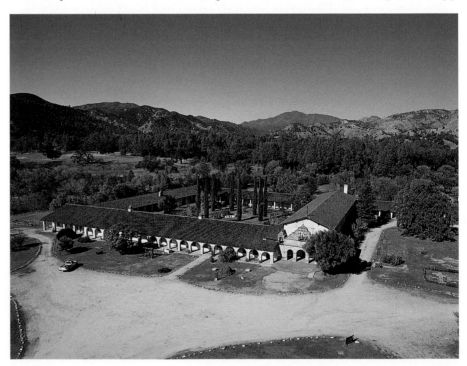

Aerial view of quadrangle shape at Mission San Antonio de Padua

crafted artifacts of wood, metal, and stone, one senses the essence of careful personal attention and devotion with which the padres pursued their labors of love.

Most often having limited, if any, experience in the matters of a hand-to-mouth existence, the padres invested their bodies and souls in faith and their belief in what it could accomplish. The old adage about the Lord helping those who help themselves eventually proved to be true. The historian Father Engelhardt was quoted as saying, "It must be remembered that the friars came to California as messengers of Christ. They were not farmers, mechanics, or stock breeders. As an absolute necessary means to win the souls of these savages these unworldly men accepted the disagreeable task of conducting huge farms, teaching and supervising various mechanical trades, having an eye on the livestock and herders, and making ends meet generally."

It is thus awe-inspiring to note the sheer numbers that added up to the missions' height of glory, shortly before their downfall. The California Missions states that, "In 1834, on the eve of destruction of the missions, the Indians at the 21 missions herded 396,000 cattle, 62,000 horses, and 321,000 hogs, sheep, and goats, and harvested 123,000 bushels of grain. Sixty-five years before, there had not been a single cow, horse, hog, sheep, goat, or grain of wheat in the entire province of Alta California."

Through those 65 years, fraught with unimaginable odds, the padres laid the cornerstones of California heritage. While numerical figures offer a quantitative perspective, the subtler, intangible humanitarian accomplishments of the padres are equally appreciable.

From raw, untapped civilizations that had remained unchanged for thousands of years, the padres worked to mold Spain's future, all within a timeframe that is less than the expected life span of a modern human. To the most wild and primitive of places, rooted utterly in the palpable, the padres brought abstract visions of the Christian divine, and dedicated their lives to instilling the invisible ideal in the native people. The immense culture gap was bridged by hard work and faith, advancing the native tribes by thousands of years in less than a century. Though there remained progress yet to be made toward meeting contemporary standards of faith, education, skill, and civilization, the neophytes had advanced phenomenally.

Thoroughly disastrous for the natives dependent upon the structured mission institution, the enforced secularization of the 1830s was the undoing of the thriving missions. In other Spanish provinces, the transformation process had gone well. However, despite their incredible progress, the indigenous Californians remained unwilling to shoulder the responsibilities of secular self-sufficiency. Secularization was opposed by both missionaries and civil authorities, who recognized the impact it would have on the people and the economy. Nevertheless, from outside the Church, pressure had been mounting for years as settlers trickled into the provinces, understandably wanting to own the land they worked. The entirety of California was owned by Spain, and without official secularization, private land ownership was impossible.

Too far removed from their traditional ways of life, the natives were left to fend for themselves. Much of the land was turned over to them, but having no understanding of titles and related privileges, they were swindled out of their holdings. Many resorted to thievery; those who sought gainful employment were treated as slaves by the new landowners.

A saga of Shakespearian proportions, the initial ambitious colonization of California fell during the sunset of the Spanish empire. Forces in action far beyond the mission walls would see 19th century California wrested from Spain by the newly independent Mexico, only to be later annexed into the United States of America.

Left in the wake of time and circumstance, Spain's grandiose California vision faded into history books. The ultimate loss of California perhaps makes it seem that the padres' lifelong labor for the Crown was in vain. But, even while tossed about on the tumultuous sea of time, through floods of fortune seekers, acts of God, and epidemic urbanization, California has not forgotten her heritage.

The 21 missions have undergone numerous changes in ownership, renovations and restorations over the years, and relatively little remains as evidence of the bustling, prosperous communities they once wore. But the surviving structures, however changed, are more than old adobe and memorabilia—they are anchors to a heritage worth a conquistador's collection of gold.

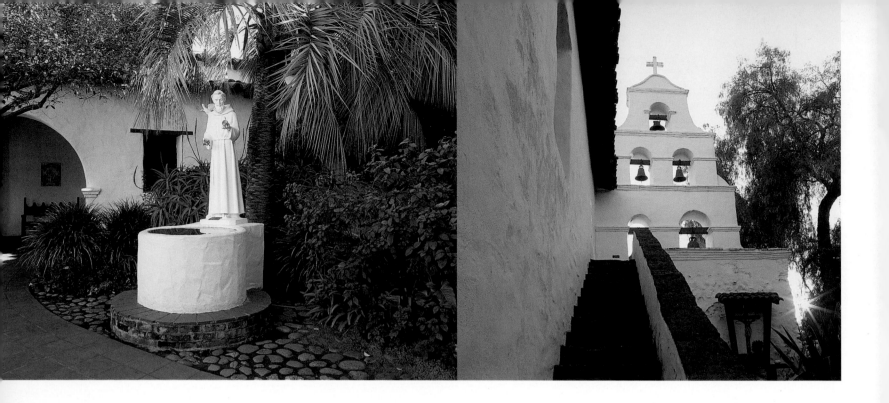

MISSION SAN DIEGO DE ALCALÁ

The first mission, founded on July 16, 1769

Cemetery garden statue of
St. Francis of Assisi

The campanario

Opposite: Mission San
Diego de Alcalá

The first mission, San Diego de Alcalá, was founded on July 16, 1769 by the man who came to be known as the father of California, Fr. Junipero Serra. Although the mission was moved in 1774, the original site was the first permanent settlement in California. The original sea-bound settlers battled scurvy, losing a large portion of their group before the mission was even under way. Barely spared from desperate abandonment, the mission struggled to convert the wary natives, erect buildings, and live through persistent illness. In its history, San Diego survived Indian attacks, droughts, and earthquakes. Secularized in 1834, it was eventually returned to the church in 1862.

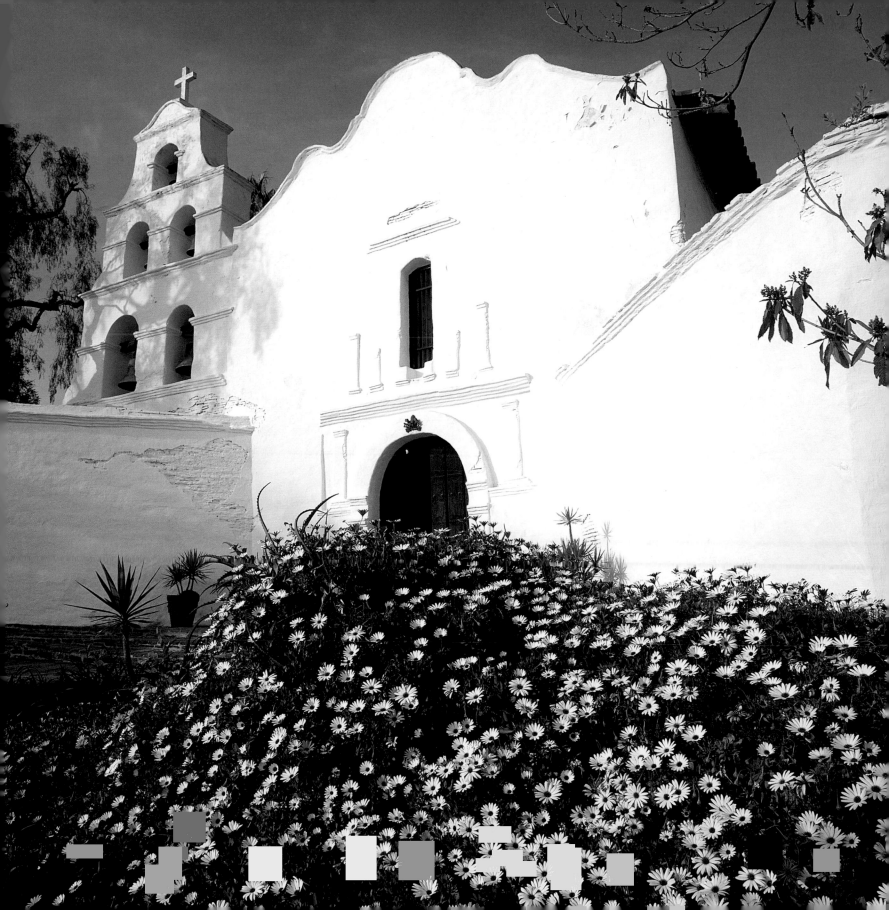

Polychrome bulto of San José

Ceiling beam. Timbers used for the buildings were carried by the Indians from the Pala Mountains 60 miles away.

Wall dado

Opposite: Since records of the interior were non-existent, the restored reredos and altar were made according to other old missions. Church records indicated that sea captains visiting the port furnished wooden planks from their ships to build the first altar.

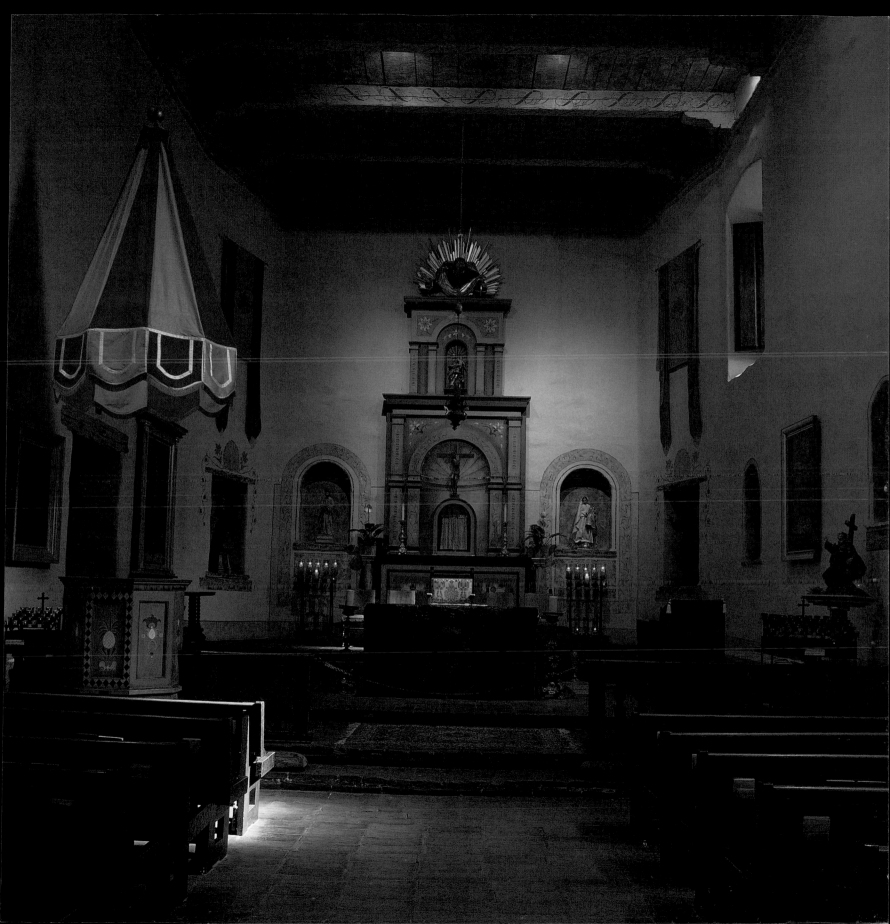

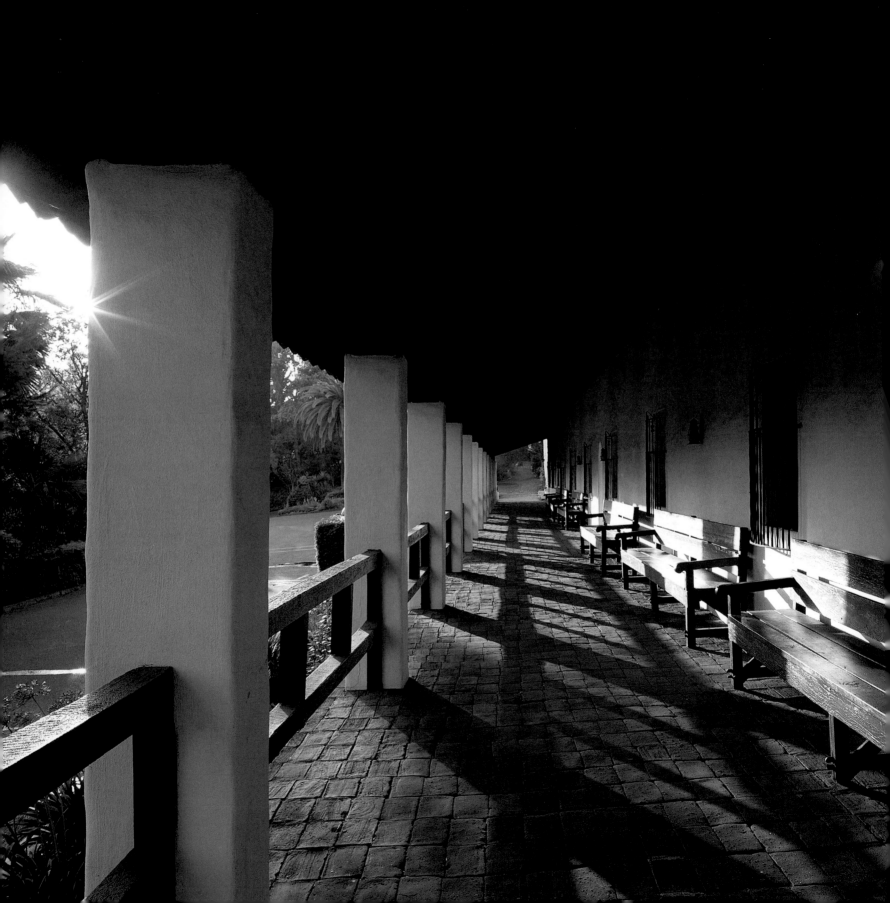

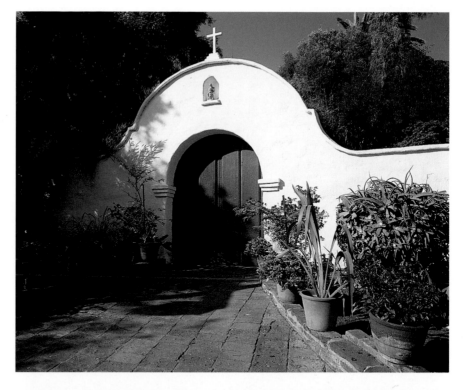

Fire-tiled crosses memorialize
hundreds of mission Indians
buried in the oldest
cemetery in California.

Gates to cemetery

A cross marks the
approximate site where
Padre Jayme was martyred.

Opposite: At sunset,
shadowed colonnades stretch
across a long corridor.

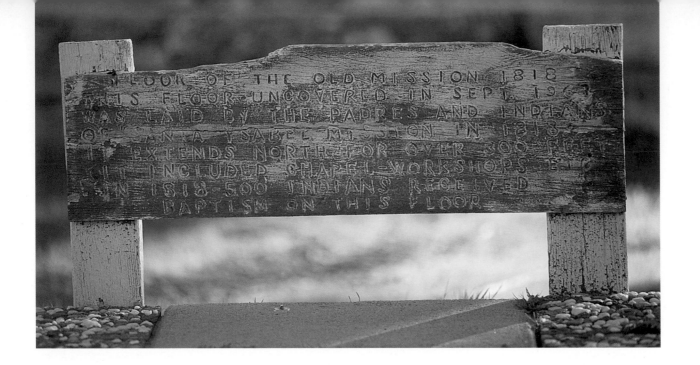

Asistencia Santa Ysabel

Assistant mission to San Diego de Alcalá
First mass held on September 20, 1818

Sign describing chapel floor tiles

Asistencia Santa Ysabel site where the original mission floor tiles that were laid by padres and Indians in 1818 were uncovered.

Opposite: In the hills 60 miles east of San Diego Mission, a small church stands on the site of a chapel (asistencia) founded by the padres in 1818 for the Santa Ysabel Indians, who found it a hardship to journey to Mission San Diego de Alcala to attend religious services.

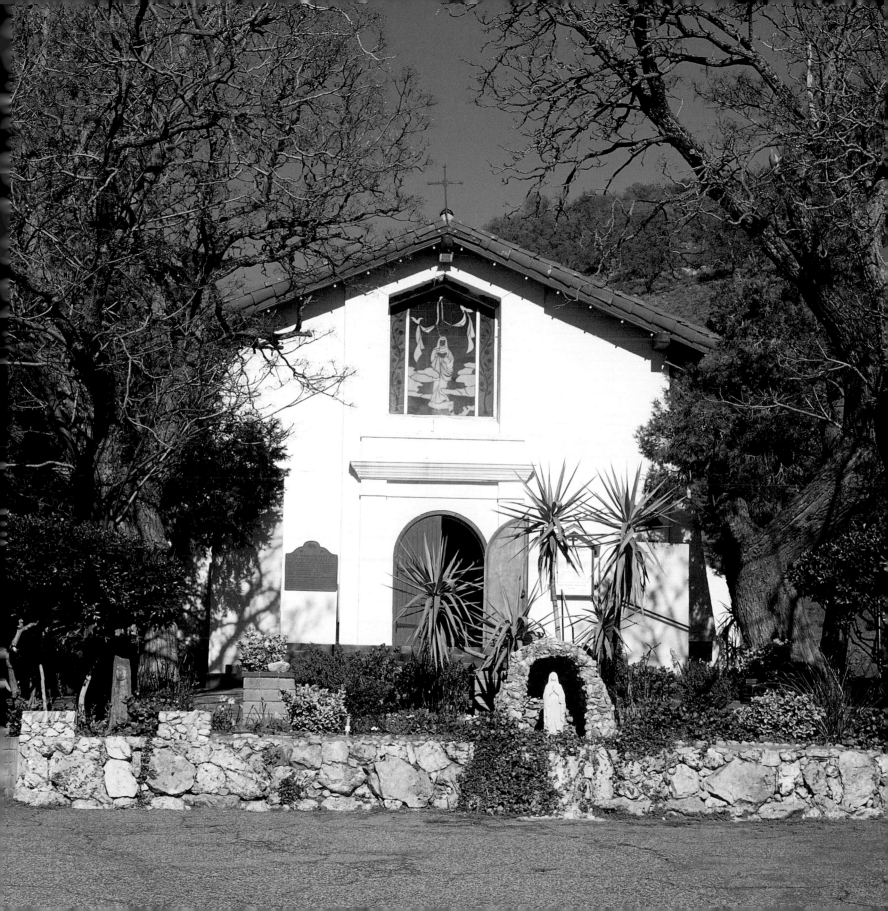

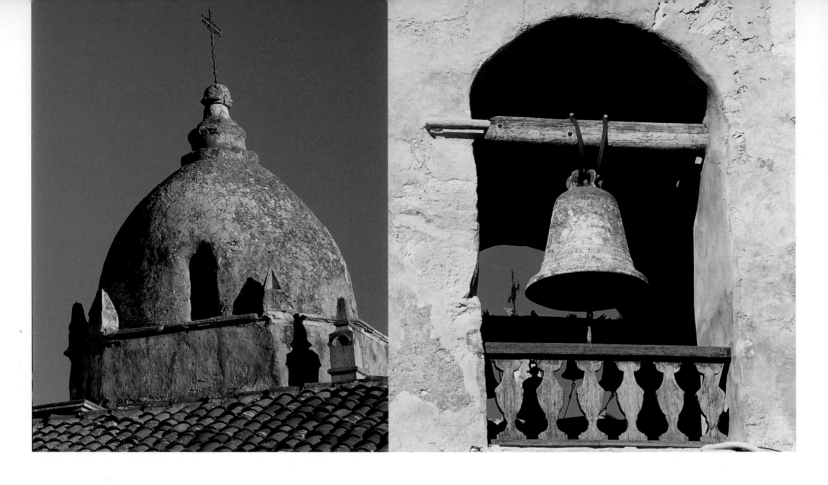

Mission San Carlos Borromeo de Carmelo

The second mission, founded on June 3, 1770

Dome-shaped bell tower

Bell in dome tower frames cross on the shorter square tower.

Opposite: Stone church with two dissimilar bell towers that crown the facade

San Carlos Borromeo de Carmelo, the second of nine missions established by Fr. Junipero Serra, was founded on June 3,1770 at the Monterey Presidio, and was moved to the beautiful Carmel Valley in 1771. The mission served as Serra's headquarters for his role as Father/President of the missions. When Serra died, on August 28, 1784, his remains were entombed at the mission. Serra's successor, Father Fermin Francisco de Lasuen, was also interred there following his death in 1803. The infamous pirate Bouchard raided Monterey in 1818, but somehow the mission was spared. Secularization came in 1834.

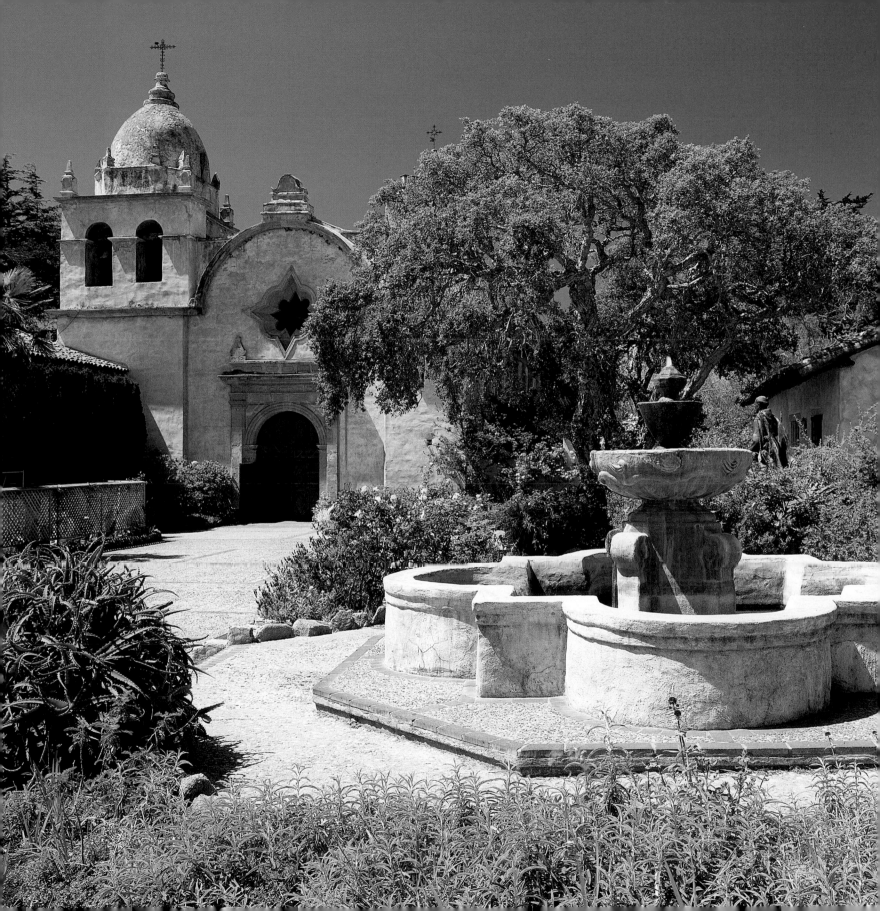

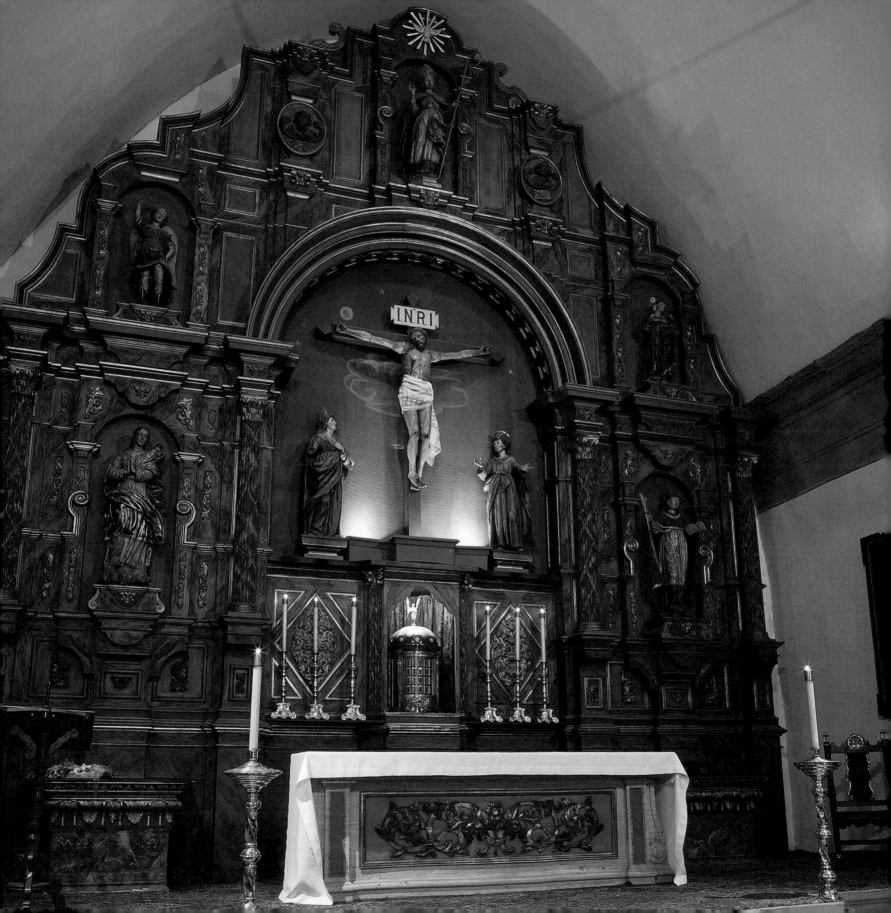

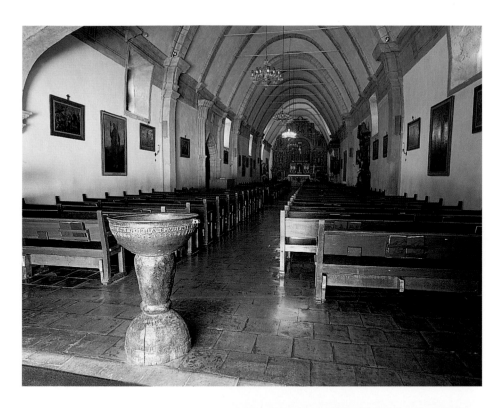

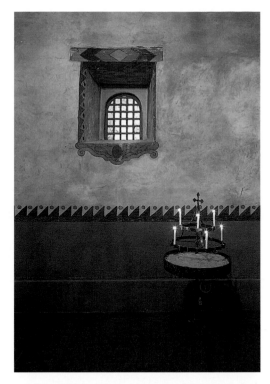

Holy water font

Prayer candles

Silk vestment worn
by the padres

Wall dado and prayer

Opposite: The sanctuary
reredos carved by renowned
restorer, Harry Downie

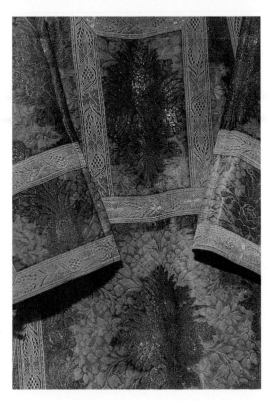

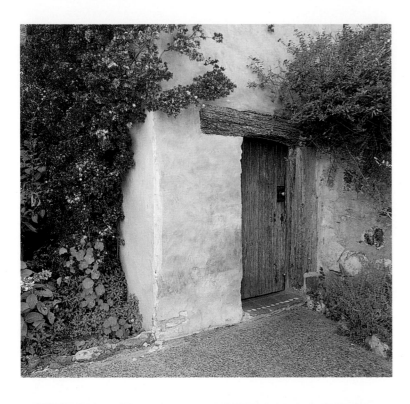

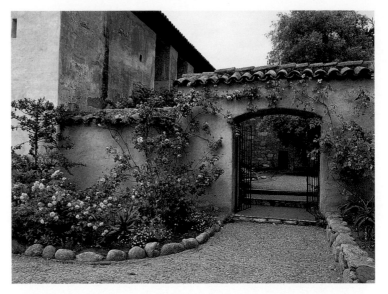

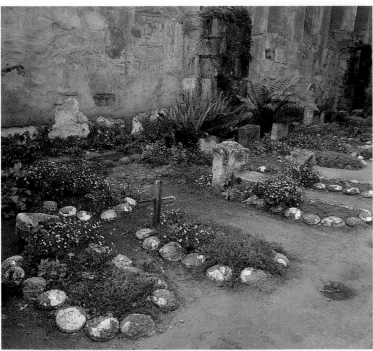

Side entrance to basilica

Arched gate to cemetery

Indians had many uses for cactus, including eating the prickly pear fruit.

Abalone shells decorate the gravesites.

Opposite: The larger dome-shaped bell tower holds nine bells, most of which are original.

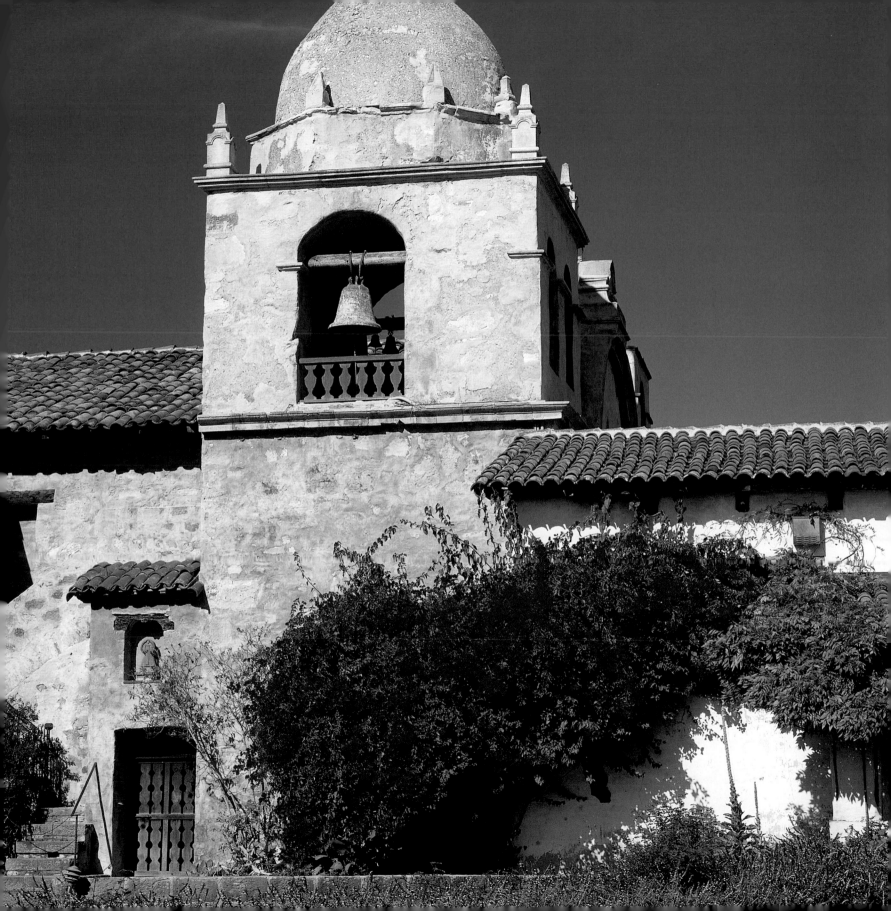

Coat of arms of the brother orders, Dominicans and Franciscans

Wood carving on outside nicho

Old carving on basilica wall above cemetery

Opposite: Junipero Serra's reconstructed cell (bedroom). The wooden bed and table are replicas built from original mission timbers.

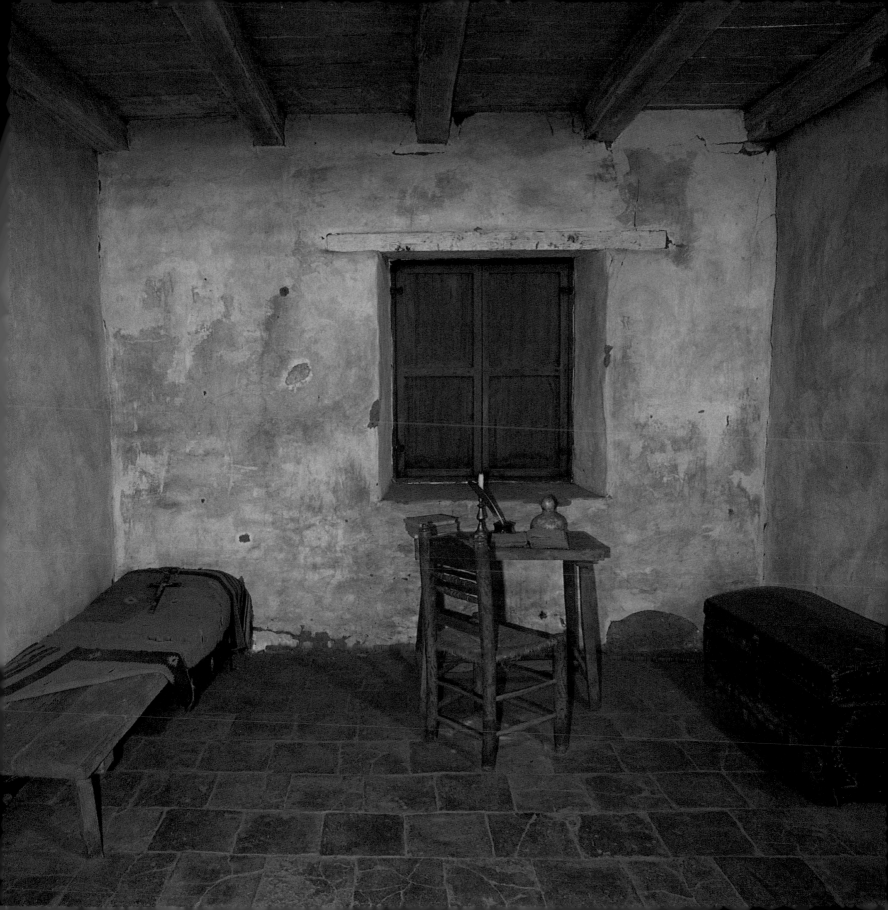

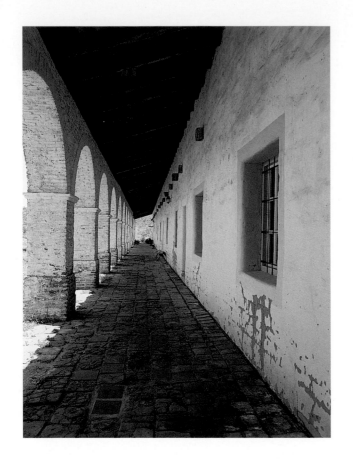

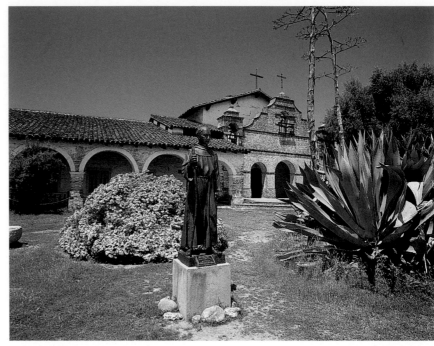

Mission San Antonio de Padua

The third mission, founded on July 14, 1771

Arched colonnades and corridor line the convento.

Statue of Father Serra in front of the mission at San Antonio de Padua

Opposite: Mission San Antonio de Padua

San Antonio de Padua was brought to life by Fr. Junipero Serra on July 14, 1771, and came to be known as one of the most successful missions in regards to productive and humanitarian accomplishment. Moved in 1773 and secularized in 1834, the mission was abandoned from 1882 to 1928 and eventually restored.

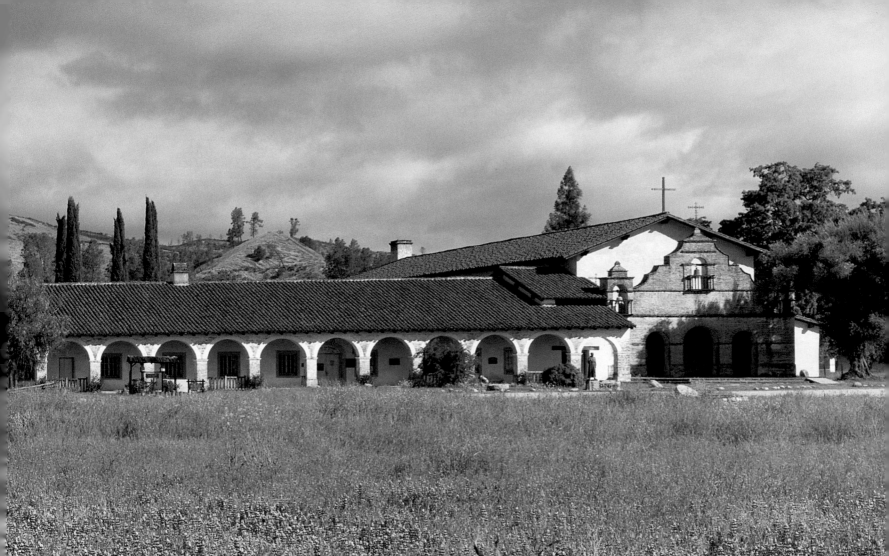

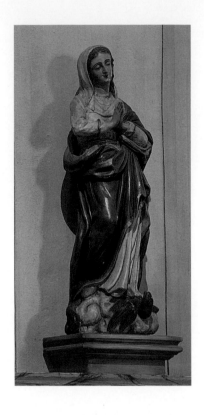

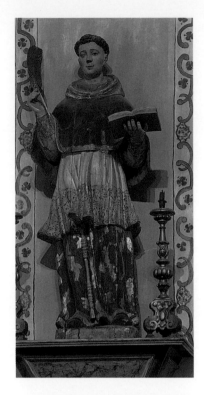

Clockwise from top left:
Bulto of Our Lady of the
Immaculate Concepción

Bulto of San Buenaventura

Bulto of San Francisco

Bulto of St. Joseph

Opposite: Indian design
painted wall dado

The sanctuary altar and reredos

Side entrance to the
mission church

Small chapel at the back of
the mission church

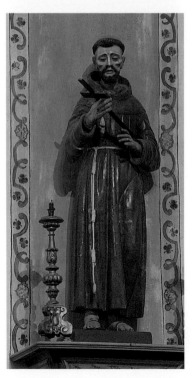

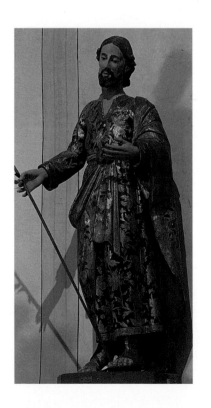

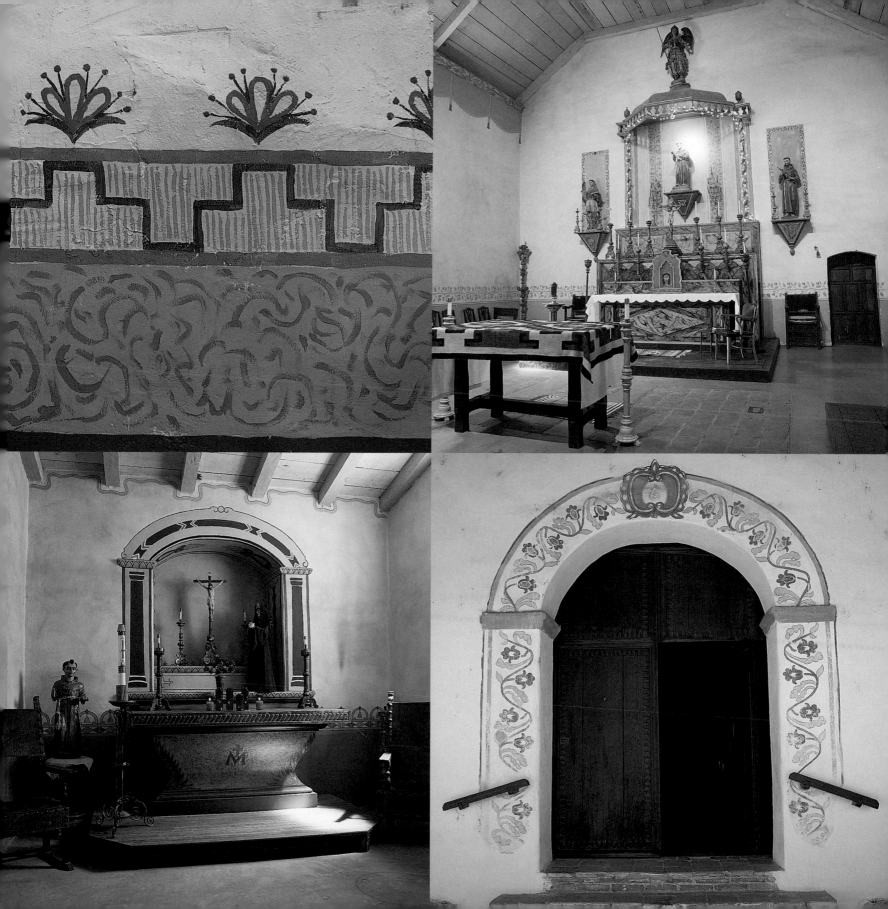

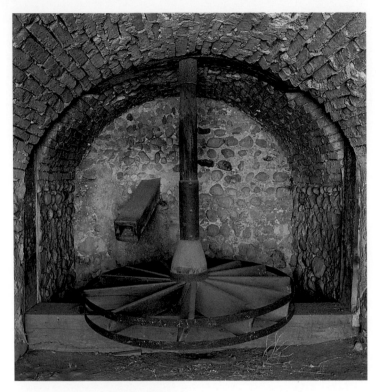

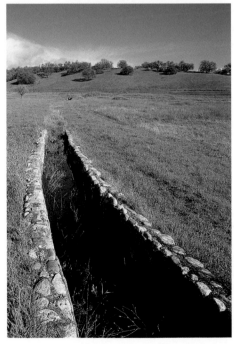

Ladder to the bells

Water from the aqueduct flowed into the turbine beneath the mill.

Partially restored water canal to gristmill

An adobe ruin wall beyond the mission

Opposite: Stone threshing floor where Indians separated grain by having mules tread on it or by beating it with flails.

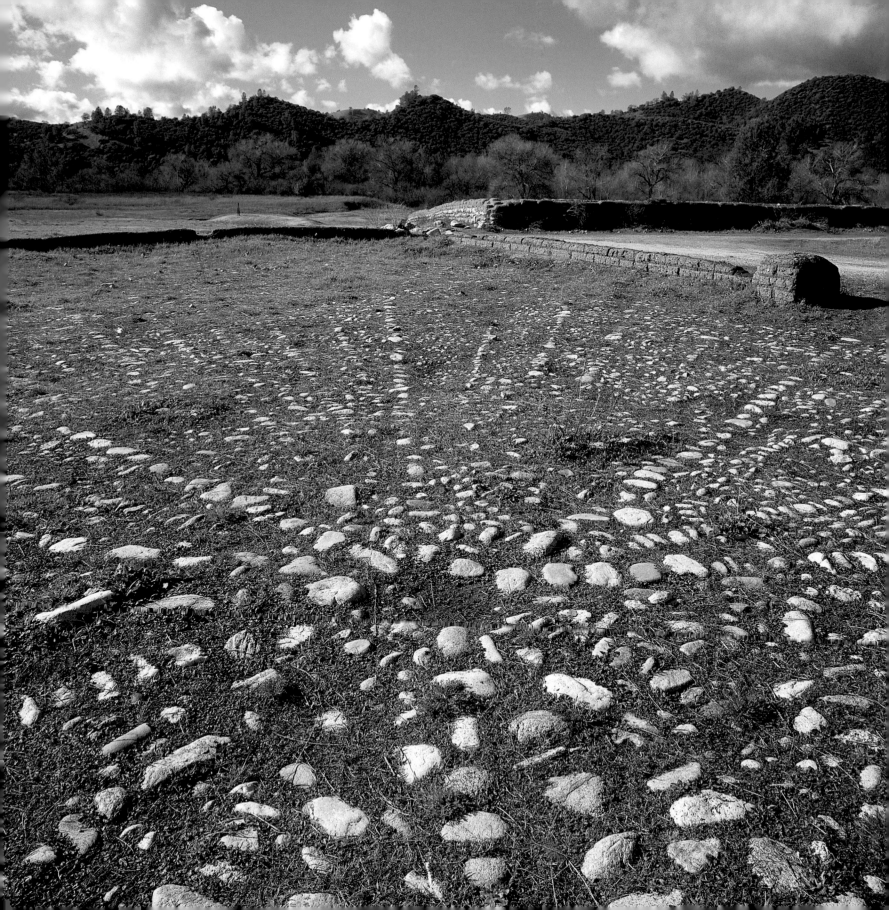

Mission San Gabriel Arcángel

The fourth mission, founded on September 8, 1771

Cannon discovered in a dry river bed after the 1914 flood. It was believed buried at the end of the Mexican War sometime between 1847-67.

Tallow and soap vats. San Gabriel was noted for the soap and candles it supplied to other missions.

Opposite: Original bell-wall toppled after 1812 earthquake. It was rebuilt on the far end of the mission where it is seen today.

The fourth mission, San Gabriel Arcángel, was founded by Frs. Pedro Cambon and Angel Somera on September 8, 1771, and moved by Father Fermin Francisco de Lasuen in 1775. Unique in its construction, the mission demonstrates more Moorish influence than most other missions. Much like the cathedral in Cordova, Spain, the structure resembles a fortress. Boasting six bells and built where three well-traveled trails met, the mission saw a great number and variety of travelers. Undoubtedly one of the most prosperous missions, San Gabriel Arcángel was home to plentiful timber, pasture, and crop lands. Damaged by the earthquakes of 1812, the mission was secularized in 1834 and returned to the Church in 1859.

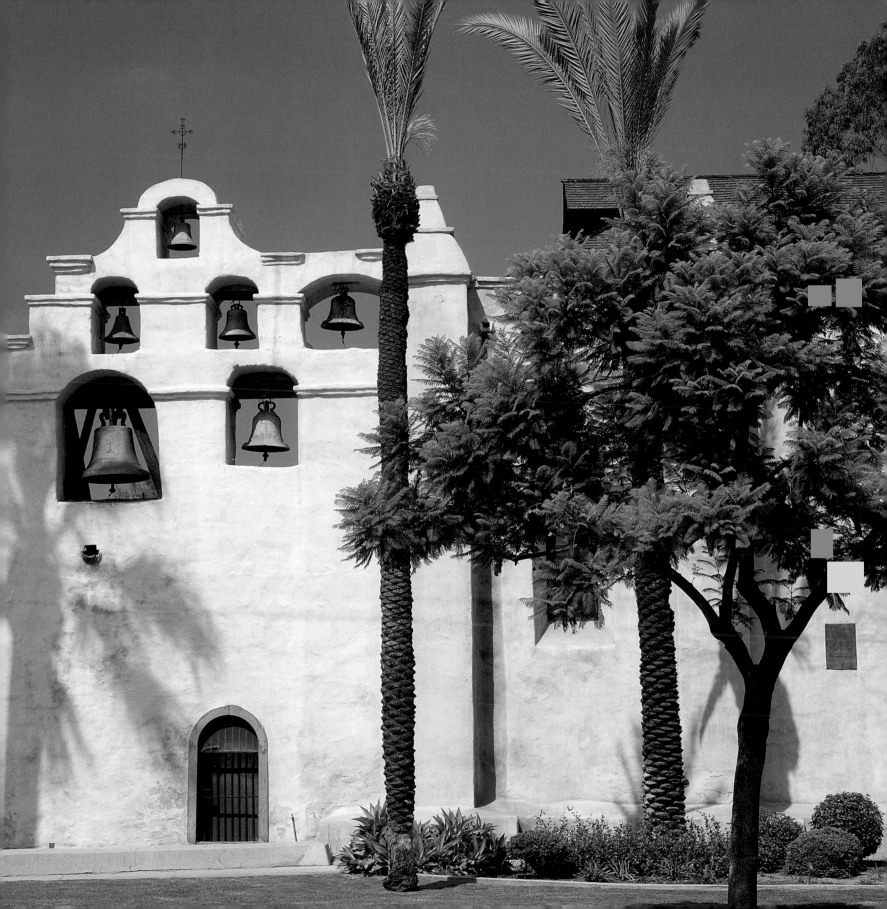

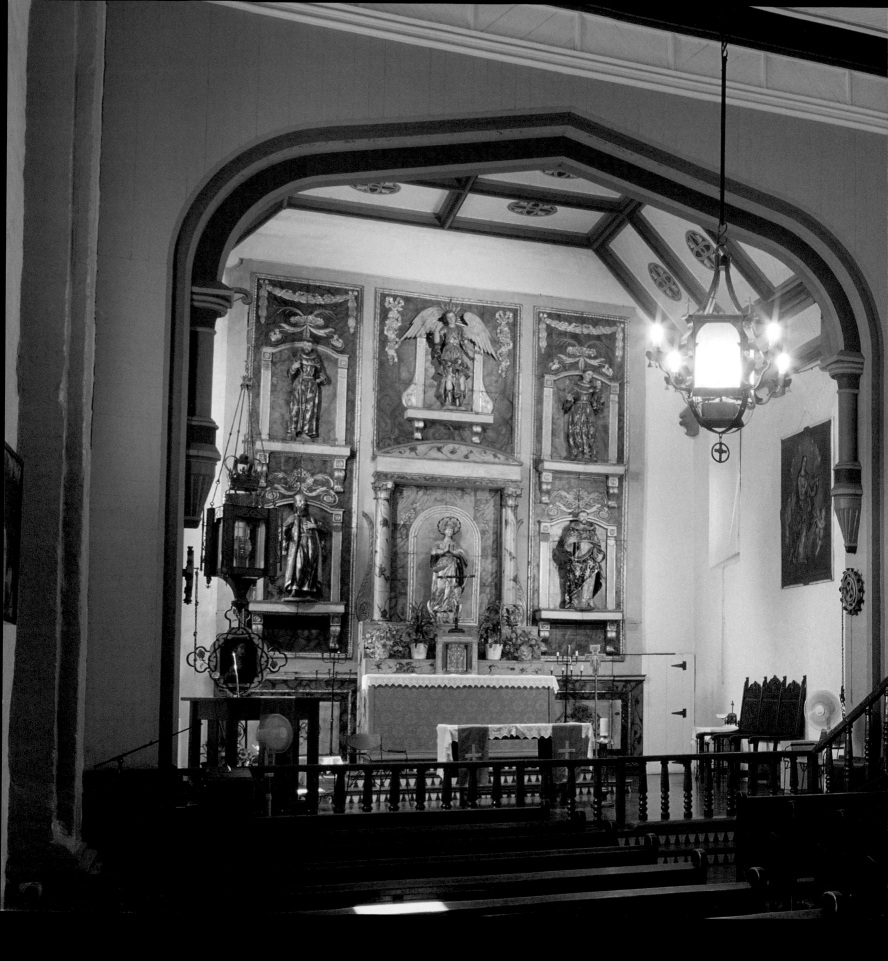

Painted ceiling fresco in the small baptistry room

Dome-shaped ceiling fresco.
Ten thousand Indians were estimated
to have been baptized in the baptistry room.

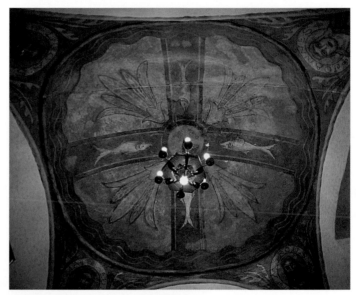

Stations of the Cross painted on
unprimed linen cloth by Indians
of Mission San Fernando. They
are the only authentic Indian
paintings in the mission chain.
The 14 Stations were exhibited
in Chicago at the 1839 World's
Columbia Expo, then became
part of a Los Angeles Chamber
of Commerce exhibit, and
later given to the padres at
San Gabriel.

Opposite: Altar and reredos
came from Mexico City in the
1790s, restored in 1993

Modern-day Stations of the Cross
decorate the walls within the
cemetery quadrangle.

Modern-day icons in the cactus garden

Modern cross in the cemetery

Opposite: Modern statue weathers away
in the cactus garden

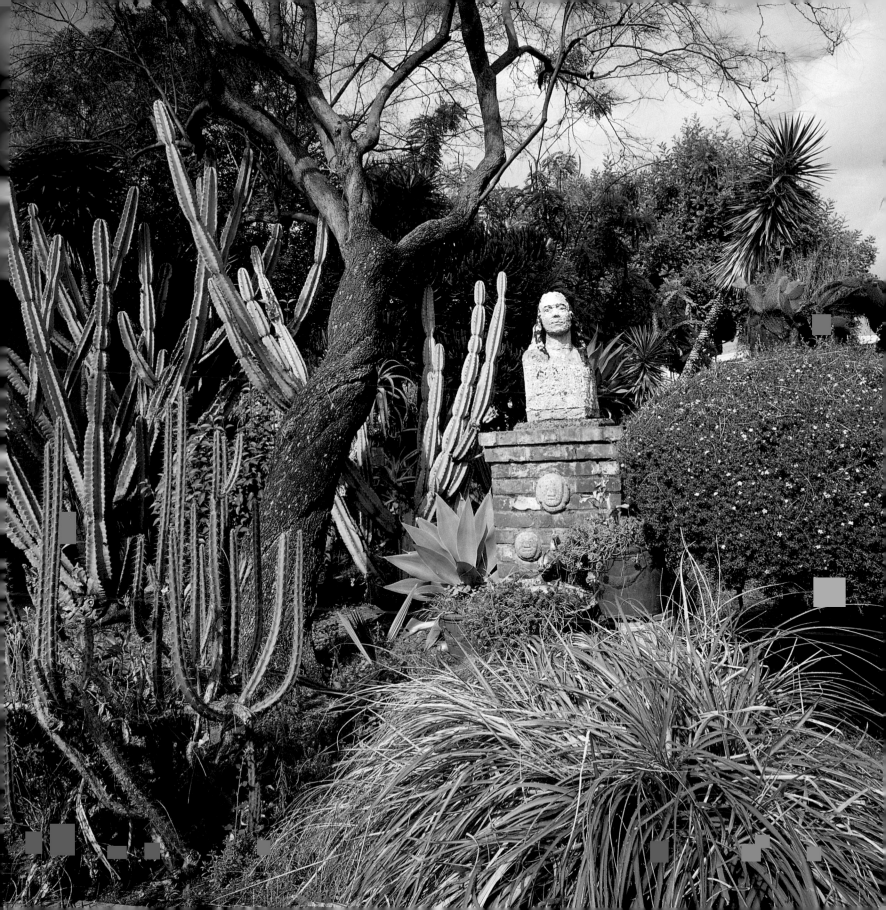

MISSION SAN LUIS OBISPO DE TOLOSA

The fifth mission, founded on September 1, 1772

Mission San Luis Obispo de Tolosa

Opposite: Tree shadow on whitewashed adobe wall

Plaza fountain at Mission San Luis Obispo de Tolosa. The area was once known as "Valley of the Bears."

Another of Serra's missions, San Luis Obispo de Tolosa, was founded on September 1, 1772. It came to be known for its wines, fruits, vegetables, and olive oil, but most significant to all the missions was the fact that San Luis Obispo de Tolosa was responsible for the design of the quintessential Spanish roof tiles that eventually graced all the missions. When flaming arrows set the thatched roof afire, the missionaries sought a better alternative, and set the trend for mission roof design. Through earthquakes and restorations, San Luis Obispo was secularized in 1835 and eventually returned to the Church in 1859.

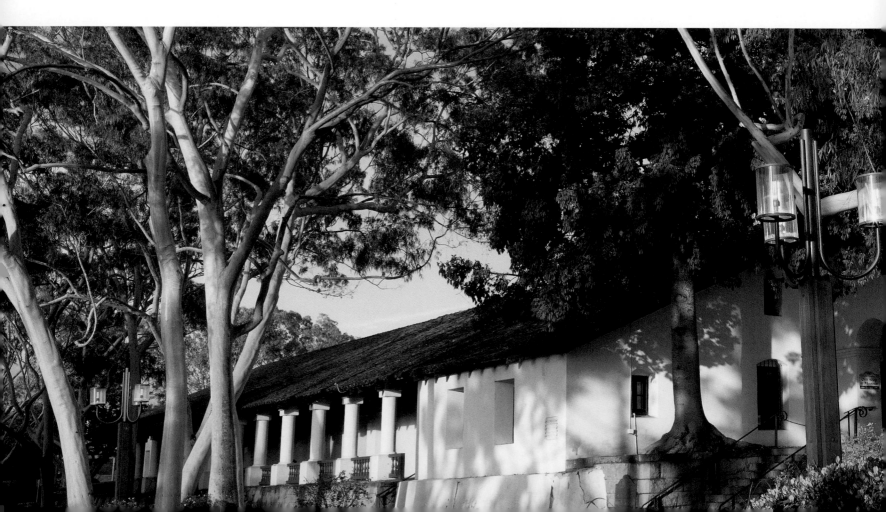

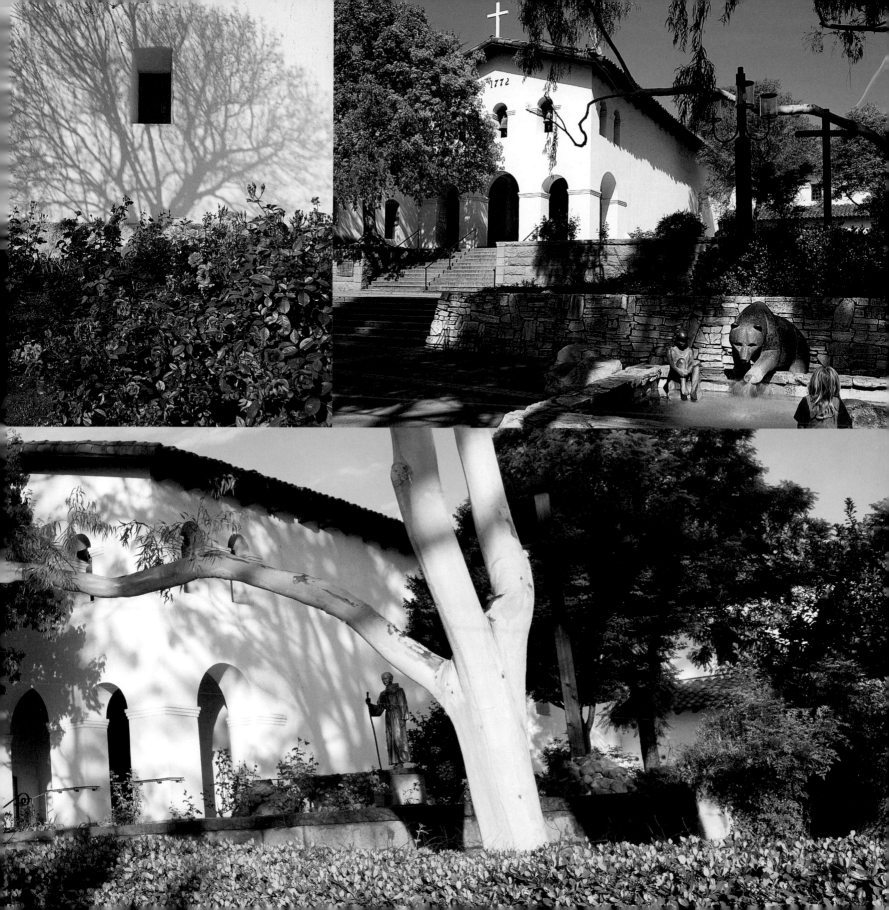

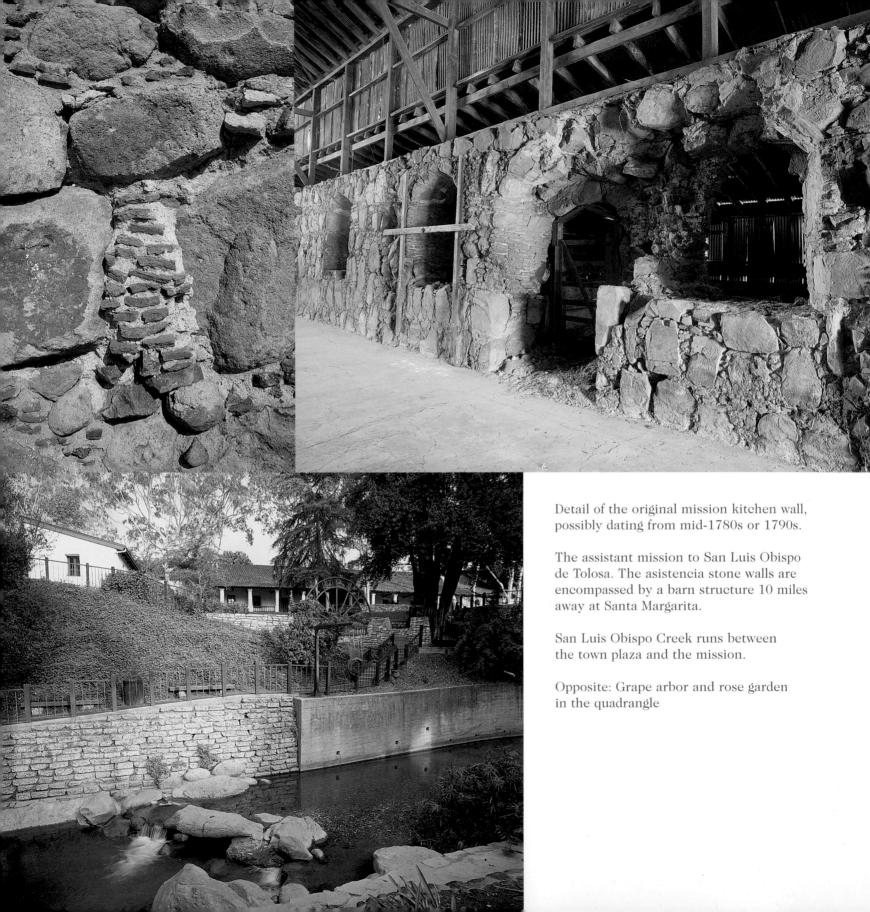

Detail of the original mission kitchen wall, possibly dating from mid-1780s or 1790s.

The assistant mission to San Luis Obispo de Tolosa. The asistencia stone walls are encompassed by a barn structure 10 miles away at Santa Margarita.

San Luis Obispo Creek runs between the town plaza and the mission.

Opposite: Grape arbor and rose garden in the quadrangle

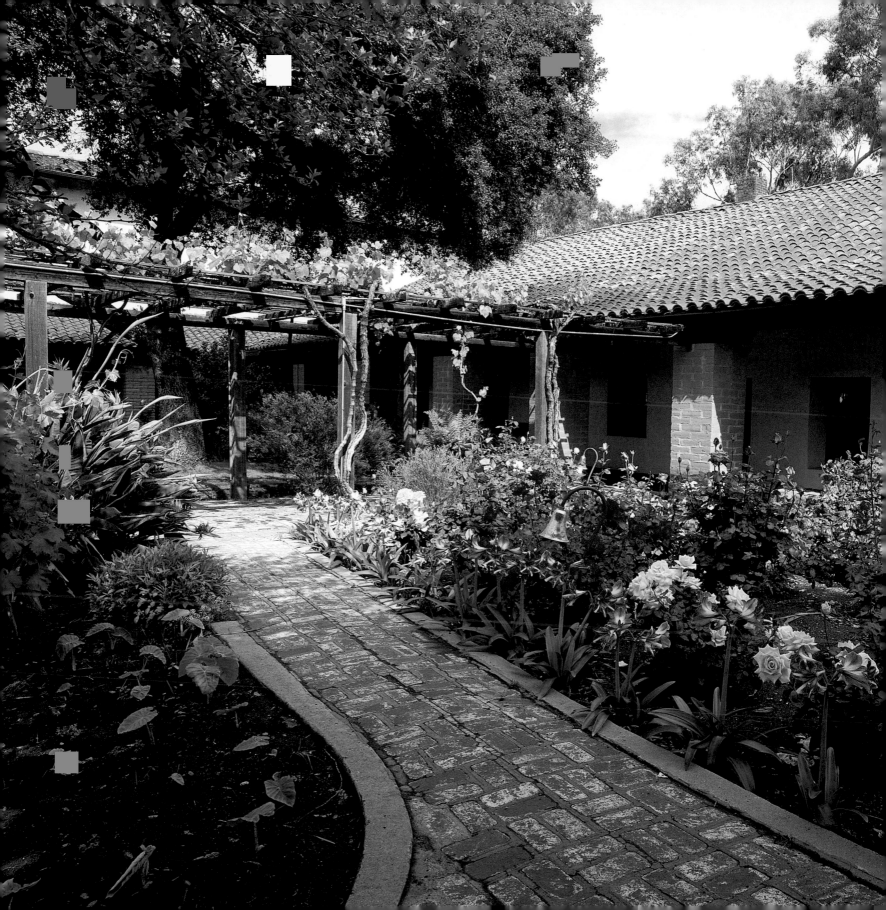

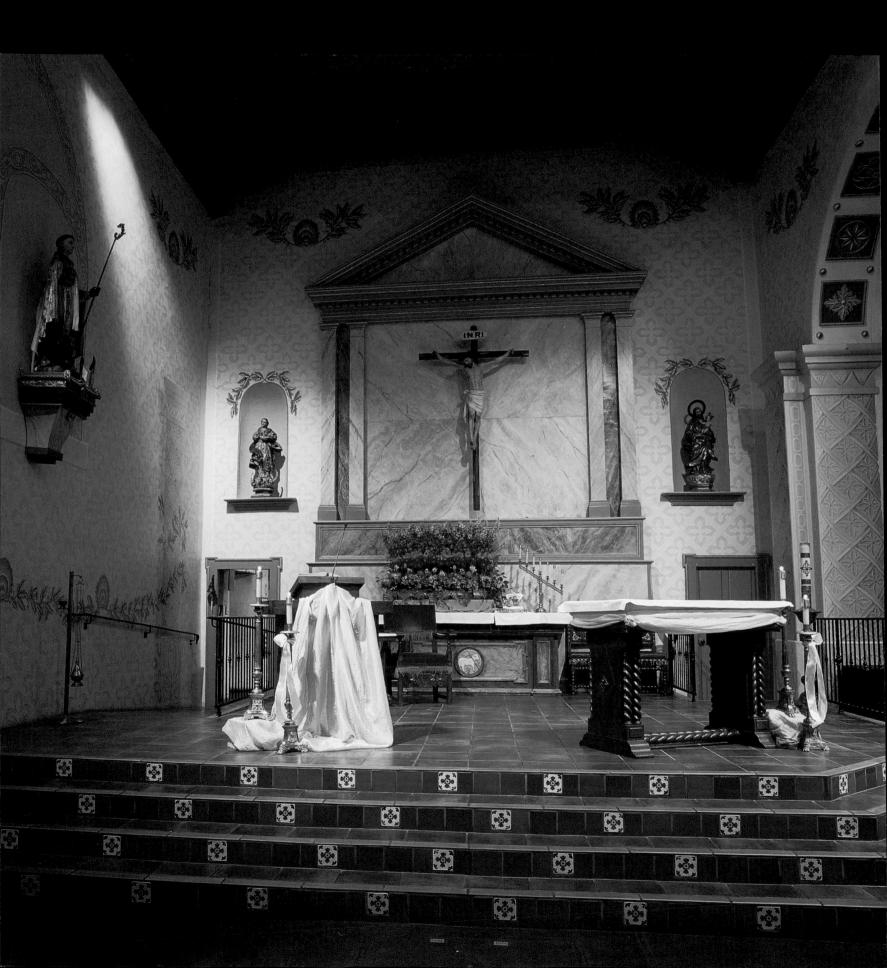

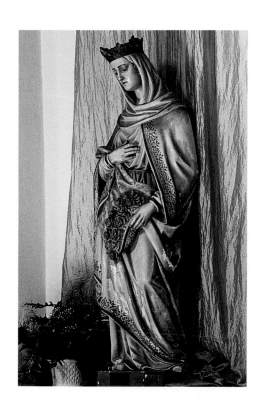

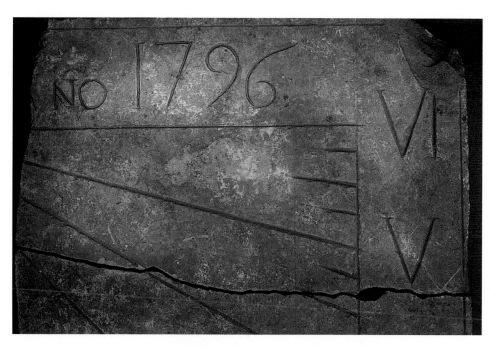

St. Isabella, Queen of Portugal. The story of
the statue tells that she was forbidden to give
bread to the poor, and when asked by
her husband to open the cloak, there
were roses rather than bread.

Sundial dated 1796, unearthed in
the mission yard in 1928.

Original mission doors

Opposite: The mission church interior,
modernized in 2002

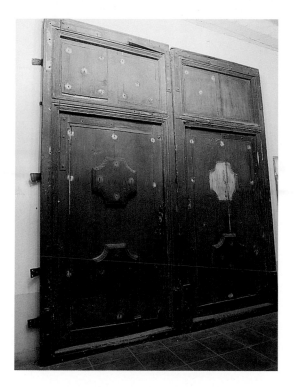

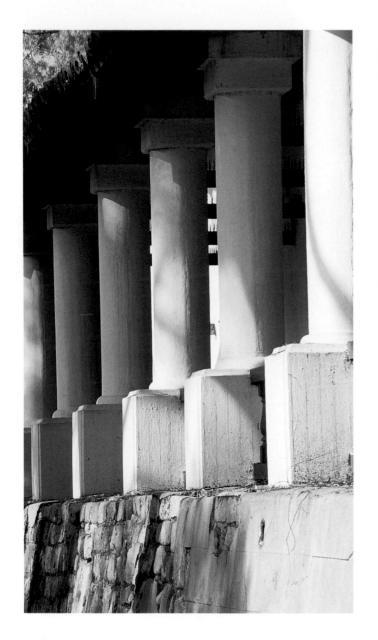

Rounded columns line the corridor.

Sunset over the mission

Opposite: Façade bell wall

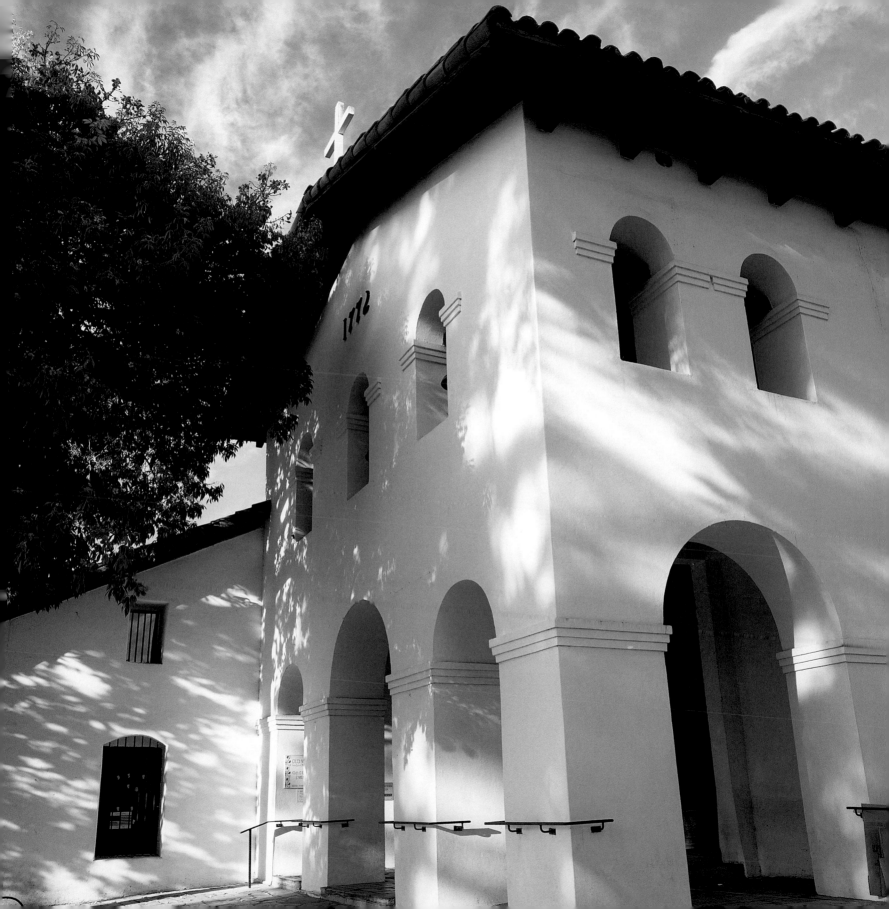

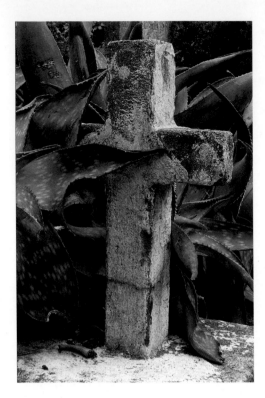

MISSION SAN FRANCISCO DE ASÍS

The sixth mission, founded on June 29, 1776

Thousands of Indians were buried in the cemetery along with many pioneers who played a major role in the history of San Francisco.

Cemetery fence detail

Opposite: The church survived epidemics, earthquakes, fires, secularization, and the Gold Rush to become the oldest building in San Francisco.

Fr. Francisco Palou founded the sixth mission, San Francisco de Asís, on June 29, 1776, a mere five days before the Declaration of Independence was signed on the east side of the continent. The mission came to be known as Mission Dolores because of a nearby stream, Arroyo de Dolores. Settled with married couples and families, the mission rested near what would become one of the busiest seaports on the West Coast. Dolores survived several serious earthquakes in her time, and remains a San Francisco landmark. The mission endured both measles and smallpox epidemics, was secularized in 1834, and returned to the Church in 1857.

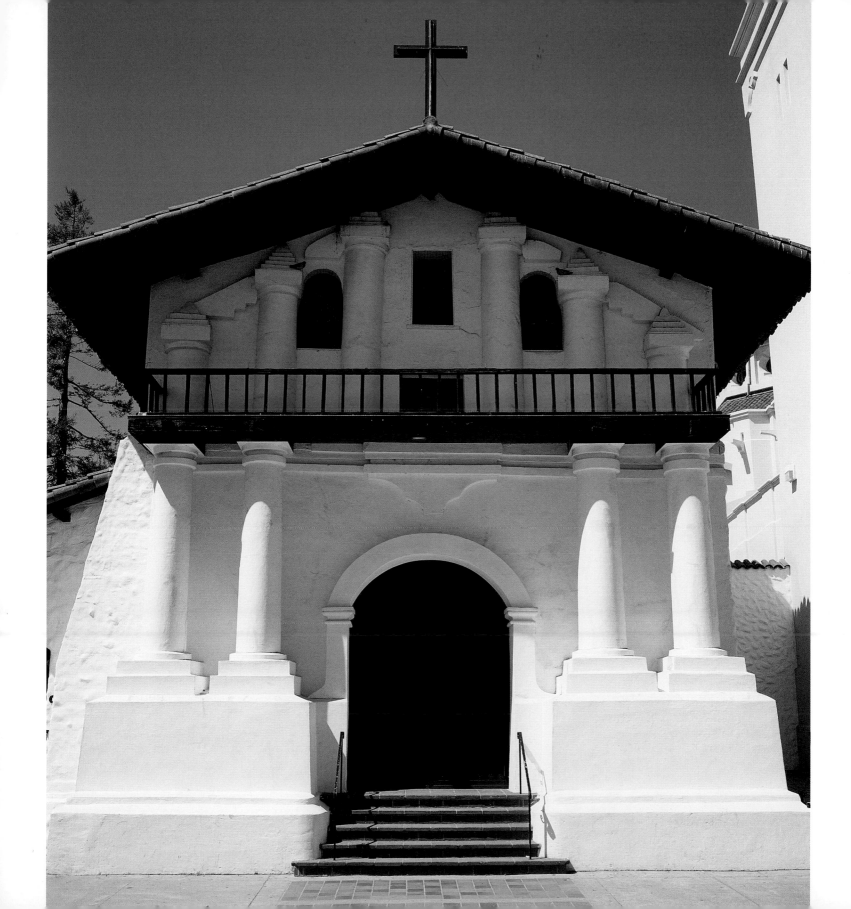

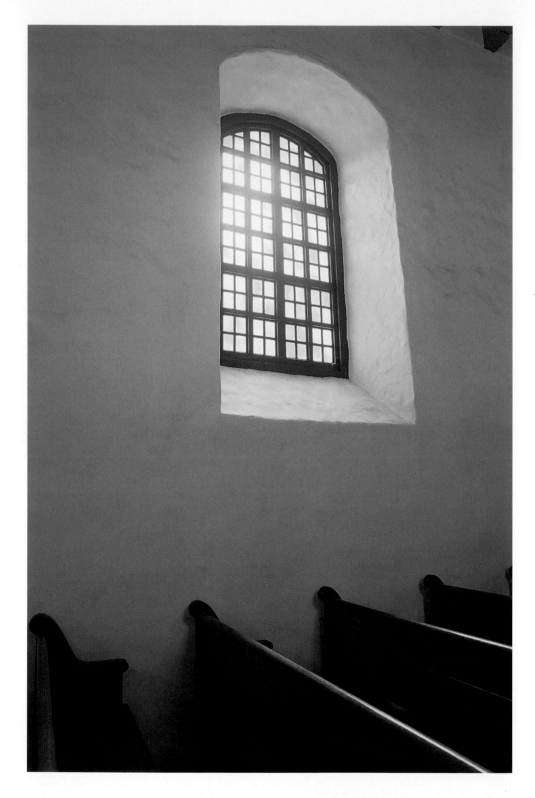

Yellow-dappled windows warm the mission church.

Opposite: Once inside the mission doors, the busy city cannot be heard.

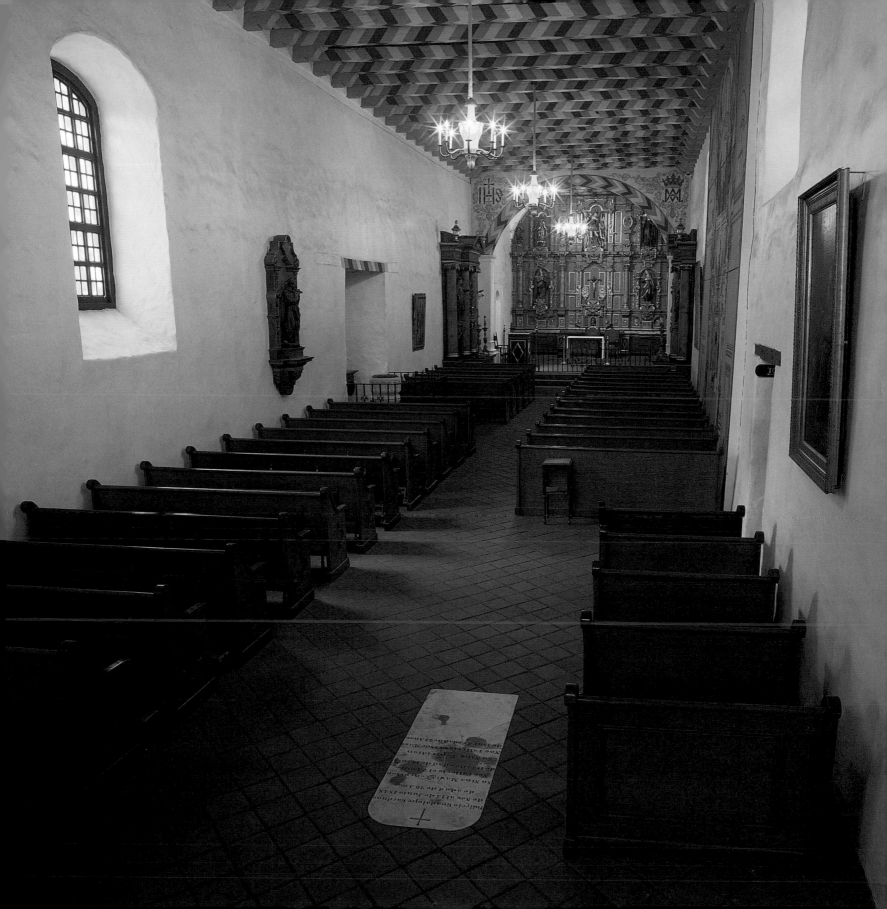

Bulto of Mary as Our Lady of Immaculate Conception

Bulto of Santa Ana, Mary's mother

Bulto of San Miguel

Opposite: Reredos built specifically for the mission were brought in pieces from Mexico in 1796. The original colors and chevron patterns decorate the ceiling.

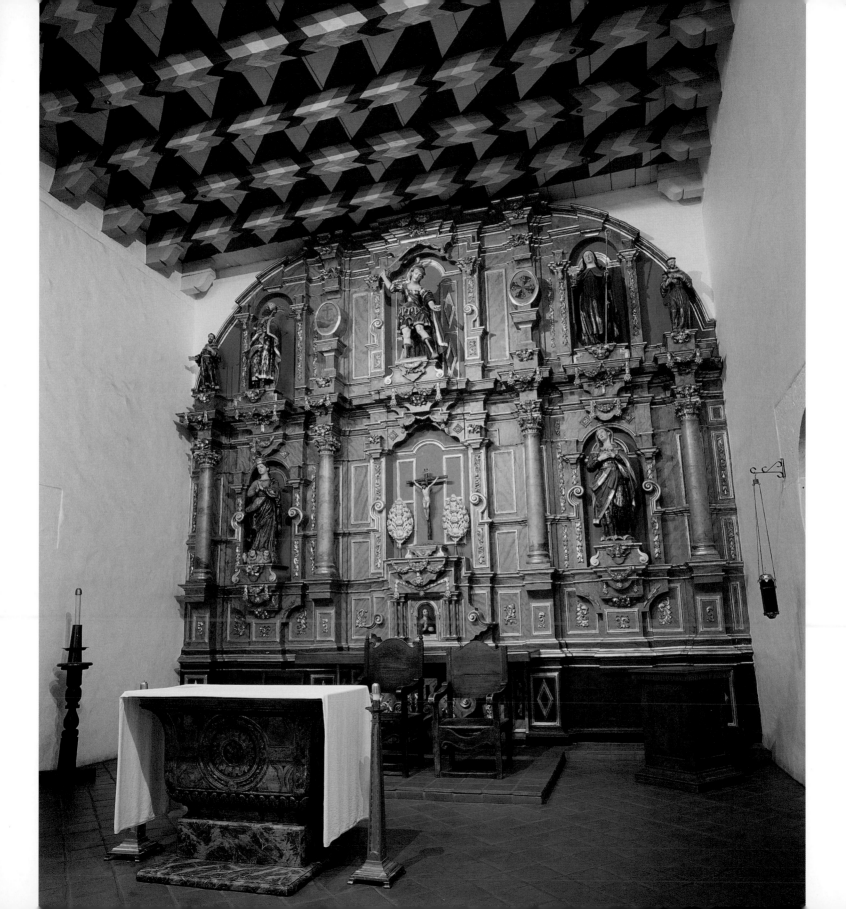

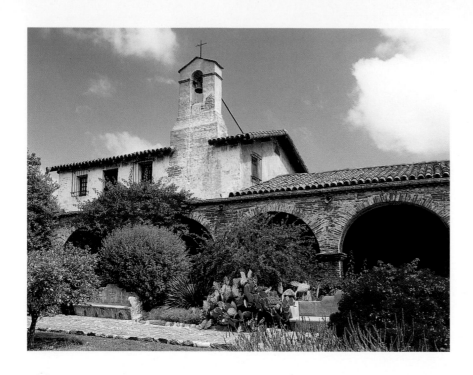

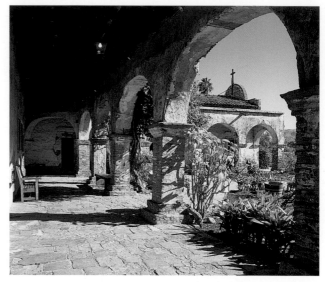

Mission San Juan Capistrano

The seventh mission, founded on October 30, 1775

Bell tower of the north wing

Arched colonnades frame the cross wall in the front courtyard.

Opposite: Spring flowers paint the entry courtyard garden.

San Juan Capistrano would be remembered as the mission that was founded twice; first, by Lasuen on October 30, 1775, and then on November 1, 1776 by Serra, after a year's hiatus. The fledgling mission was abandoned following news of the Indian attack on San Diego. Construction took over ten years, and it had been in use for only six when the earthquake of 1812 struck, destroying the cross-shaped, elaborate stone church and killing over 40 worshippers. Also contributing to the turbulent history of the mission were fires, epidemics, droughts, and an attack from the pirate Bouchard. Otherwise a fortunate mission, San Juan Capistrano flourished with livestock and the trade of hides and tallow. The Indians were emancipated in 1833, and the sale of the property followed in 1845. It was eventually returned to the Church in 1859.

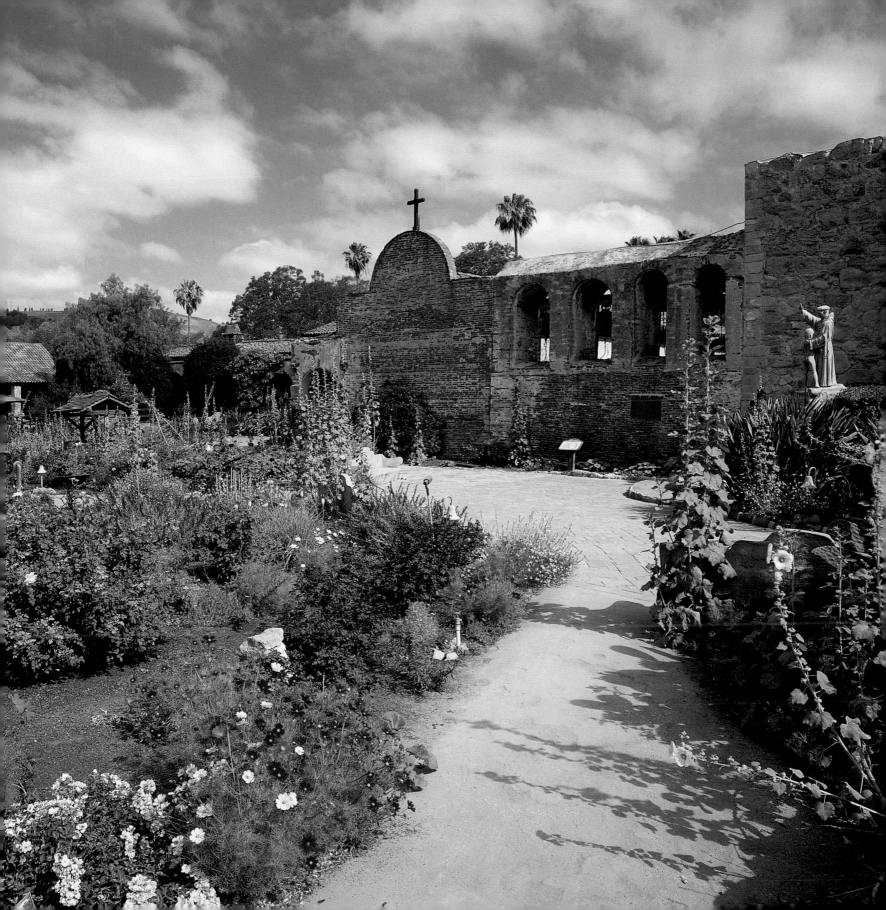

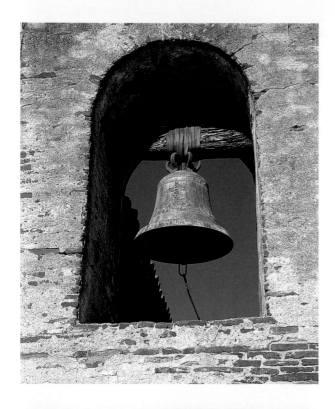

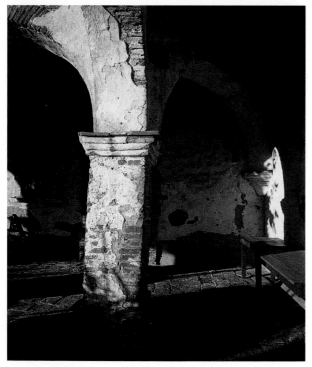

Large bell is a copy of the bell dating to 1796.

Evening shadows and dappled sunlight accentuate a niche carved in the wall.

Three arches rest on the strength of one

Opposite: The great stone church was cruciform in shape, and the altar had a vaulted ceiling surmounted by seven domes.

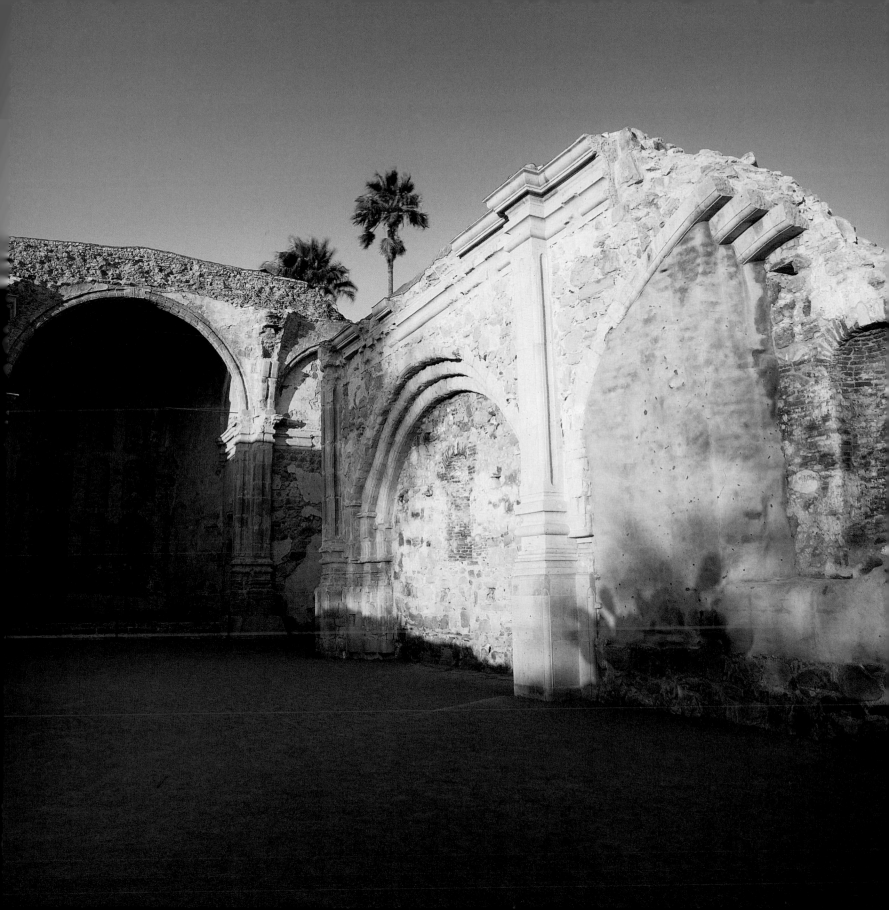

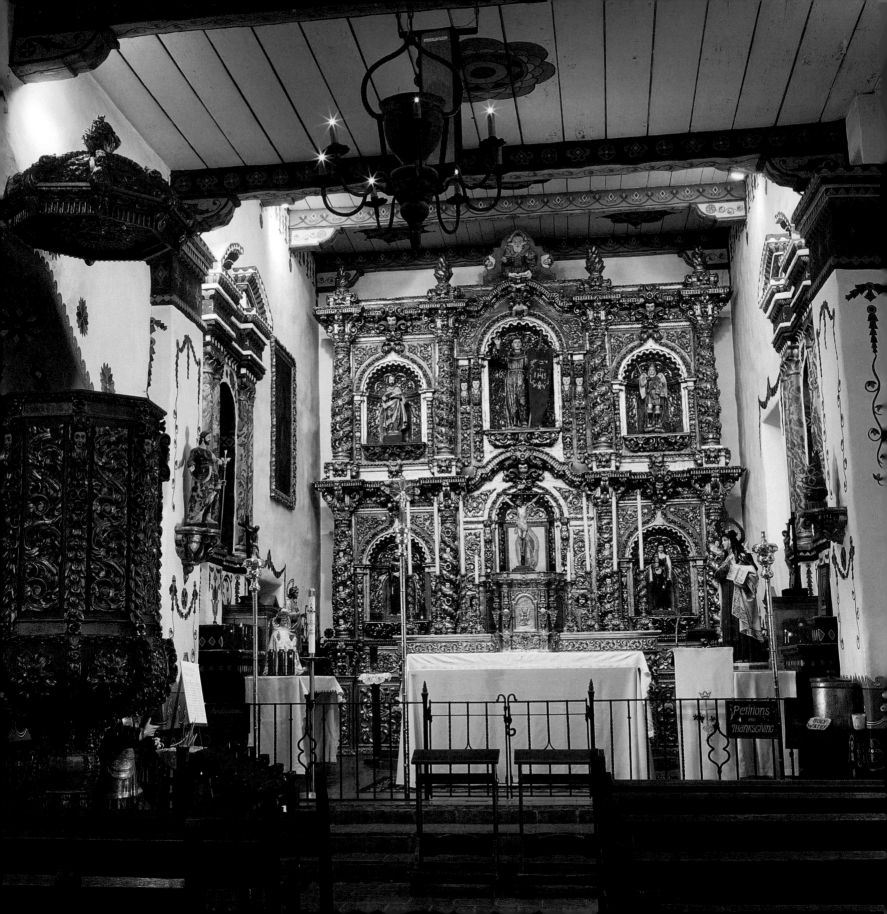

Stations of the Cross predate the mission; the baptismal font was used in the Great Stone Church.

Statue of St. Teresa of Avila, known for her extensive writings on religion and religious life.

Holy water stoup

Frescoed ceiling decorations

Opposite: The Golden Altar, made in Barcelona in the mid-1600s, was a gift to the mission in 1906 and delivered in 10 crates with 396 puzzle pieces.

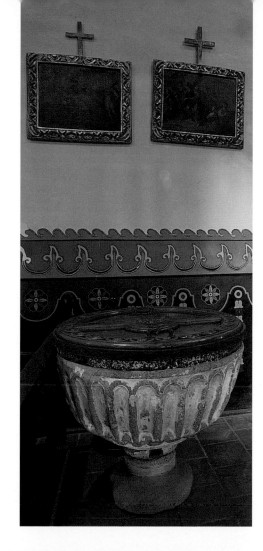

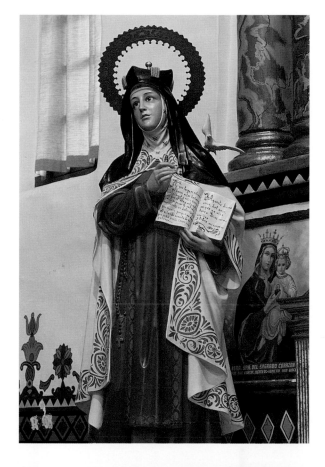

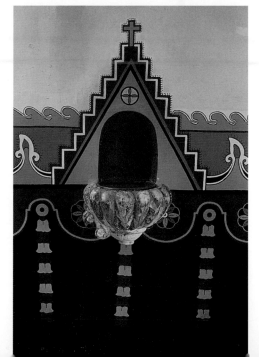

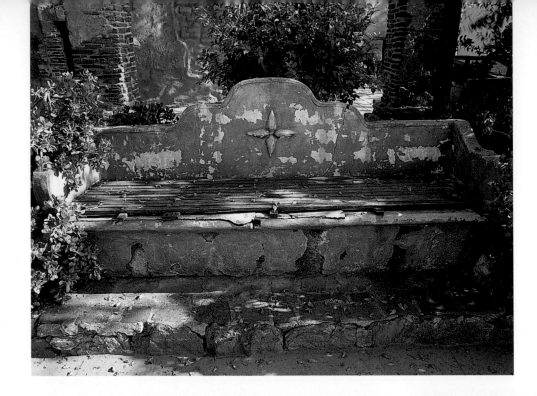

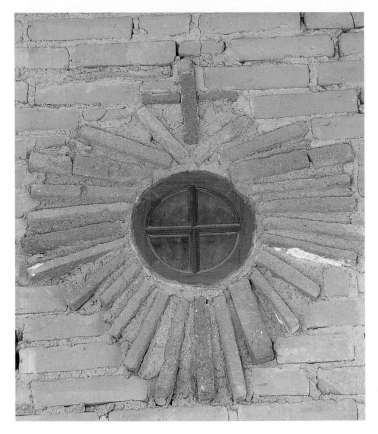

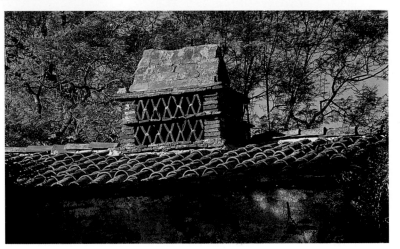

Garden benches in the courtyard quadrangle

Frescoed keystone in the Great Stone Church

Capped chimney

Outdoor wall design

Opposite: Benches to rest and reminisce

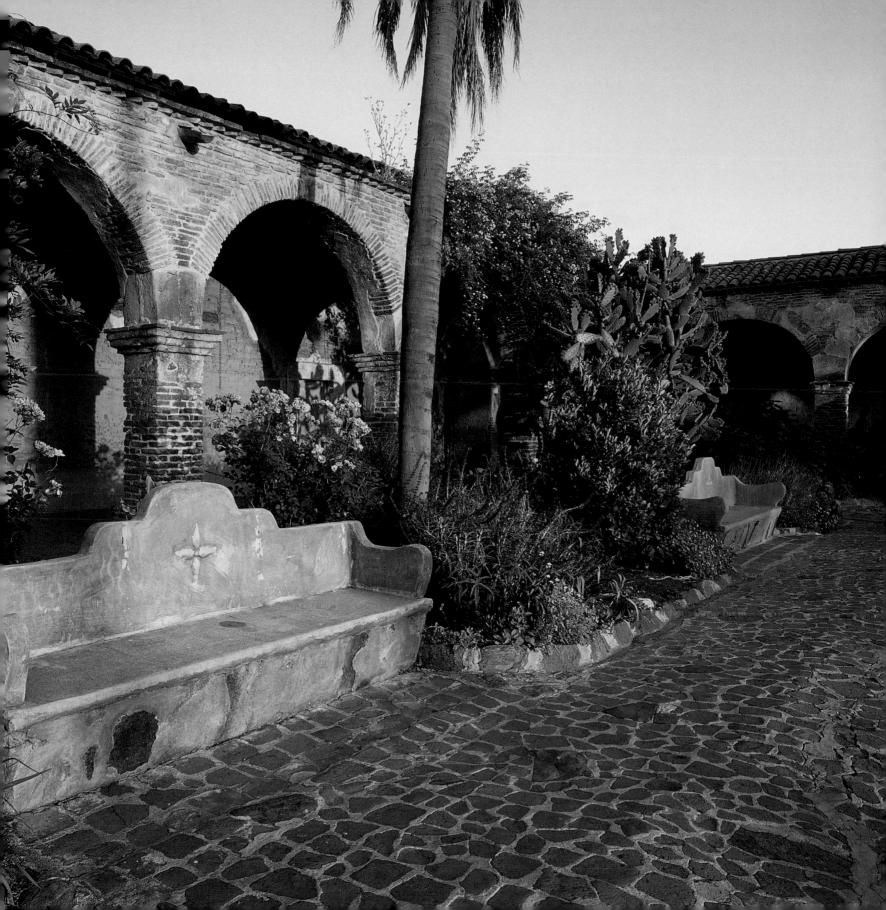

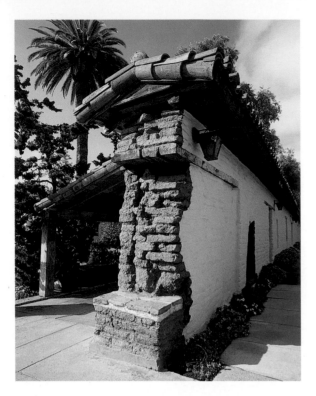 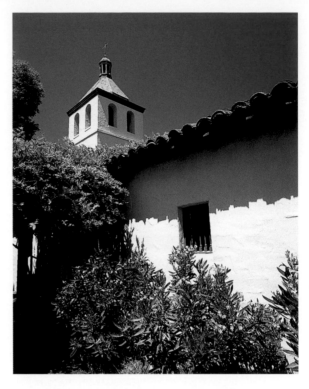

Mission Santa Clara De Asís

The eighth mission, founded on January 12, 1777

In the midst of the University campus stands the last of the original adobe quadrangle walls.

Modern-day bell tower (Three bells are mission period, and the fourth was donated in 1929 by King Alfonso XIII of Spain.)

Opposite: After floods, earthquakes, and fire, the fifth and final mission site was established.

Santa Clara de Asís was founded by Serra on January 12, 1777, the second of the San Francisco-area missions founded to help secure the valuable port area. Difficulties with the mission Indians and settlers over grazing and water caused problems, in addition to an epidemic, earthquakes, and multiple floods through the years. Fr. Magin de Catala came to be known as a prophet, and was also responsible for creating the four-mile Alameda promenade, bordered with decorative trees, that made a direct path from the pueblo of San José to the mission. It became traditional for the wealthy landowners to tour along the eye-pleasing route, providing a venue to see and be seen, and easing tensions somewhat between the mission and pueblo. Secularization came in 1836, and the college was founded in 1851.

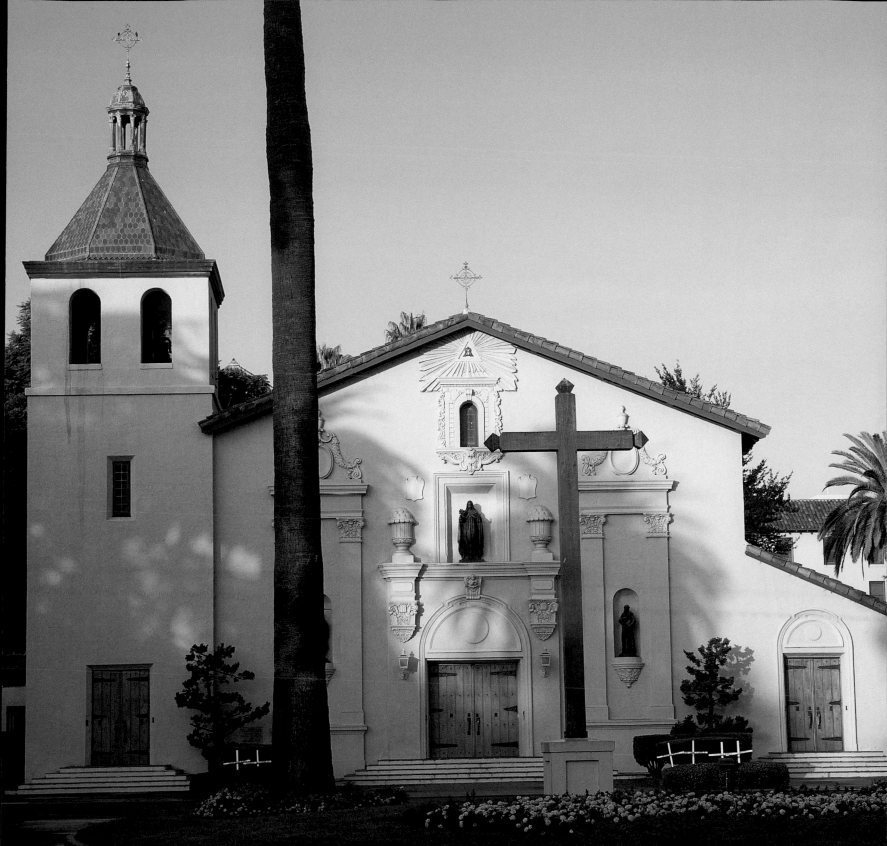

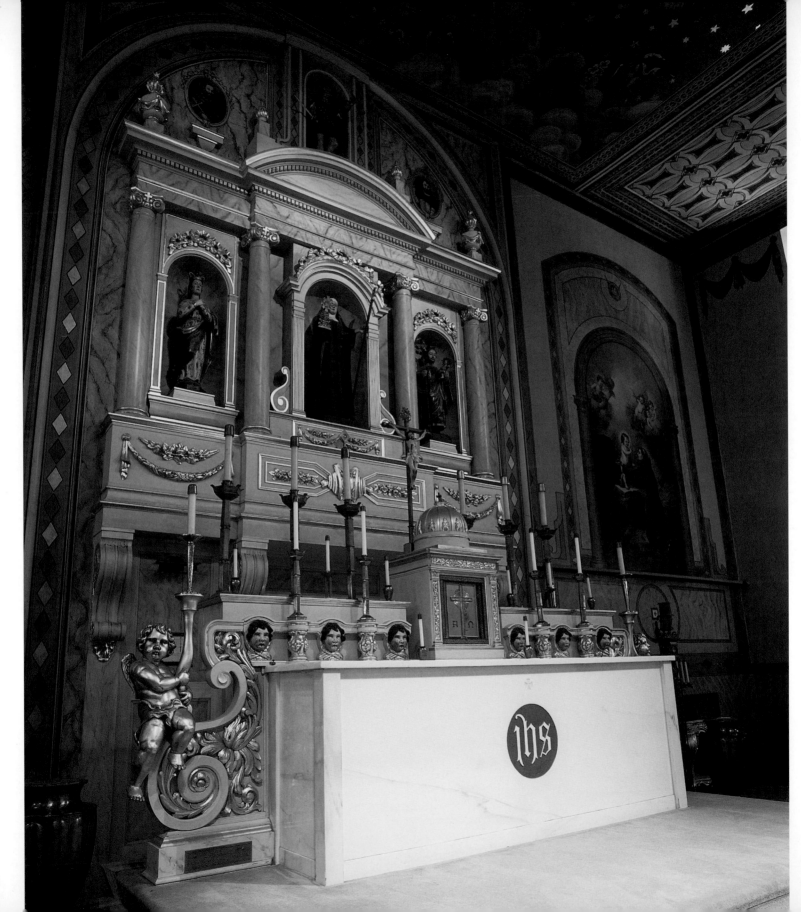

Sanctuary ceiling paintings depicting the heavenly court and the Holy Trinity. Originally painted on redwood ceiling slabs in the mid-1800s by an artist imported from Mexico, Agustin Davila, with neophyte assistants. They were destroyed in the 1926 fire, and have since been reproduced to match the originals.

A portion of the mission adobe structure from 1825 is revealed in the St. Francis Chapel

Cherubim faces painted on the ceiling above the nave

Opposite: Replicated reredos replaced the originals destroyed in the 1926 fire.

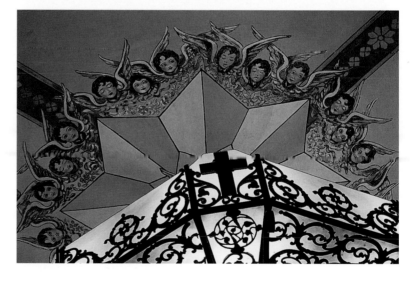

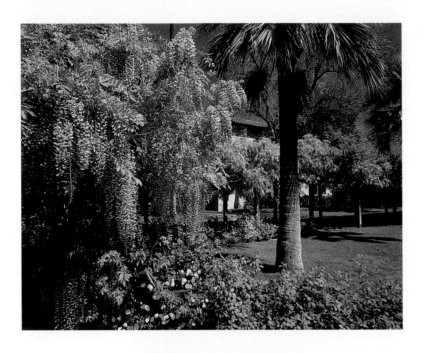

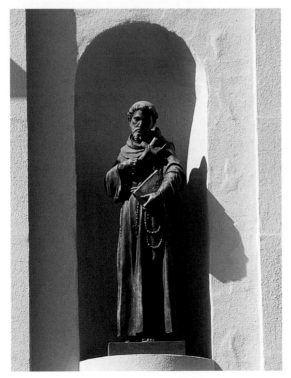

Wisteria drapes over an arbor, once known as the mission courtyard quadrangle.

Gate to the rose garden cemetery

San Francisco de Asís

Opposite: A statue of Jesus marks the site of the mission-period well.

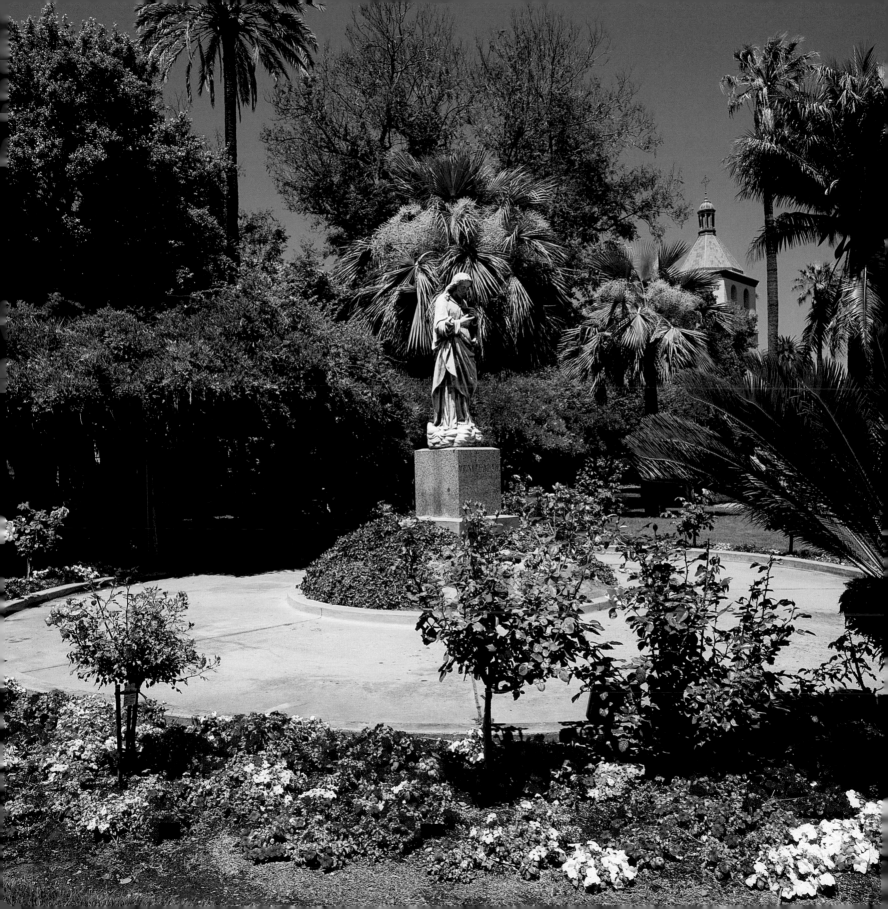

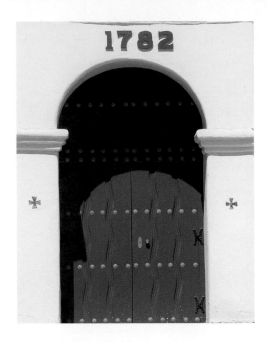

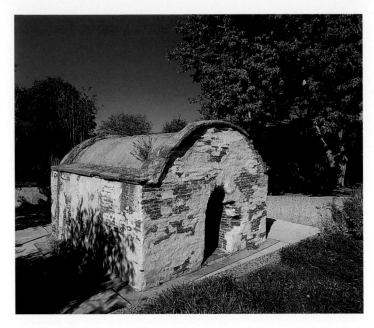

Mission San Buenaventura

The ninth mission, founded on March 31, 1782

Front doors to the mission, replicated to match the original doors (Handcrafted by restorer, Harry Downie)

The oldest structure in Ventura, the water filtration building furnished water to the mission in 1782.

Opposite: The façade of the mission church has changed little since being rebuilt after the 1812 earthquake.

San Buenaventura was the last mission founded by Fr. Junipero Serra, on March 31, 1782. San Buenaventura had been slated to be the third mission founded, directly following those at San Diego and Monterey. It was postponed, however, because all available military was needed elsewhere. In the midst of one of the most highly concentrated Indian populations, the mission was fortunate that they were, for the most part, friendly and willing. The tribes were known for the astounding quality of their canoes and basketwork, and their skills as craftsmen were a great asset to the mission. The unique locale of the mission allowed exotic crops to be grown, in addition to mission staples. The first church built burned down within ten years, and the second church, built of stone, had only been used for three years when the earthquake hit in 1812. Surviving raids by Indians and the pirate Bouchard, the mission was secularized in 1836, sold in 1846, and returned to the Church in 1862.

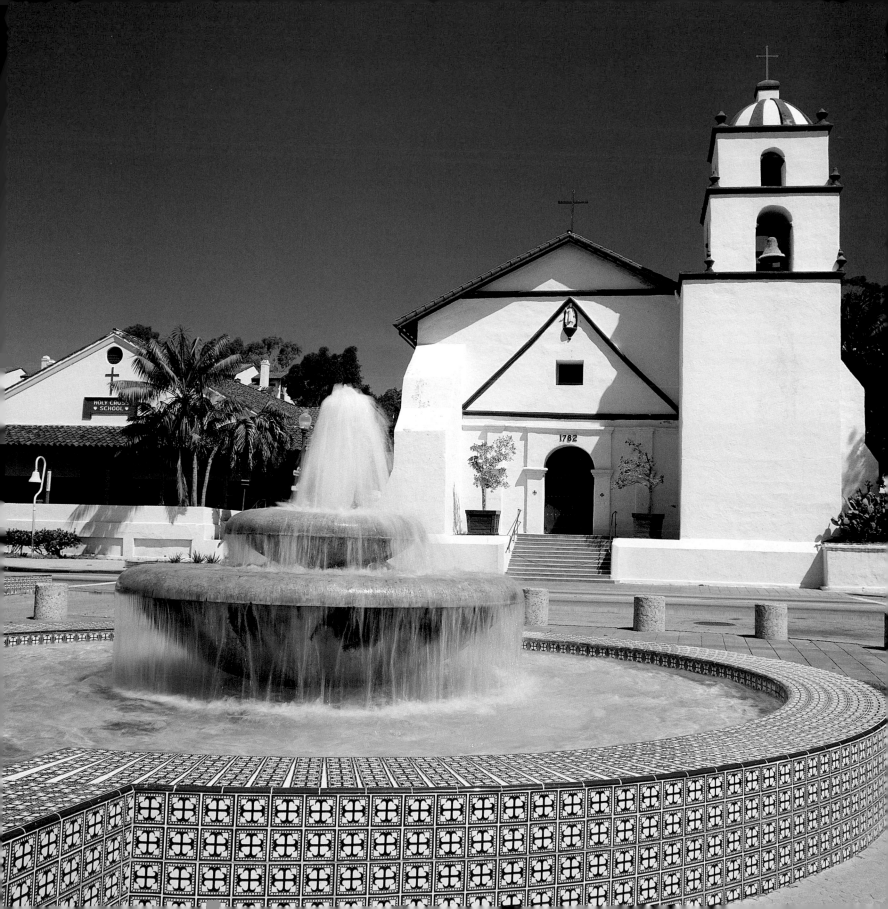

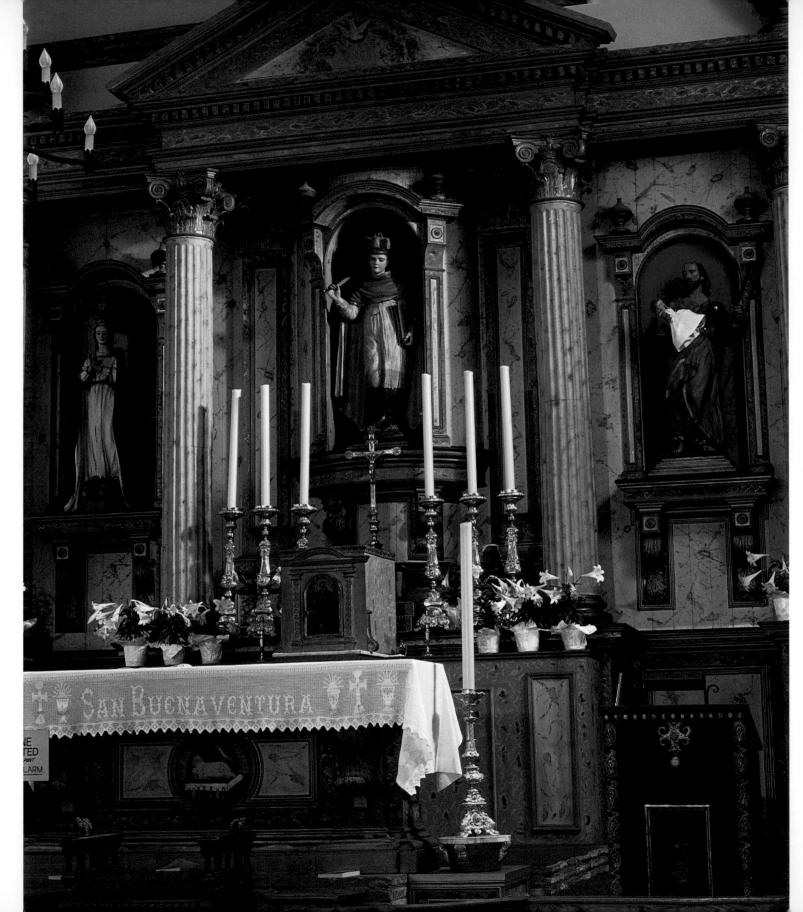

Rare wooden bell carved out of two-foot blocks of wood
that was used during Holy Week when the
metal bells were silent.

Carved wood details on the confessional

Small wood carving in the baptistry

Opposite: Church altar with mission patron,
San Buenaventura

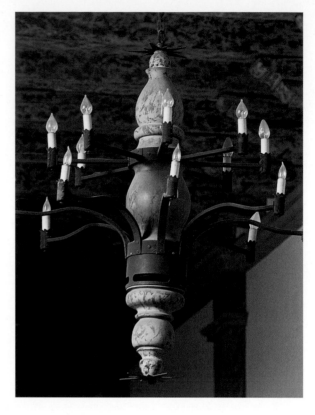

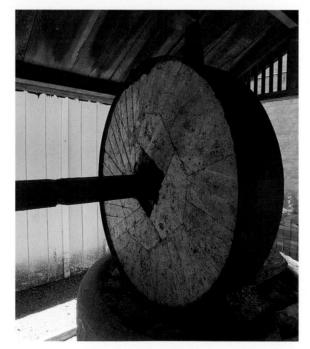

Plaster fragment
removed from the
wall during
restoration.

Replica chandelier
made by restorer,
Harry Downie.

Olive crusher

Opposite: Stations of
the Cross paintings
from 1809

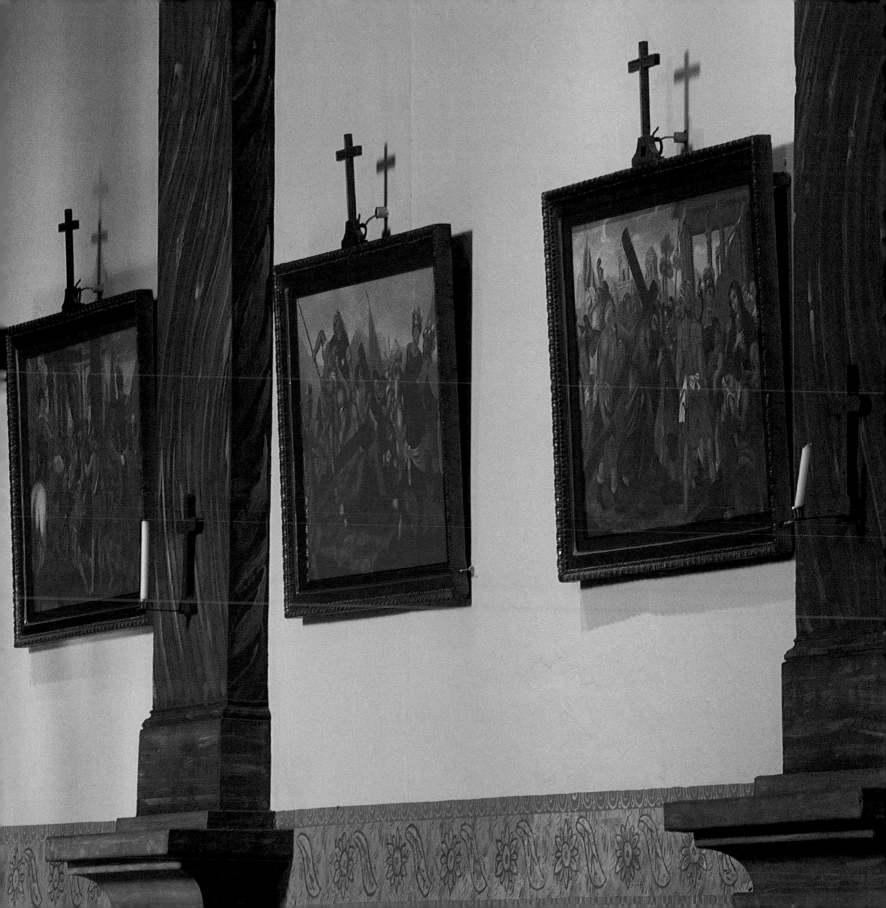

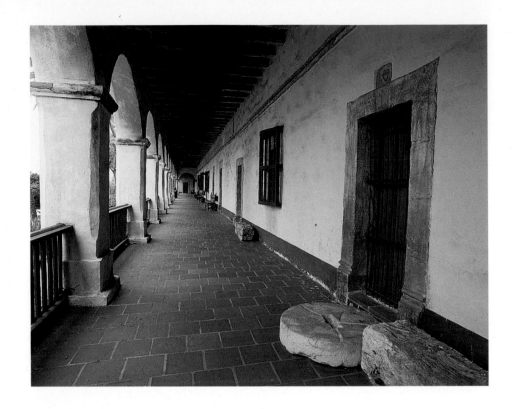

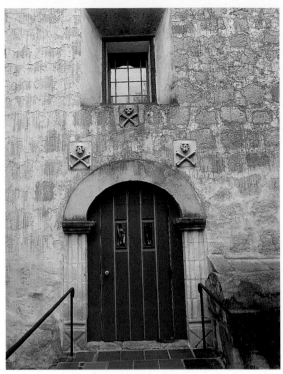

MISSION SANTA BÁRBARA

The tenth mission, founded on December 4, 1786

In the beginning, sixteen arches lined the colonnade corridor—later it was expanded to eighteen.

Two human skulls and thigh bones are embedded in the masonry above the door facing the cemetery. (Above them is the carved skull and crossbones.)

Opposite: At the edge of the Santa Ynez mountains, Queen of the Missions glows from the clear ocean sunrise.

Santa Bárbara, the tenth mission, was founded on December 4, 1786, by Serra's successor, Fr. Fermin Lasuen. A total of three churches were built over the years, the third of which was destroyed by the 1812 earthquake. At one time, the mission boasted well over 200 houses for the converts, in addition to the industry workshops. The mission was secularized in 1834, sold in 1846, and returned to the Church in 1865.

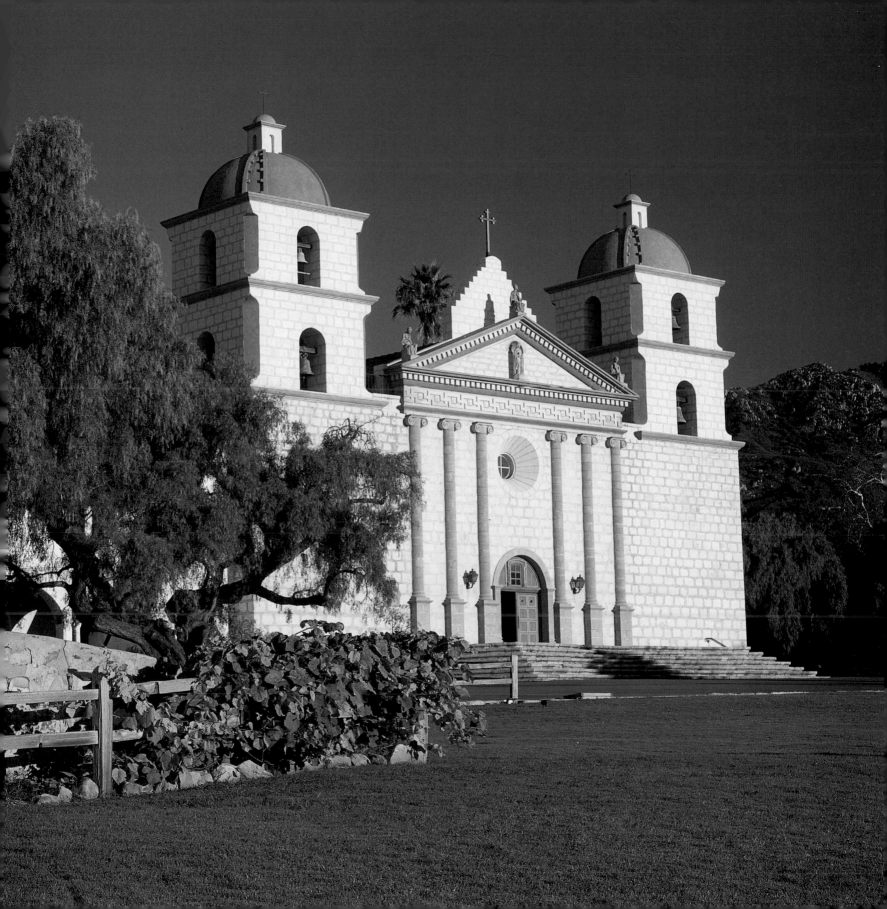

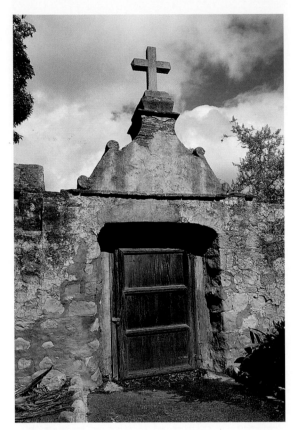

Carving tucked on a high wall

Cemetery gate

Courtyard quadrangle

Neo-classical façade centered with a stone sculpture of patroness, St. Bárbara. (Façade was copied from a book found in the mission library on architecture by a first-century Roman, published in 1787.)

Door latch decoration

Opposite: The north bell tower stands strong over the cemetery.

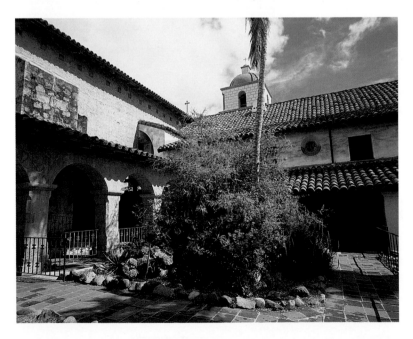

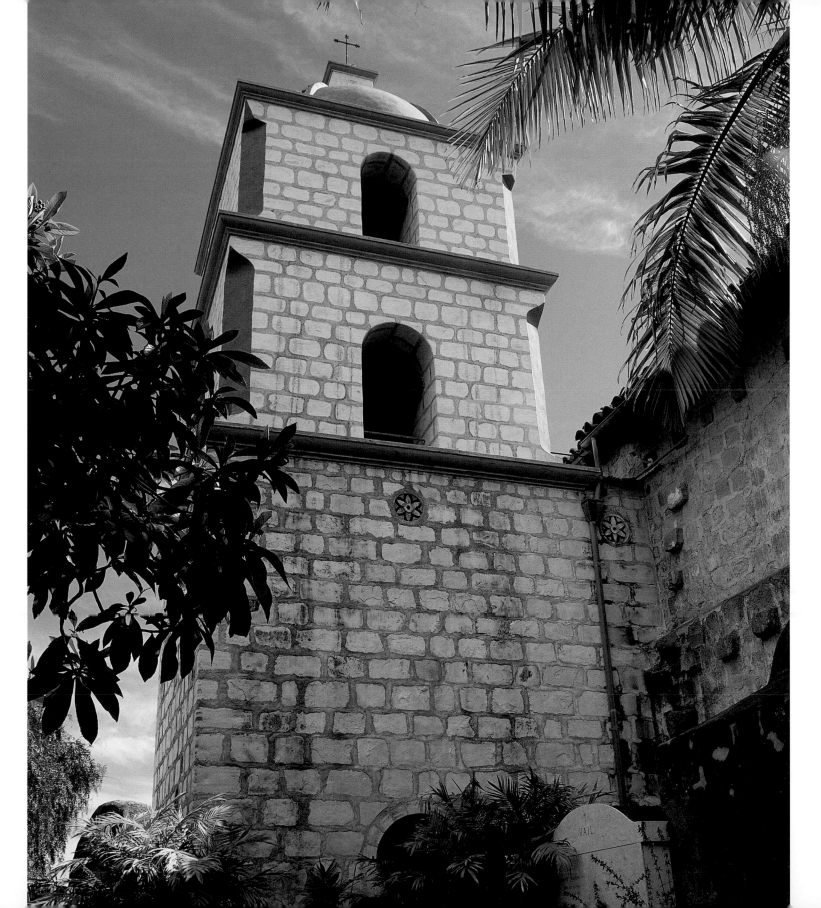

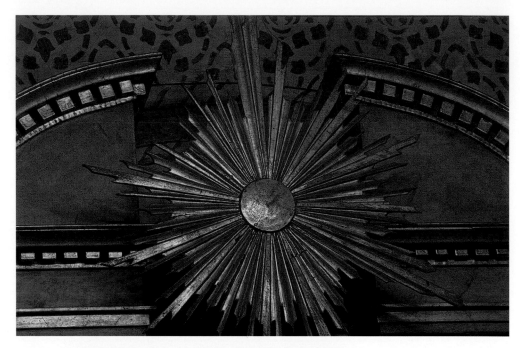

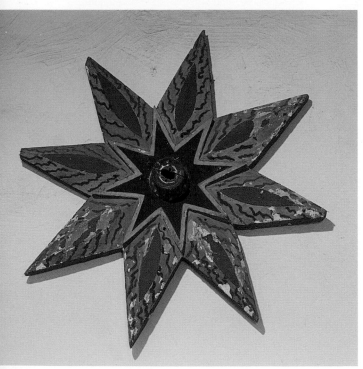

Painted pilaster in the mission church

Gilded rays of light

Painted wall motif

Ceiling star of polychrome wood

Opposite: Mission patroness, Santa Bárbara, bulto dated 1793

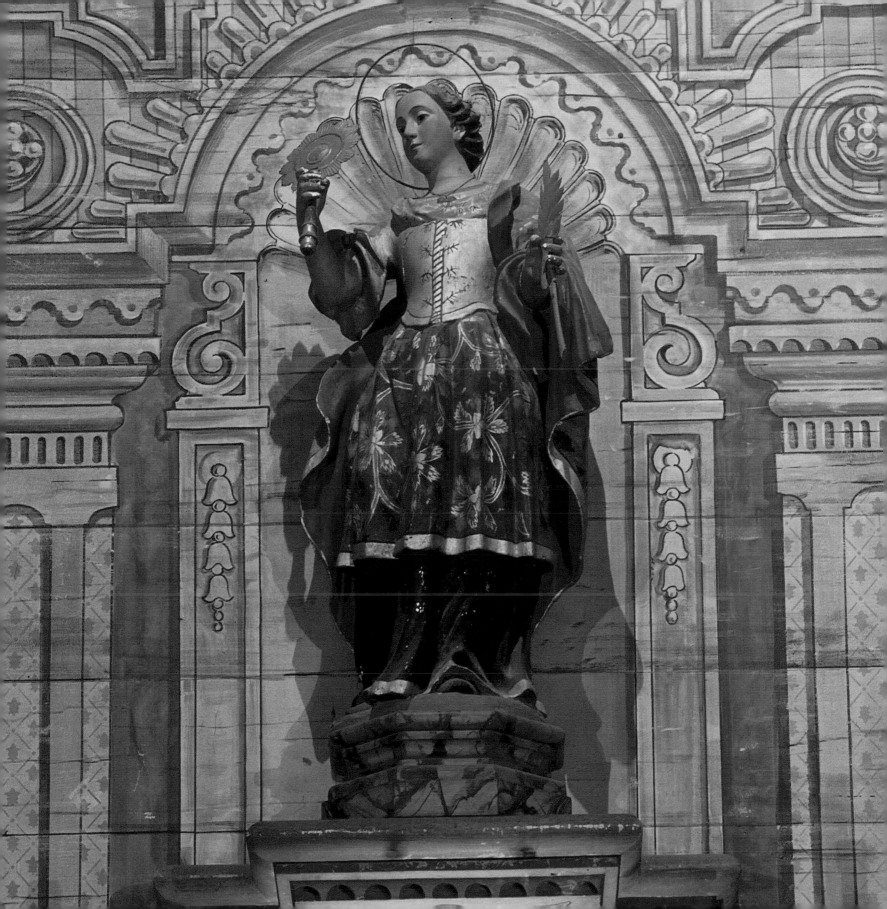

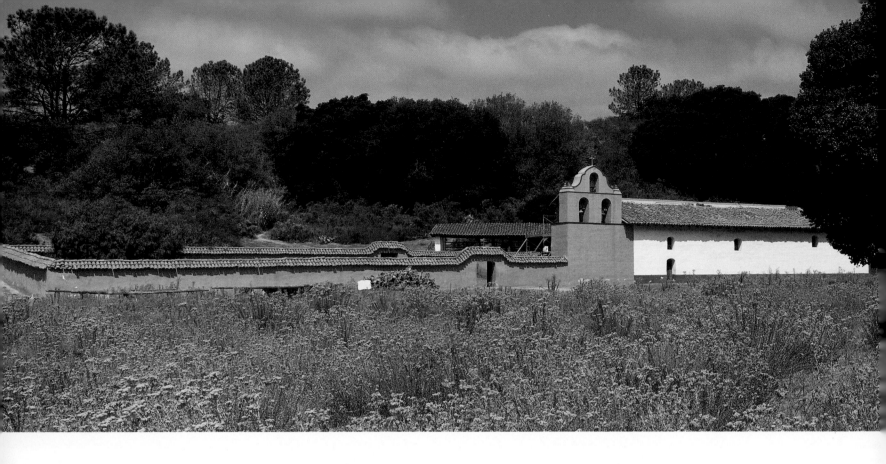

MISSION LA PURÍSIMA CONCEPCIÓN

The sixteenth mission, founded on December 8, 1787

Mission La Purísima Concepción

Opposite: Cemetery gate

There were no drawings or descriptions of the original campanario. The shape of the present campanario is copied after its neighboring mission, Santa Inés.

La Purísima Concepción, founded on December 8, 1787 by Fr. Fermin Lasuen, endured a full slate of hardships in its time, and managed to become completely self-sufficient, with plentiful livestock and crops. Initial construction was delayed because of rain, foreshadowing the destructive floods of years to come. The 1812 earthquake did great damage to the buildings, and floods continued the destructive onslaught, prompting the padres to seek a new site. After the mission was moved, droughts, fires, epidemics, and Indian uprisings plagued the prosperous settlement. Secularized in 1834 and sold in 1845, the Church regained some of the original holdings in the 1870s.

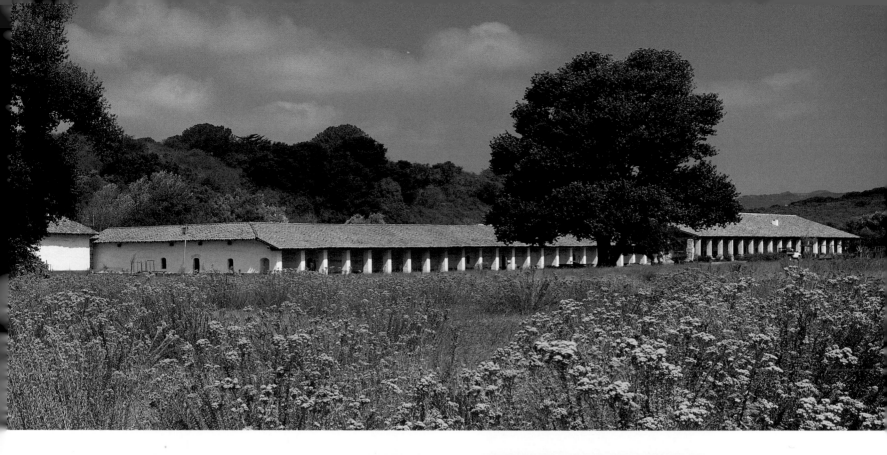

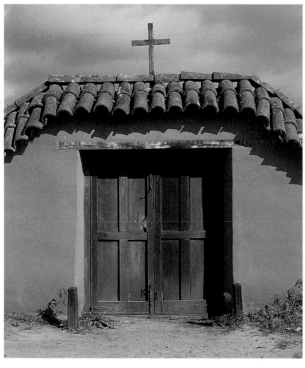

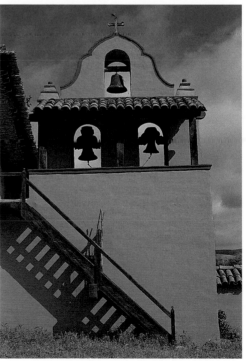

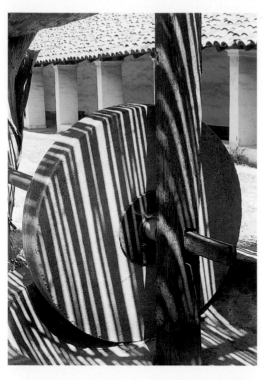

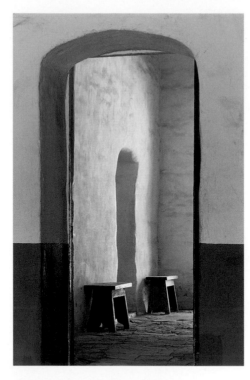

Olive crusher with patterns from an overhanging reed roof

Arched doorways in the monastery building

Example of restoration on adobe walls (During restoration, walls were diagonally scored, lime mortared and then roof tile chips were inserted before the wall was finally plastered over.)

Colonnades line the corridor at the residence building.

Opposite: Paintings were brought from Mexico and furnishings replicated to match originals.

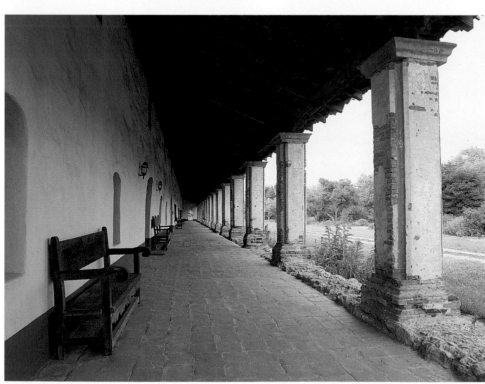

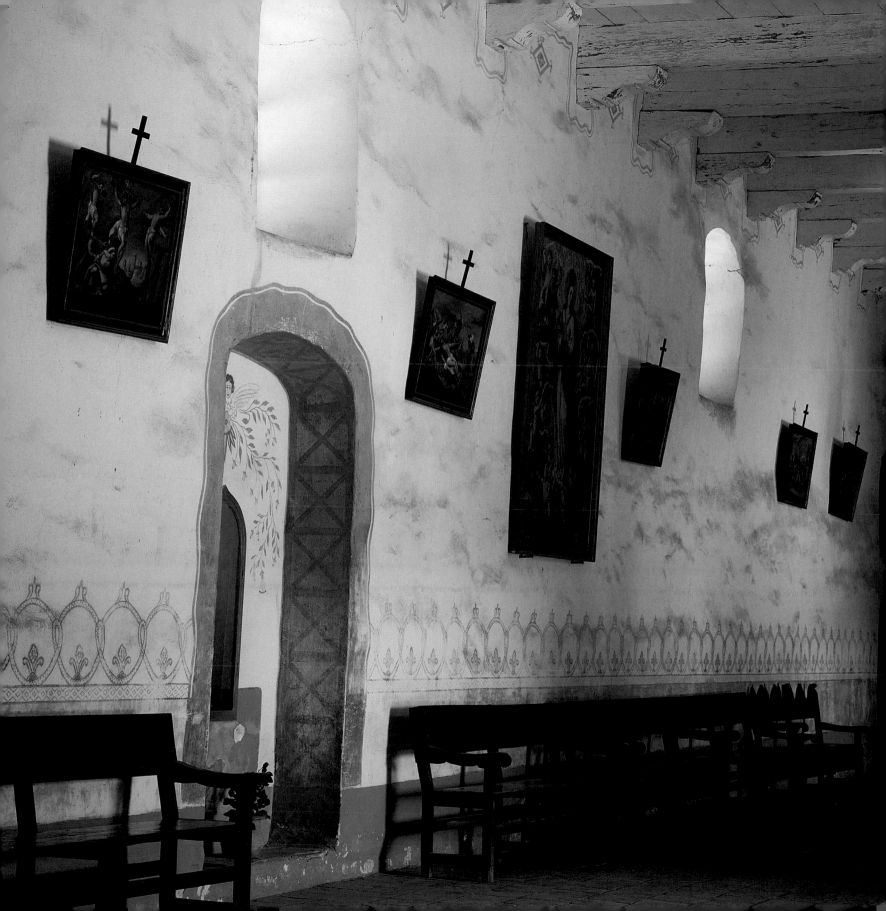

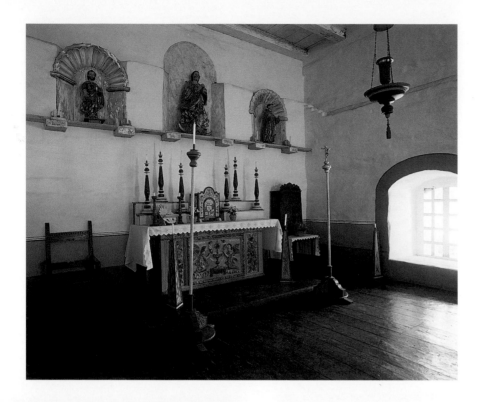

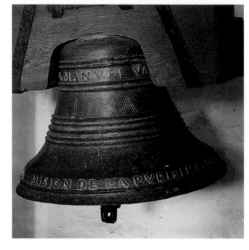

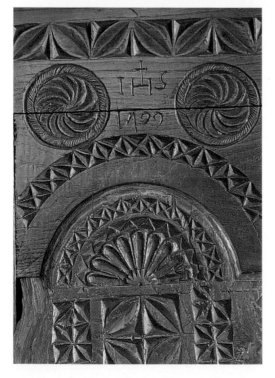

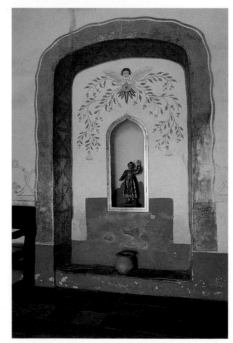

Padre's chapel

Original bell made for La Purísima Mission from Lima Peru in 1818.

Decorations throughout the mission replicated as they were thought to have been during the early mission days.

Close-up of a sacristy chest carved in 1799.

Opposite: Main church with mission patroness, the Immaculate Conception of Mary. (After 1826, services were moved from the main church to the padre's chapel when spring water suddenly bubbled up right under the church damaging the foundation and walls.)

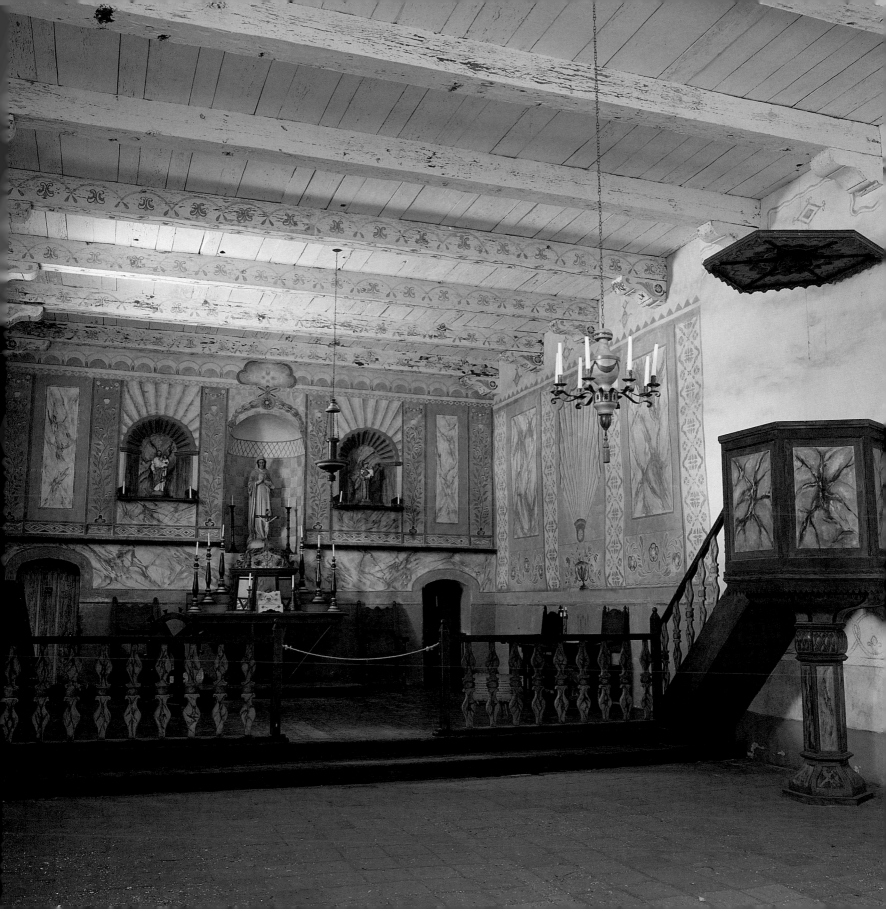

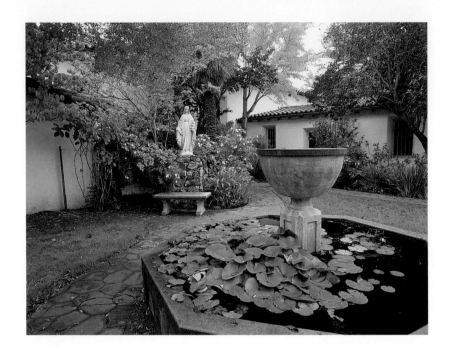

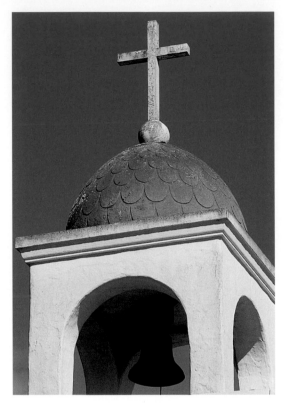

MISSION SANTA CRUZ

The twelfth mission, founded on August 28, 1791

Garden fountain and statue of Blessed Virgin Mary

Dome bell tower, replicated after the original was destroyed from the 1840 earthquake. Records reported the three mission bells were valued at $3,500, the highest value of any of the missions, but sometime after the earthquake they disappeared.

Opposite: The replica chapel of the old mission Santa Cruz was constructed in 1931, and is about one-third the size of the original building.

Santa Cruz, founded on August 28, 1791 by Fr. Fermin Lasuen, seemed to be an ideal mission site, with good climate and soil, and receptive, amiable local Indians. Problems arose for the mission when a pueblo was founded just across the river, despite the fact that Spanish law forbade a pueblo being established within a league of a mission. Pueblo residents were mostly drifters and criminals, who trespassed on mission land with livestock. During these turbulent times, one padre was suspiciously found dead, probably because of the strict rules enforced to keep the Indians away from the unlawful, unruly pueblans. With the threat of pirate invasion, the padres took refuge further inland with the mission valuables. While pirates left the mission alone, it was the pueblan residents that looted what was left. One of the first missions to be secularized in 1834, Santa Cruz's church was destroyed by an earthquake in 1857.

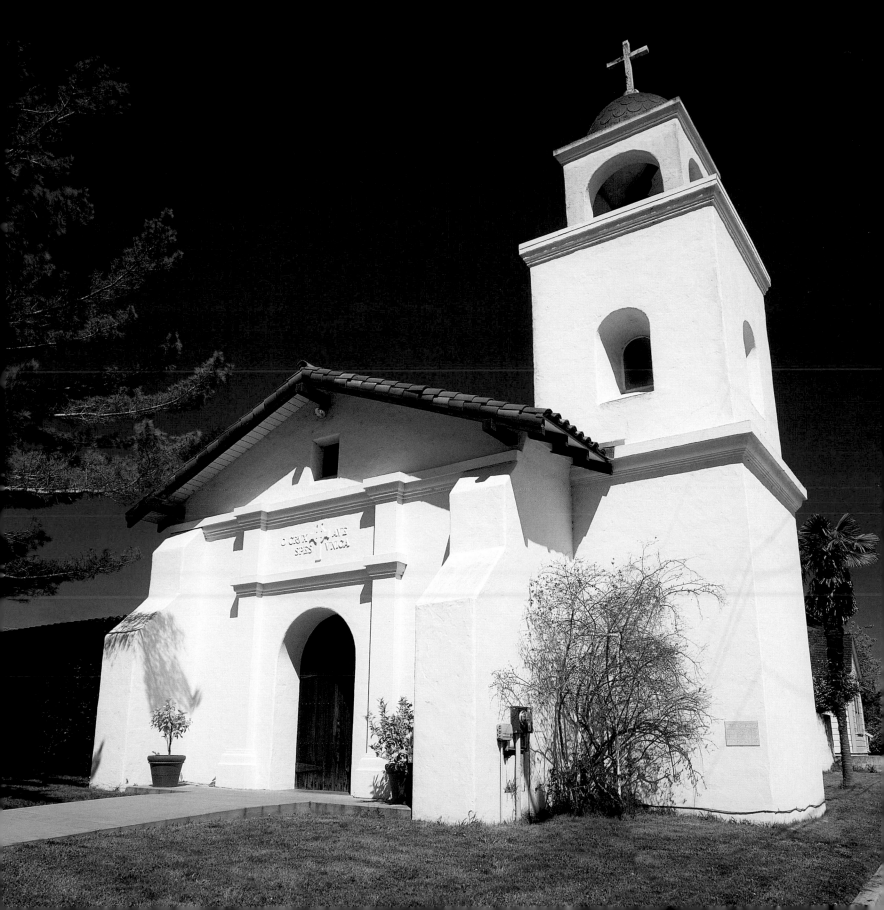

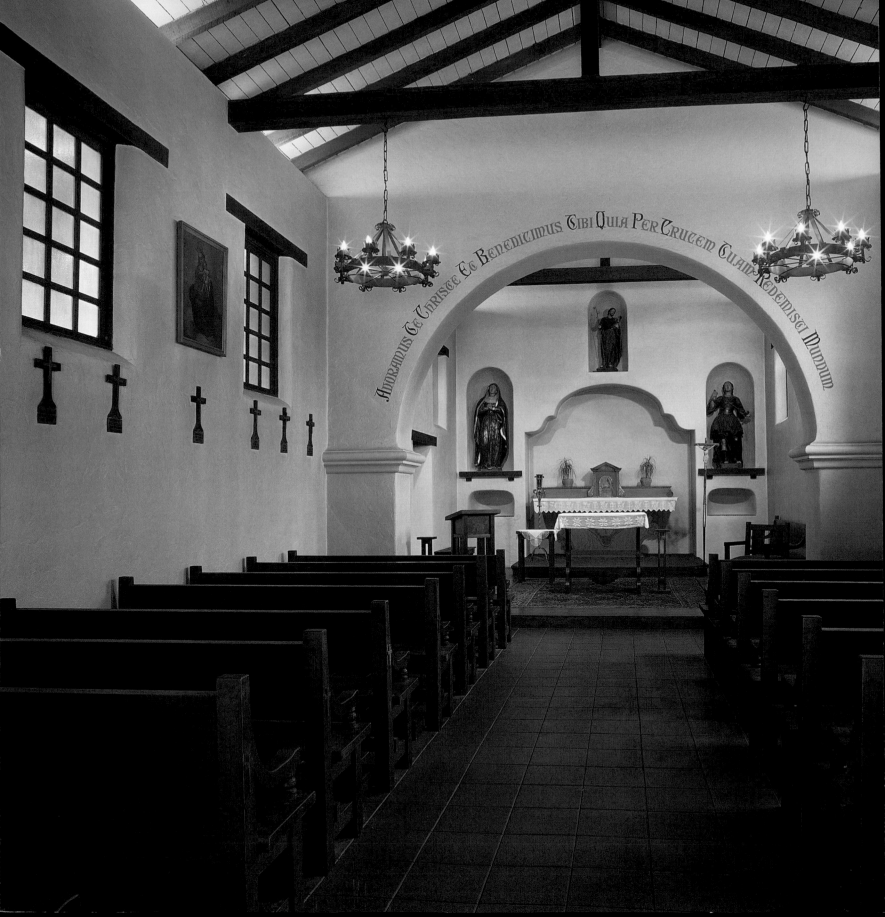

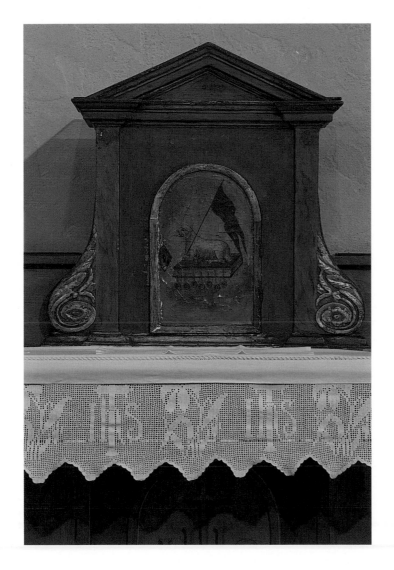

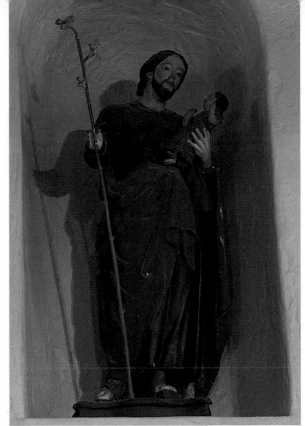

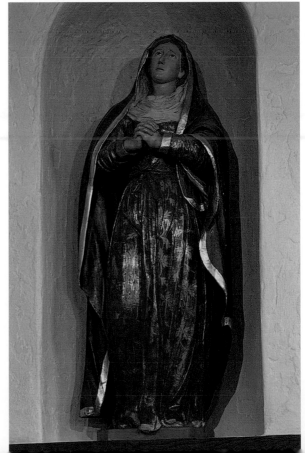

Original mission tabernacle

Bulto of St. Joseph

Bulto of Mary, Immaculate Conception

Opposite: The interior of the replica Mission
Santa Cruz is contemporary in style.

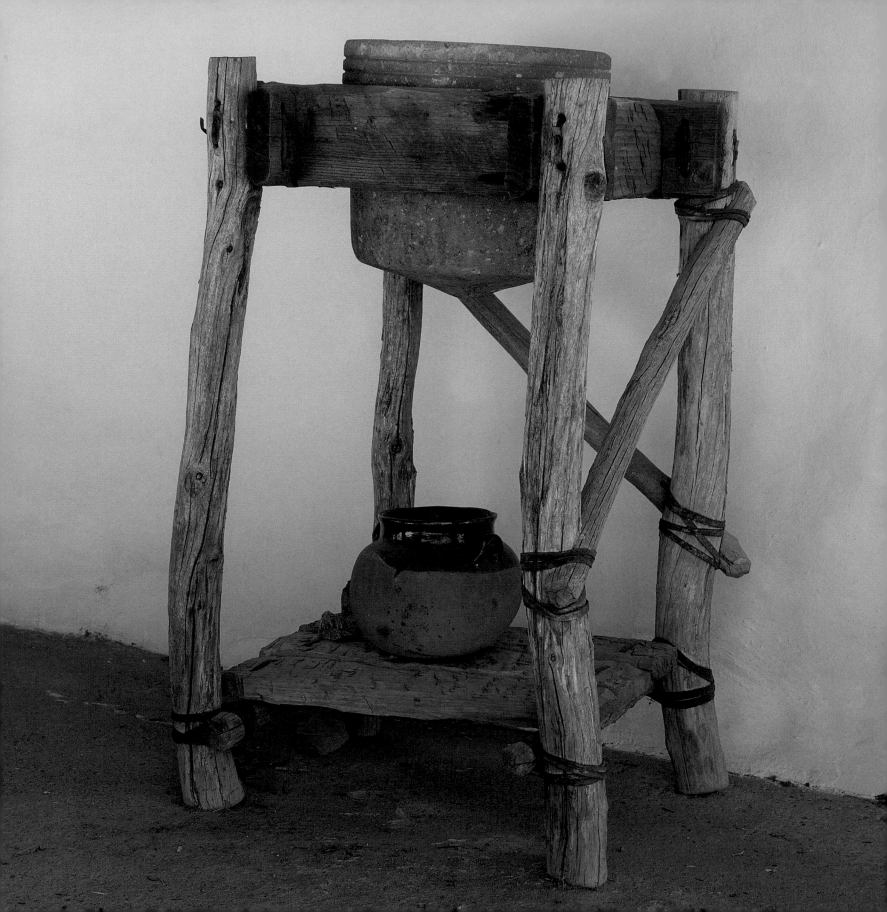

Statue of Father Junipero Serra

Reconstructed carreta

Detail on statue of Fr. Serra's rosary

Opposite: Replica lava rock water filter

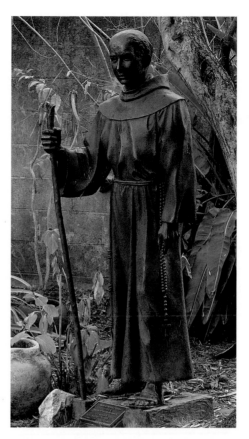

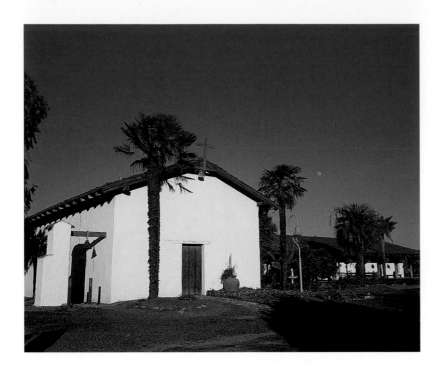

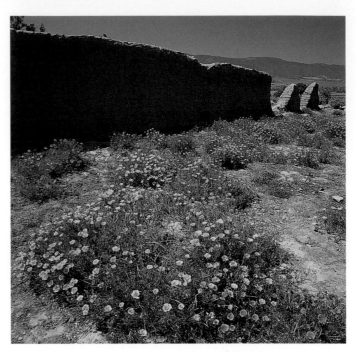

Mission Nuestra Señora de la Soledad

The thirteenth mission, founded on October 9, 1791

When the mission was restored in 1954, the front corner of the chapel was all that could be used from the original structure.

California poppies bloom while the last of the original adobe walls in the mission quadrangle crumble.

Opposite: Spring flowers add color to the plain façade of the mission at Soledad.

Nuestra Señora de la Soledad was appropriately named, for soledad means solitude in Spanish. In isolated, lonely country, the mission was founded by Fr. Fermin Lasuen on October 9, 1791. "Our Lady of Solitude," while distant from other missions, still managed to become highly productive and successful on a small scale. Epidemics preceded the flooding that barraged the mission, destroying neophytes, herds of livestock, crops, and supplies. When the beloved padre, Vicente Francisco de Sarria, died, his faithful followers carried his body cross-country to be interred at San Antonio de Padua. Following his death, the mission also died. Secularized in 1835, and sold in 1845, the mission was restored somewhat to its former holdings in the 1870s.

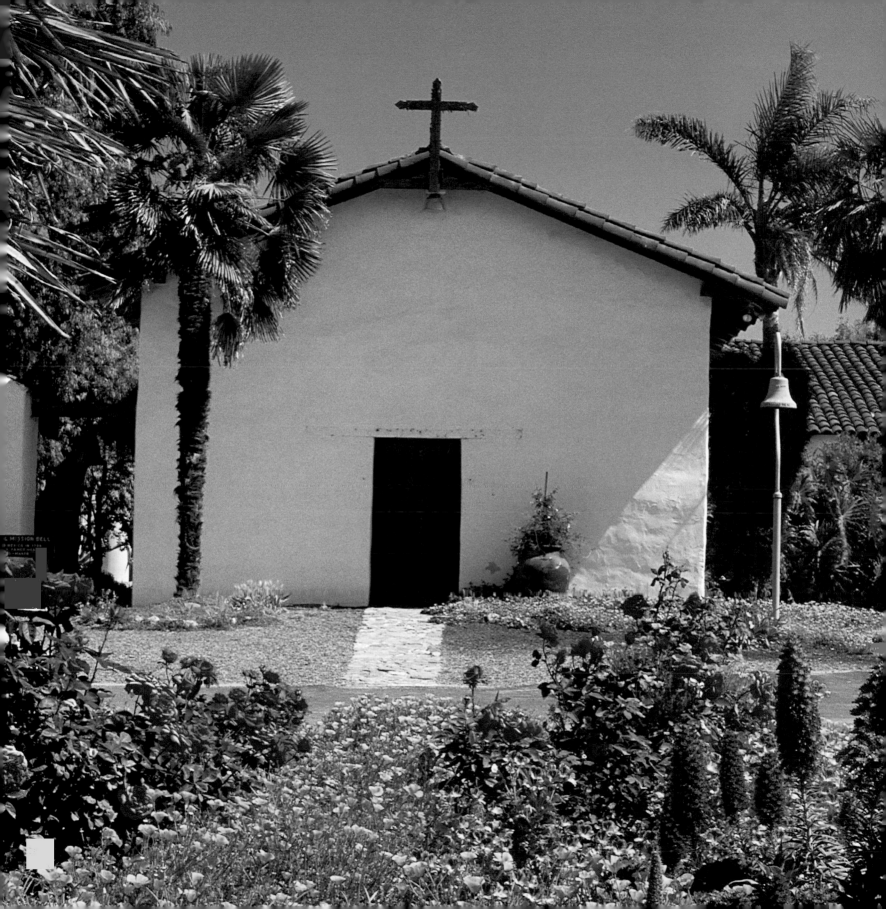

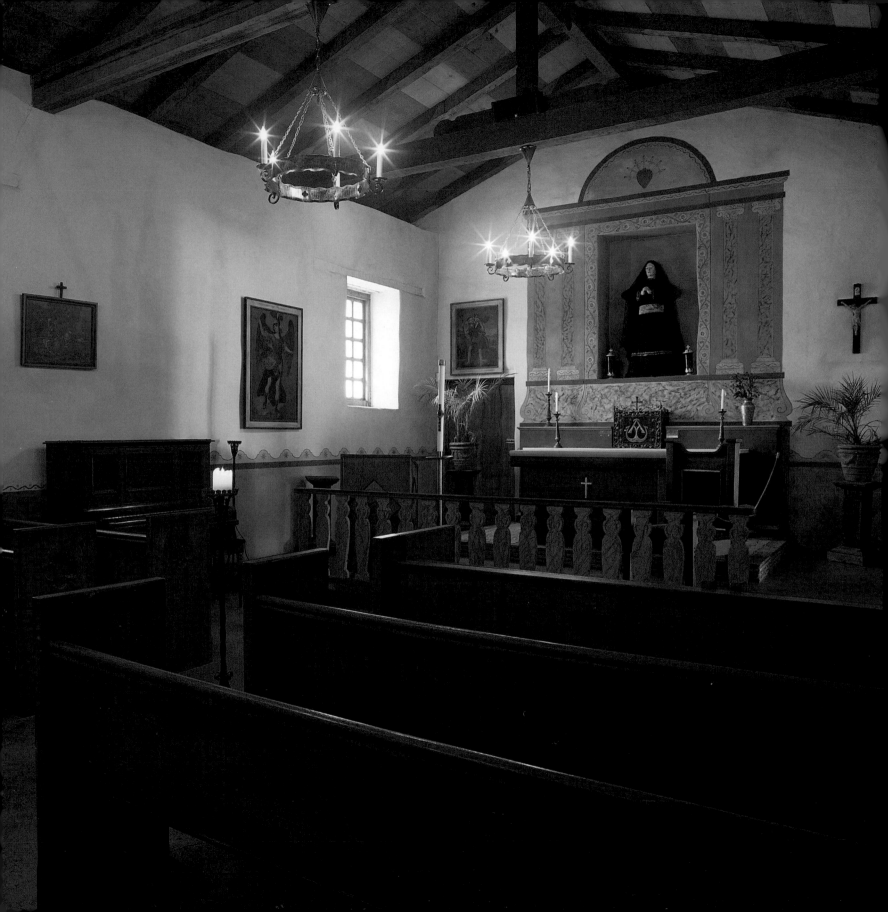

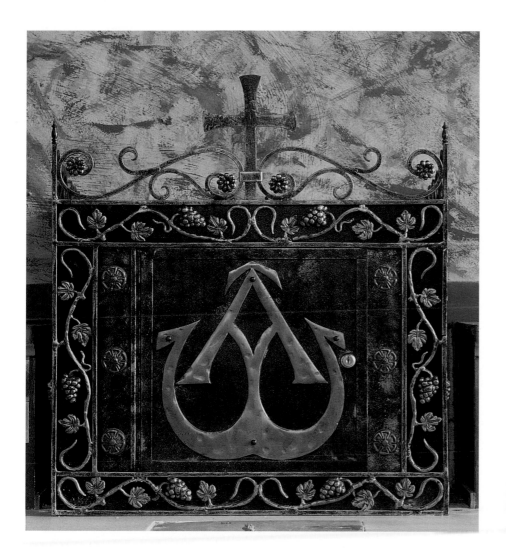

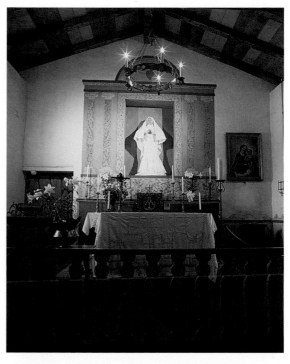

Modern-day tabernacle

Mission patroness, Our Lady of Solitude,
wearing white for a festive holiday.

Holy water stoup

Opposite: Small and quaint, the chapel is a
very peaceful place of solitude.

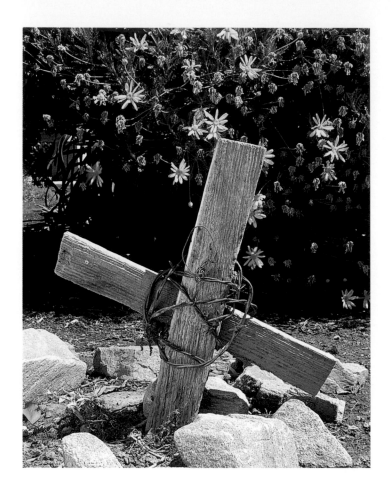

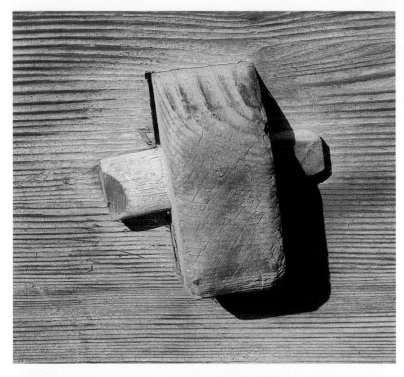

An old wooden grave marker

Wooden peg secures a bench.

Original mission bell from Mexico, cast in 1799.

Opposite: Wooden posts line the corridor of the convento.

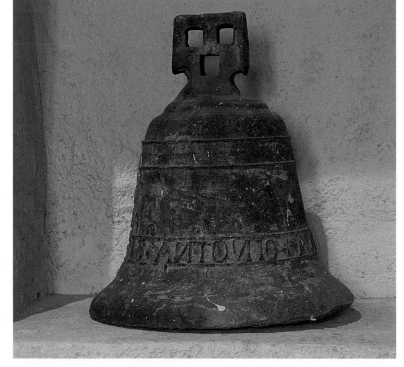

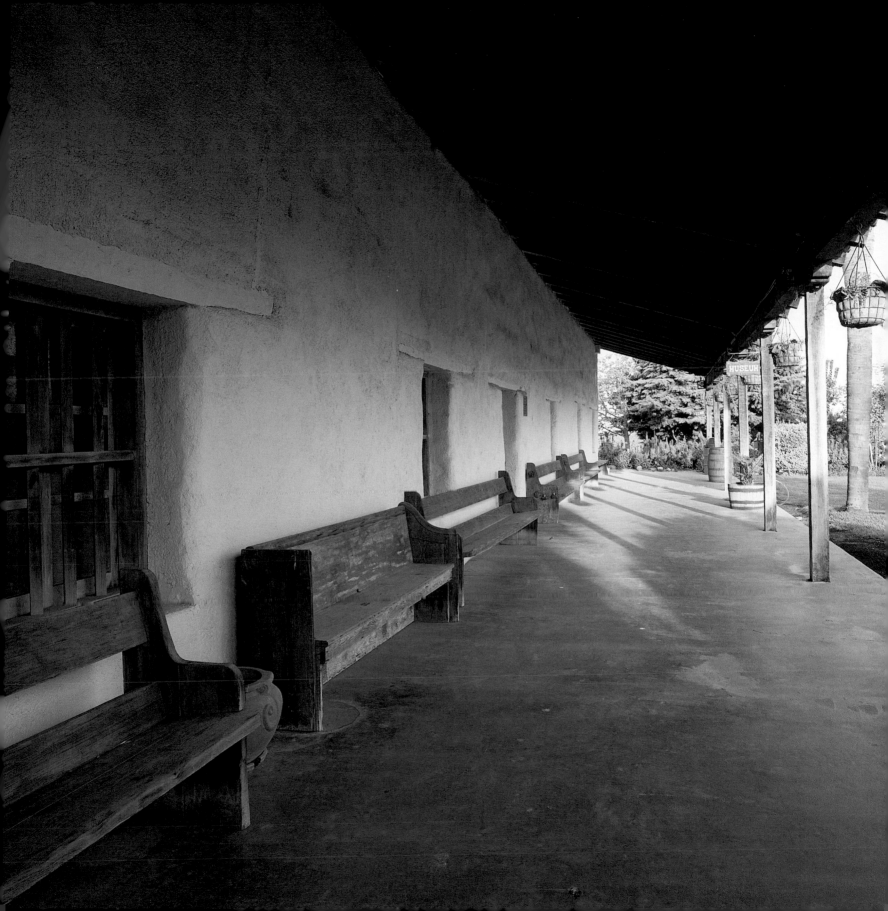

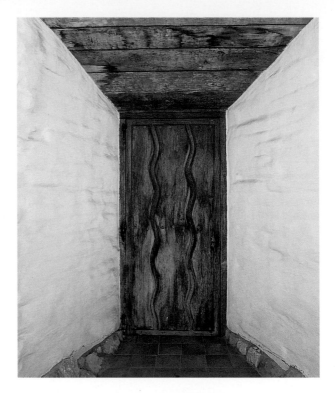

MISSION SAN JOSÉ

The fourteenth mission, founded on June 11, 1797

Cemetery gate detail

'River of Life' door design at the side entrance to the mission

Opposite: El Camino Real Bell marked the mission trail.

The fourteenth mission, San José was founded by Fr. Fermin Lasuen on June 11, 1797 as part of a concerted effort to shorten the gaps between existing missions. The summer of 1797 brought four new missions to the chain. The site was chosen within sight of Mission Dolores, and although the footwork had been done, it took a full two years for the necessary authorization to arrive from Spain. The area was in need of another mission to deal with the recurring problem of neophytes that had run away from Dolores. Even though amassing converts was initially difficult, San José was eventually responsible for converting nearly 7,000 Indians—a number bested only by San Luis Rey. One of the padres was musically gifted, and the converts of San José became some of the most accomplished musicians in the mission chain. While San José was spared of floods and epidemics, it had more than its fair share of Indian uprisings, and suffered great earthquake damage in 1868. It was secularized in 1834, sold in 1846, and returned to the Church in 1858.

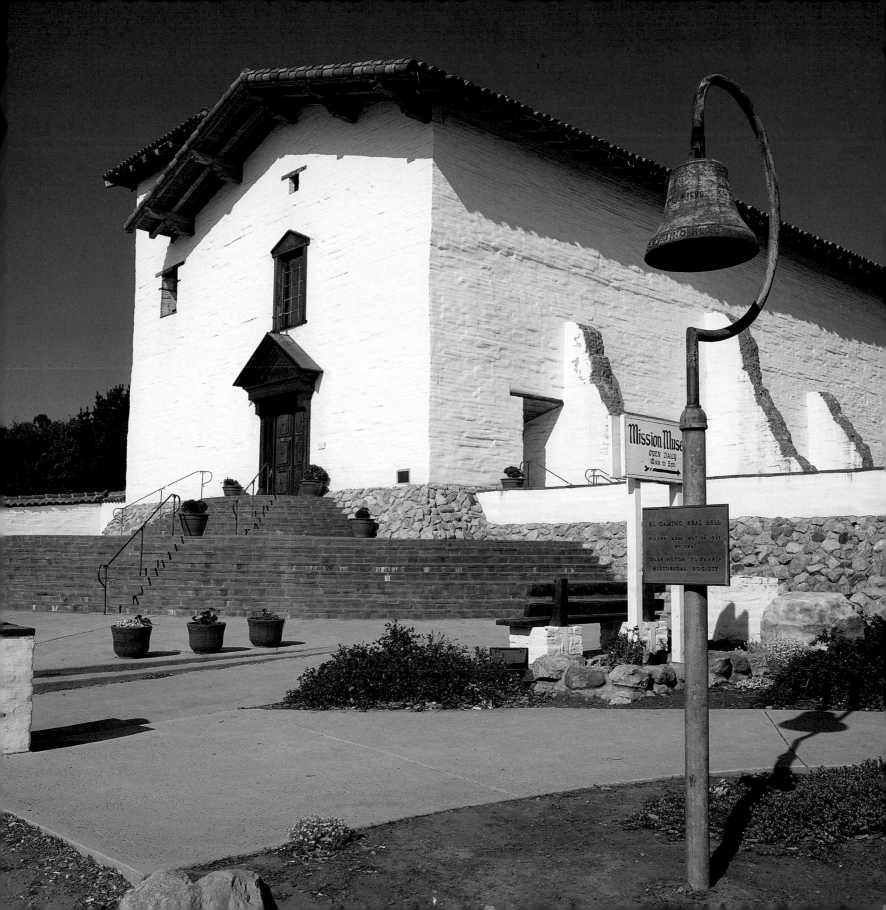

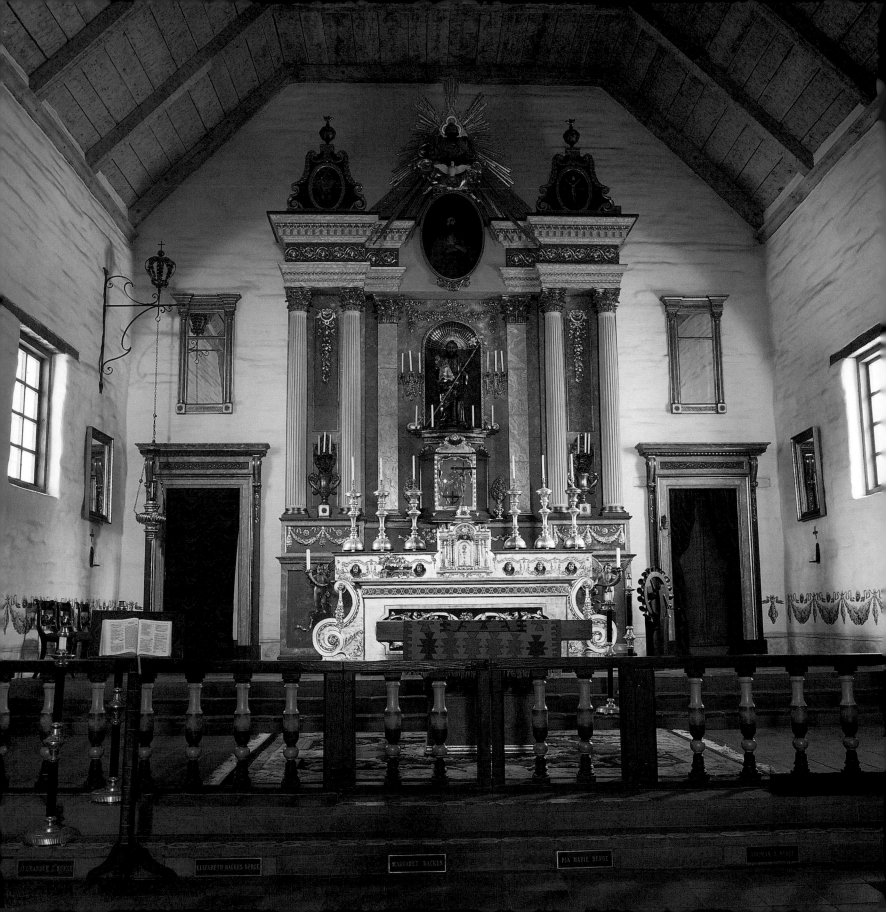

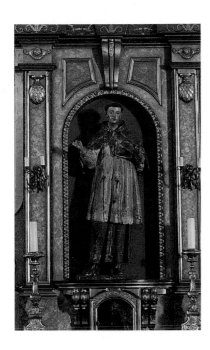

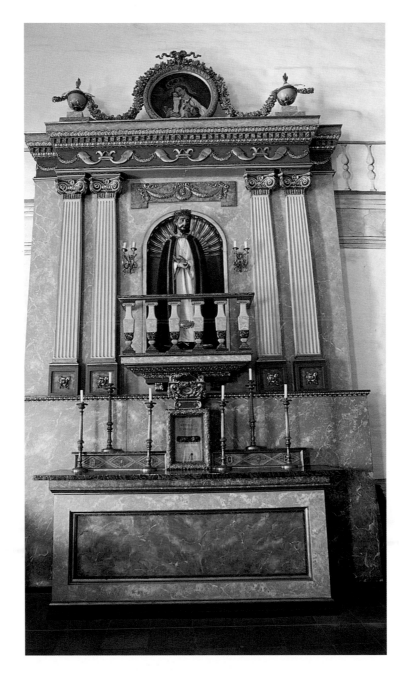

Early 1800s bulto of San Buenventura on a side altar

Side altar of life-size statue of Christ with crown of thorns.

Old sanctus bells

Original hand-hammered baptismal font

Opposite: Above an ornately gilded altar is a fifteenth century bulto of mission patron, San José.

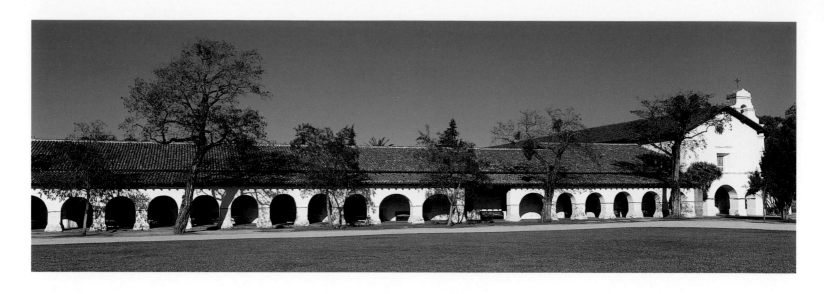

Mission San Juan Bautista

The fifteenth mission, founded on June 24, 1797

Mission San Juan Bautista

Opposite: Arched colonnades line the mission.

The bells hung from a wooden crossbar until 1865. The present campanario was built during the 1976 restoration project.

Olive trees shade the cemetery.

San Juan Bautista was the fifteenth mission to be founded, and the second during the busy summer of 1797. Fr. Fermin Lasuen performed opening ceremonies on June 24, 1797. In a mere six months, the willing and capable Indians had made possible the construction of not only a church, but also several other buildings vital to the mission. It was recognized that a larger church would be needed to accommodate the ever-increasing number of neophytes, and after a series of small earthquakes, it was decided to build a new, bigger church with room for 1,000 worshippers. Although built directly over the San Andreas Fault, San Juan Bautista was spared any major earthquake damage until 1906. The padres were skilled in linguistics and music, and created a system of written music with different colored notes for different voices for their famous boys' choir. The reredos, painted by the first Anglo-American settler in the area, remains a bright and beautiful attraction. The mission had a famous barrel organ that once actually saved the mission from attack, when the padre virtually hypnotized the charging attackers with its music. San Juan Bautista was secularized in 1835.

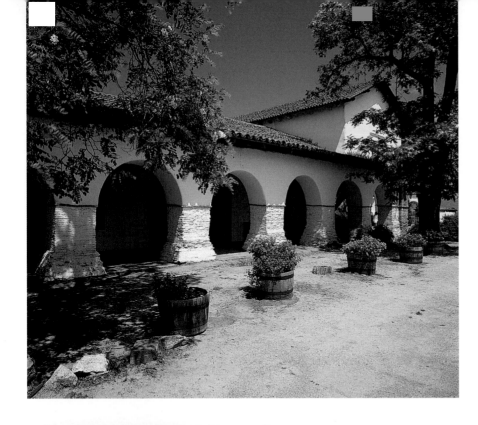

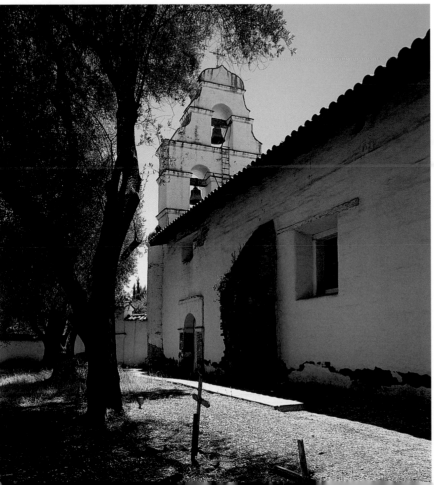

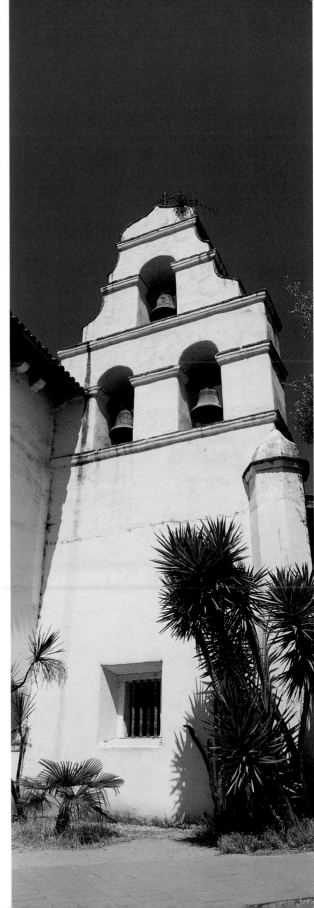

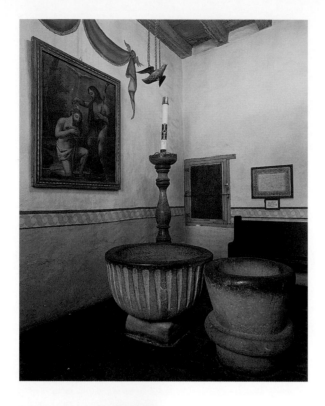

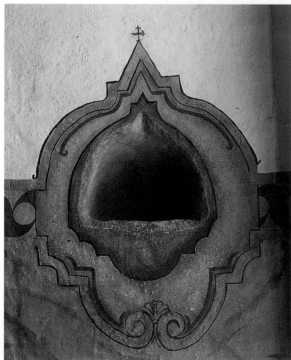

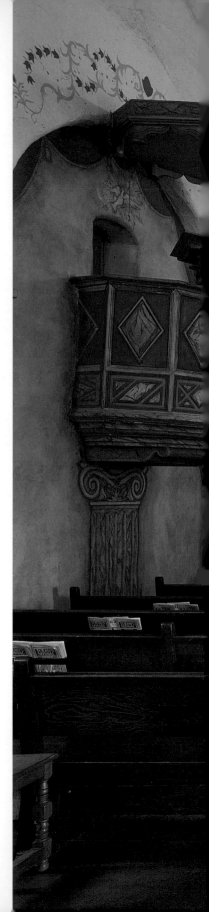

Indian-sculpted baptismal fonts
below a painting of patron
John the Baptist baptizing Jesus.

Holy water stoup

Opposite: Worn tiles lead to the
largest and only three-aisled church
in the Alta California mission chain.

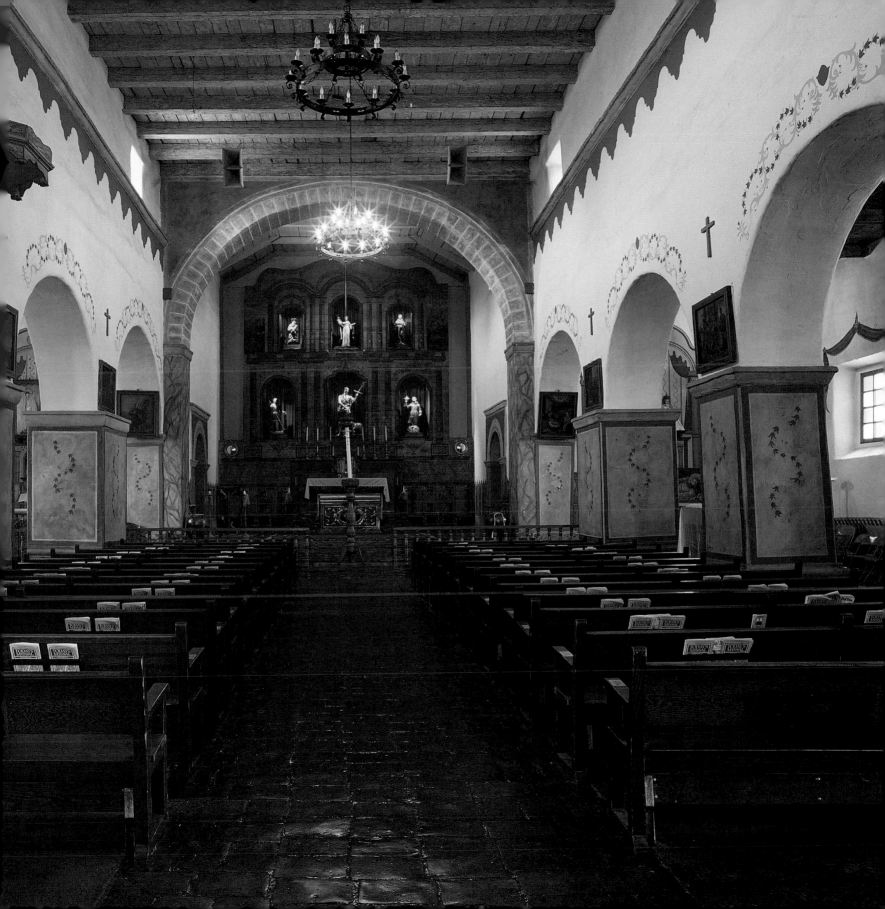

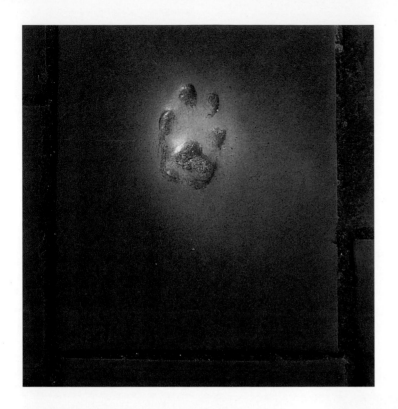

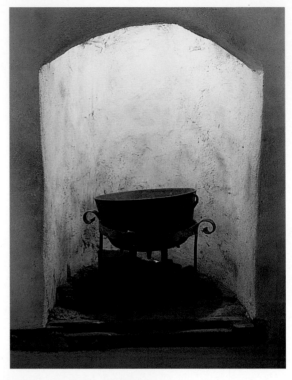

A coyote's track was set in a fresh, still-drying floor tile.

Cooking kettle

An aged cross carved into the wall in the convento.

Cross carved on Indian-sculpted baptismal font.

Opposite: 'River of Life' door design with cat hole

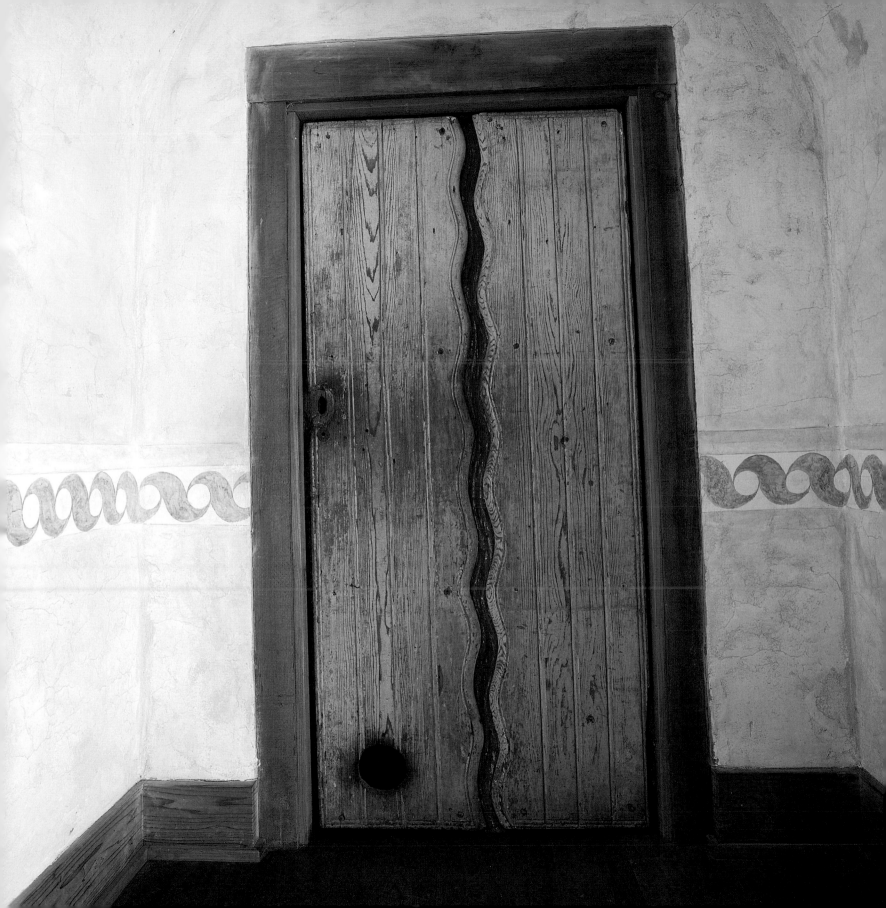

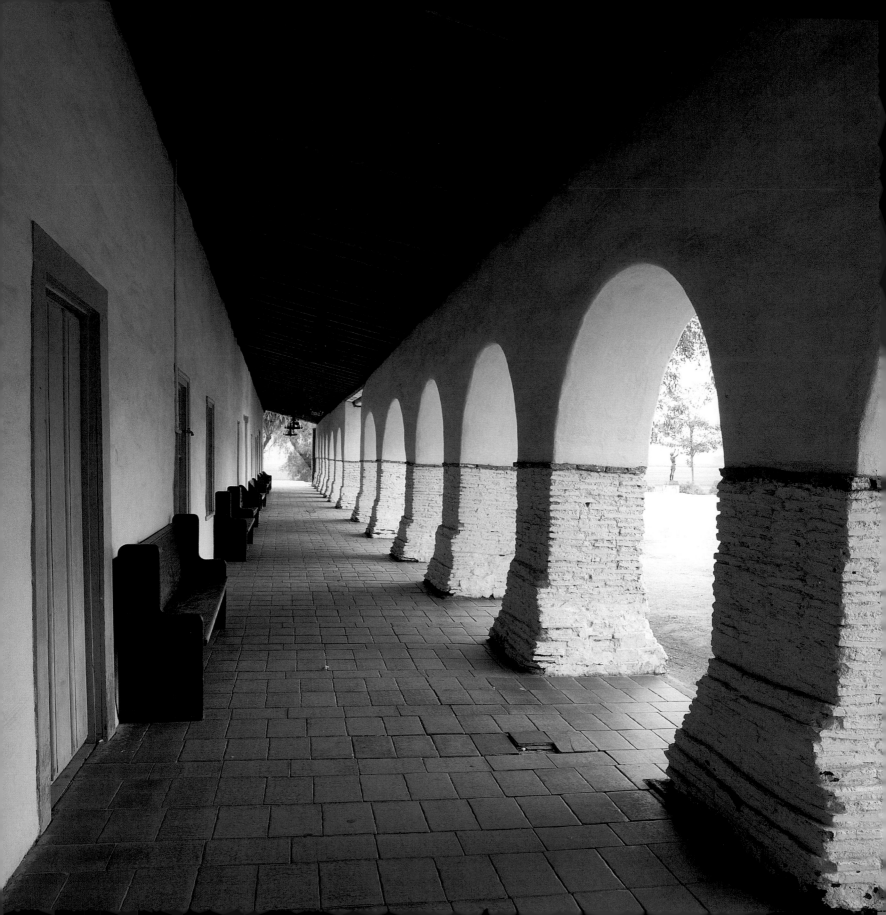

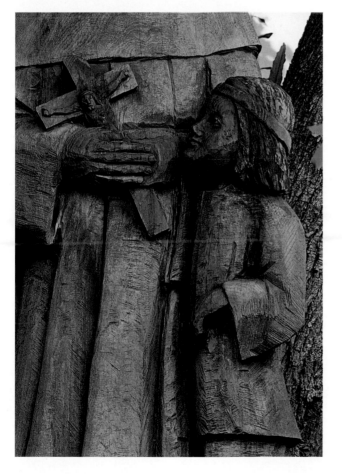

Indian stone mortars

Side door to the mission church

Wood carved statue of a Franciscan padre
and an Indian boy

Opposite: Nineteen arched colonnades
line a long corridor.

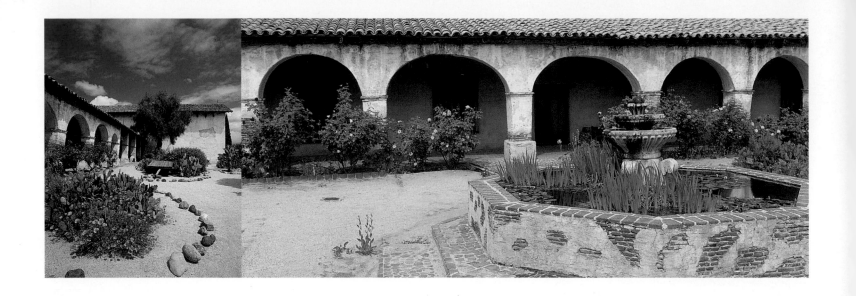

MISSION SAN MIGUEL ARCÁNGEL

The sixteenth mission, founded on July 25, 1797

An arid front courtyard of cacti and California poppies

A newer fountain backed by the old arched colonnades

Opposite: Façade of the church, prior to the December 22, 2003 earthquake

Fr. Fermin Lasuen founded San Miguel Arcángel on July 25, 1797 to help span the distance between San Antonio and San Luis Obispo. Neophytes from both missions came to assist with the construction, and the mission prospered almost immediately. An especially destructive fire destroyed many of the buildings in 1806, and all stored goods were lost. Nurtured back to life by the other missions, a new church was started in 1816, and took only two years to complete. The mission is famous for its murals, painted by the famous Spanish artist Estevan Munras. With its success, San Miguel sought to establish asistencias in nearby areas. Indians were offered their 'freedom' in 1831, due to the impending secularization, but chose to stay at the mission until the enforced secularization of 1834. Sold in 1846, the mission was returned to the Church in 1859.

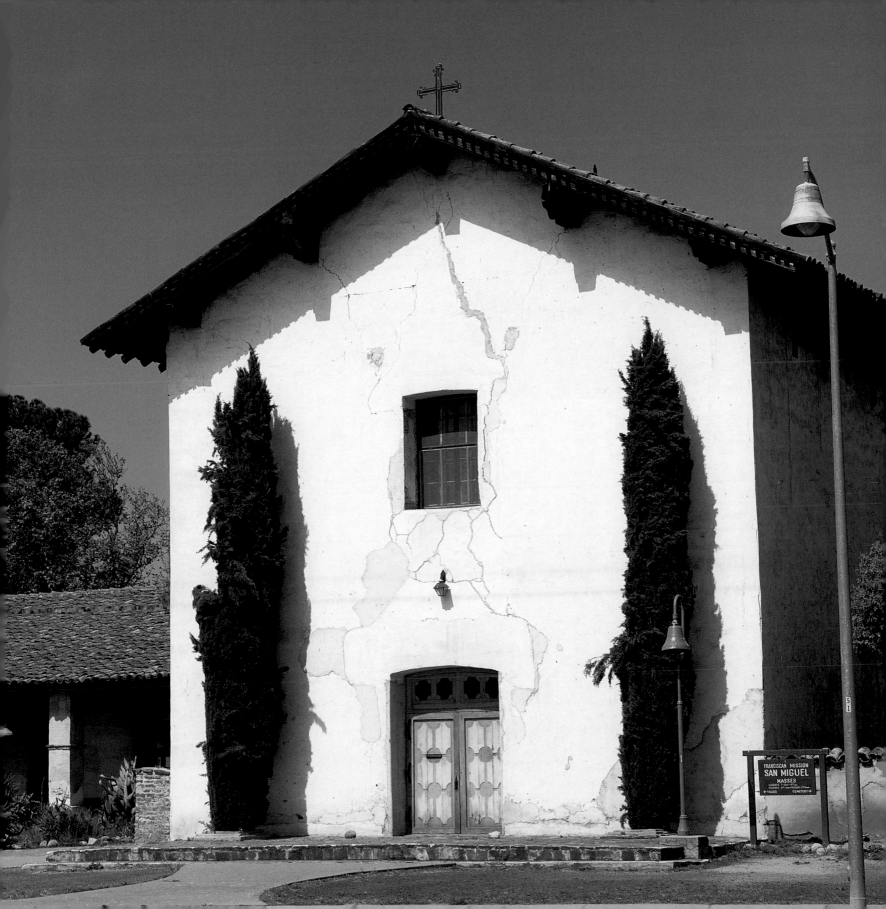

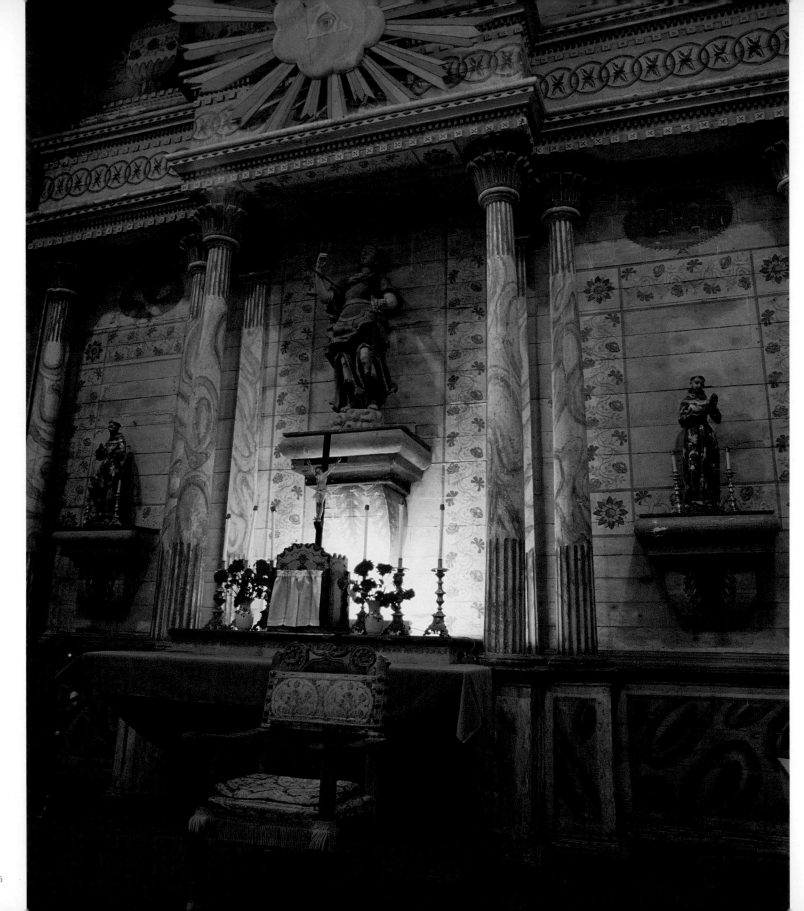

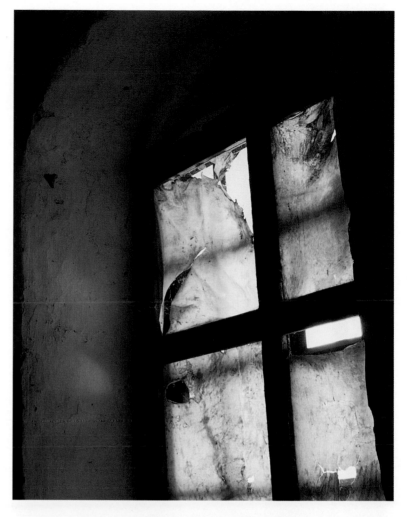

Opposite: The most original painted reredos
in the Alta California missions, painted by
Spanish artist Estevan Munras and his Indian
assistants in 1820-22. The artists painted
stenciled designs from floor to ceiling using paint
made from cactus juice, which preserves
the paint's intensity, and a glue made from
powdered bones mixed with natural pigments.

Silk vestment

Sheepskin parchment panes

Silk vestment

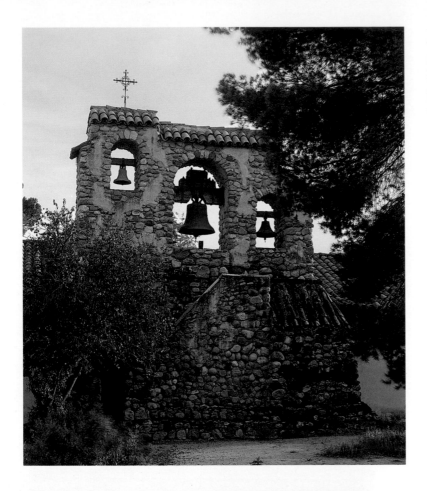

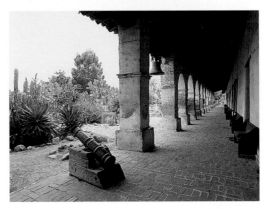

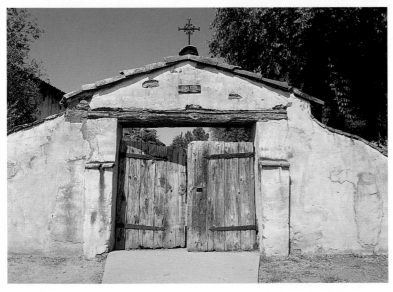

Adjacent to the cemetery is a stone campanario built in the 1950s. The center bell weighs over 2,000 pounds and was recast in 1888 from broken bells of other missions.

Wrought iron door hardware

Spanish mission bell cast in 1800 and a Spanish cannon from the late 1600s

Cemetery gates

Opposite: Memorial bell tower dedicated to the Franciscan priests and brothers who served in World War II.

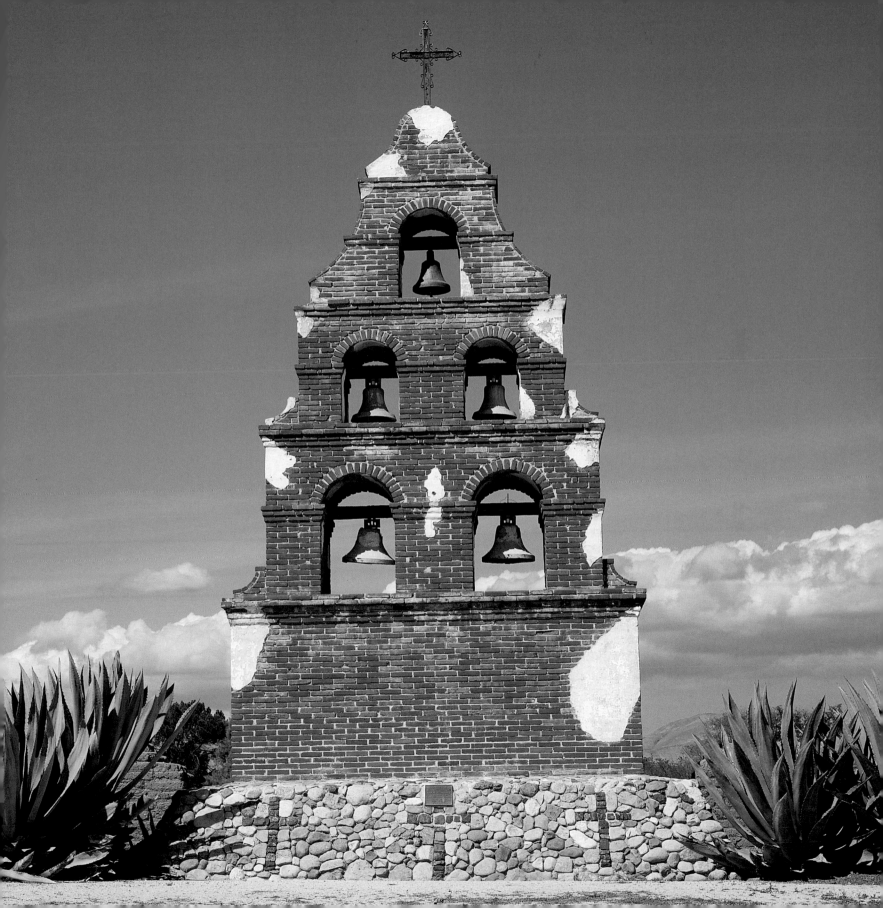

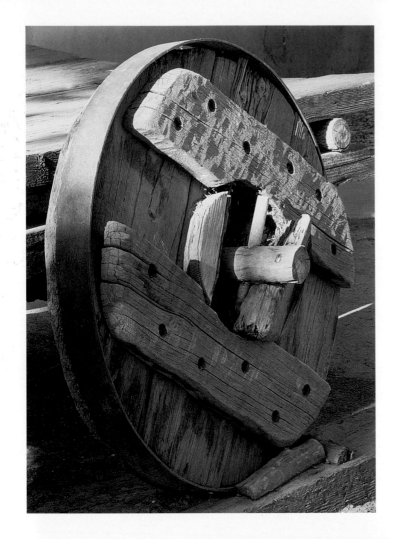

Wooden pegs replace nails on a carreta wheel.

Horno oven used for baking bread and smoking meats

Decorative gate latch and hinge

Opposite:
Colorfully painted door with window

Interior frescoes from the 1820s have remained unaltered by latter day restorers.

A bench fits perfectly into an arched doorway.

A stylized scallop shell painted in the early 1820s backs the pulpit. These wall paintings are the best-preserved of all the missions.

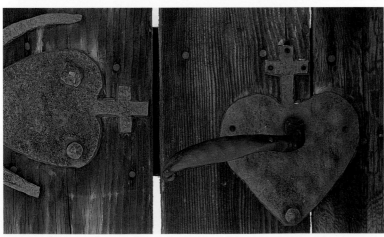

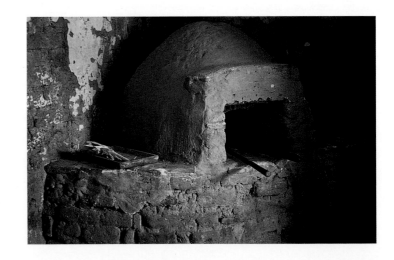

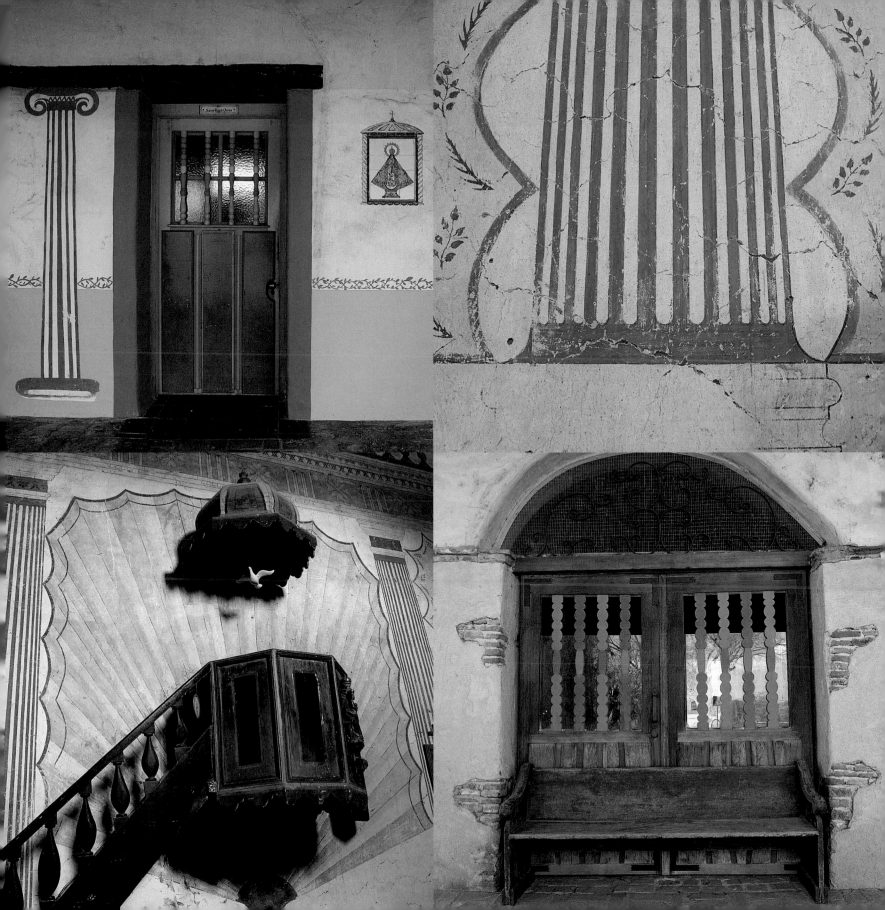

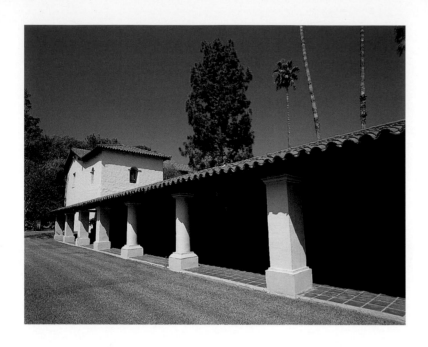

MISSION SAN FERNANDO REY DE ESPAÑA

The seventeenth mission, founded on September 8, 1797

Restored Indian workshops and church

Spring blooms shroud a door at the mission site.

Opposite: Mission buildings face the colonial highway, the El Camino Real.

The seventeenth mission, San Fernando Rey de España, was founded by Fr. Fermin Lasuen on September 8, 1797 between San Buenaventura and San Gabriel. Blessed with four strong-running springs, the area showed great promise. The mission grew rapidly, and soon became the foremost cattle-raising mission in the chain, boasting exceptional hides, tallow, and leather-work. The related skills of the neophyte herdsmen developed accordingly, and rodeos of some sort were staged almost daily. Three churches were built over the years, and the third was completed in 1806 but damaged by the earthquake of 1812. Secularized in 1834, it was returned to the Church in 1861.

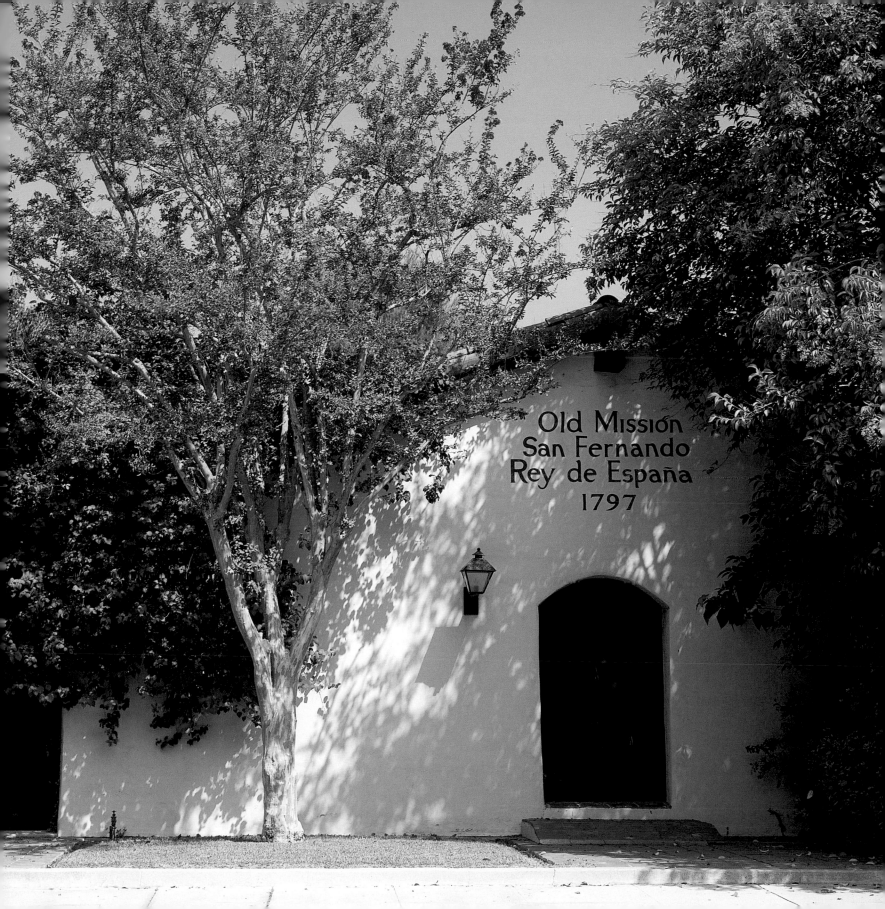

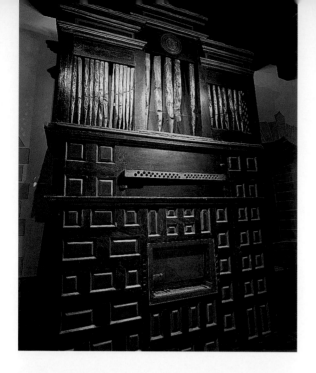

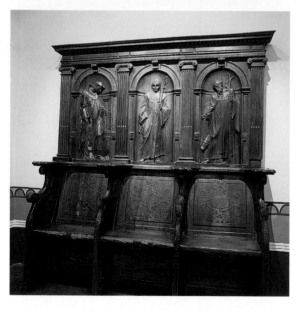

Wood carved organ, part of the sixteenth century Ezcaray altar collection

Painted wall dado

Adobe tile shaper used after 1970's earthquake

Surrounded by the golden rays of eternal bliss, mission patron, San Fernando

Wood carved choir stall, donated to the mission

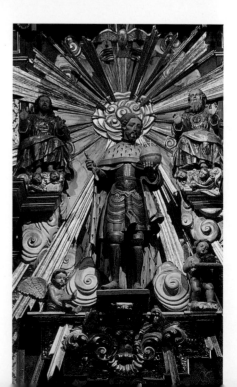

Opposite: Sixteenth century Ezcaray altar and reredos from Spain carved from blocks of solid walnut, and surfaced with gold leafing.

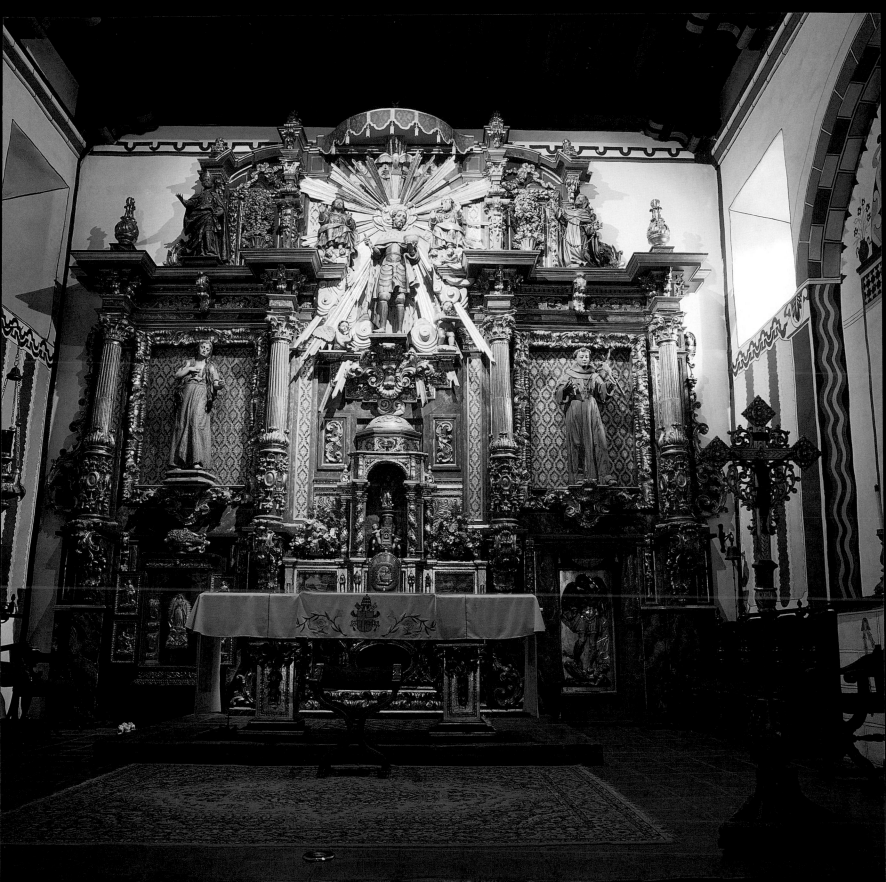

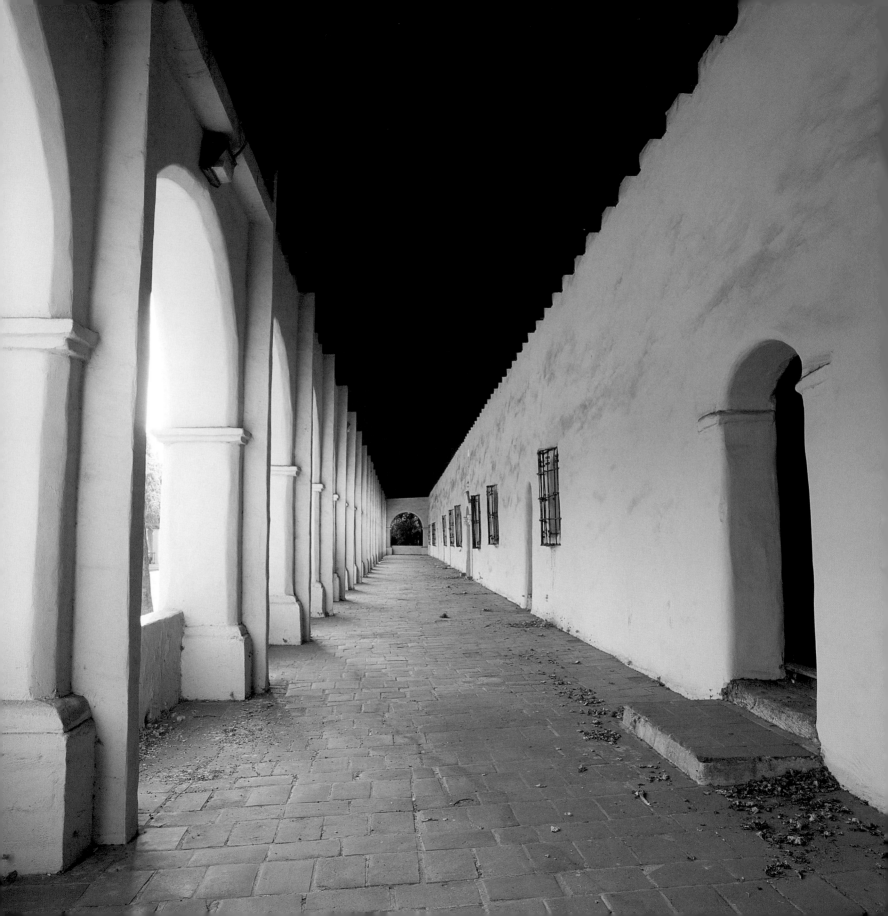

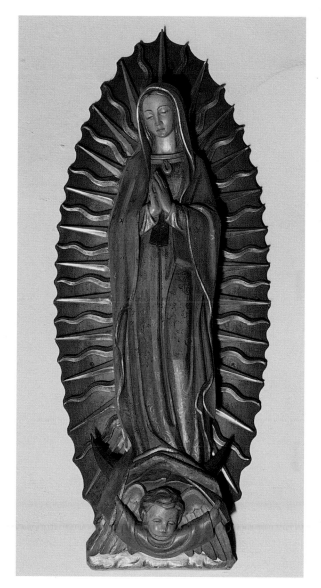

Holy water stoup

Virgin of Guadalupe, carved wood piece

Coat of Arms over church entrance (from visit by Pope John Paul II)

Opposite: Twenty one arched colonnades line the convento, the oldest two-story adobe building in the State of California.

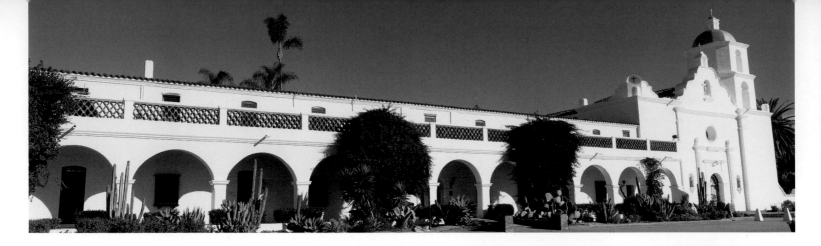

Mission San Luis Ray de Francia

The eighteenth mission, founded on June 13, 1798

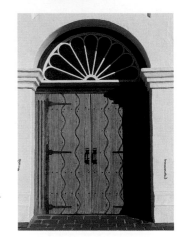

Mission San Luis Rey de Francia

Entrance doors to mission church

Gateway to the cemetery, designed by
a Walt Disney artist and used as a
backdrop for the Zorro films.

Opposite:
Mission San Luis Rey de Francia

San Luis Rey de Francia was founded between San Diego and San Juan Capistrano by Fr. Fermin Lasuen on June 13, 1798. Known as the largest and most populous Indian mission of both Americas, San Luis Rey de Francia was the last to be founded by Lasuen. The mission grew rapidly with military help from San Diego, under the inspired guidance of Father Antonio Peyri, who built a beautiful, unique cruciform church comparable only to San Juan Capistrano's in design. Across six acres, Peyri's mission boasted an advanced water system that not only fed an elaborate sunken garden and lavendería, but also utilized a charcoal filtration system for drinking water. An asistencia (sub-mission) was established at San Antonio de Pala in 1815. On the eve of 1834's secularization, Peyri retired so as not to witness the downfall of his labors. The mission was sold in 1846 and returned to the Church in 1865.

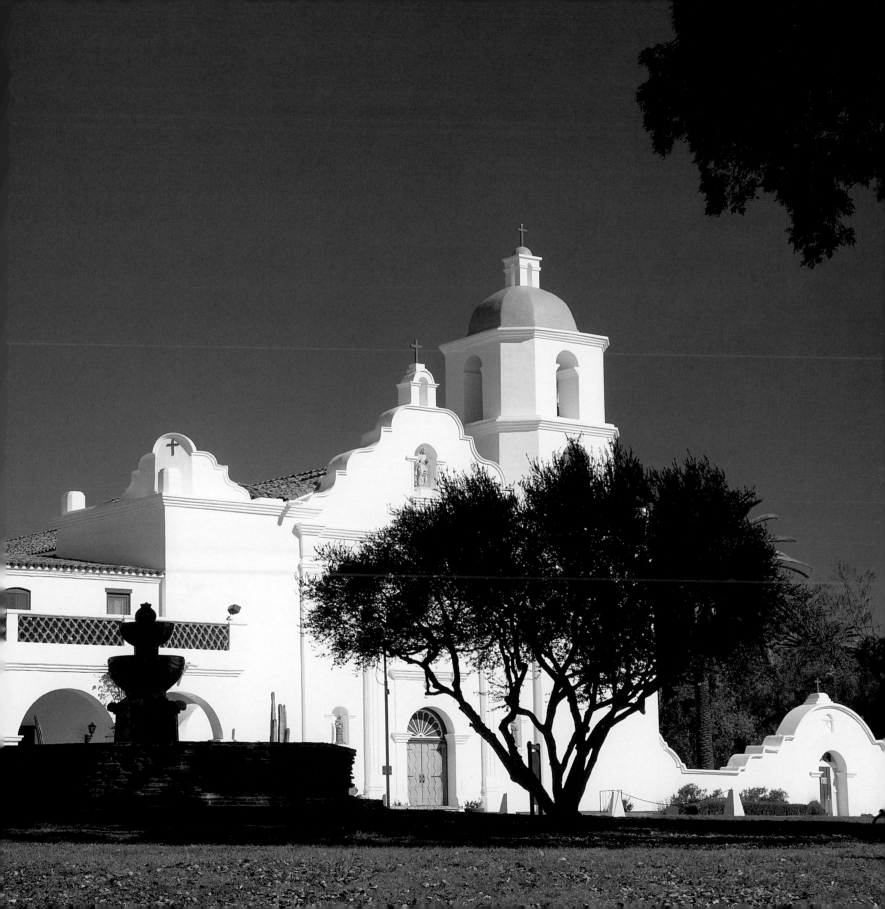

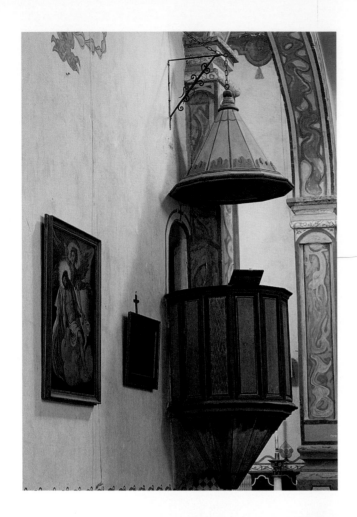

Original wooden pulpit and sounding board

Mission patron, Saint Louis King of France

Small holy water stoup made with an abalone shell

Opposite: Decorative arches frame the sanctuary

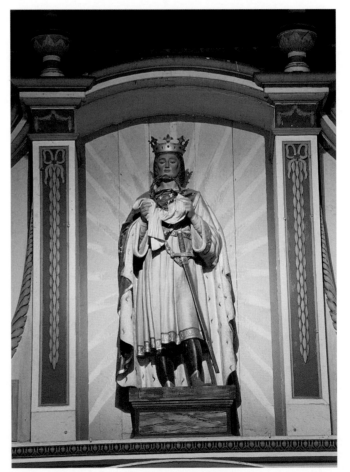

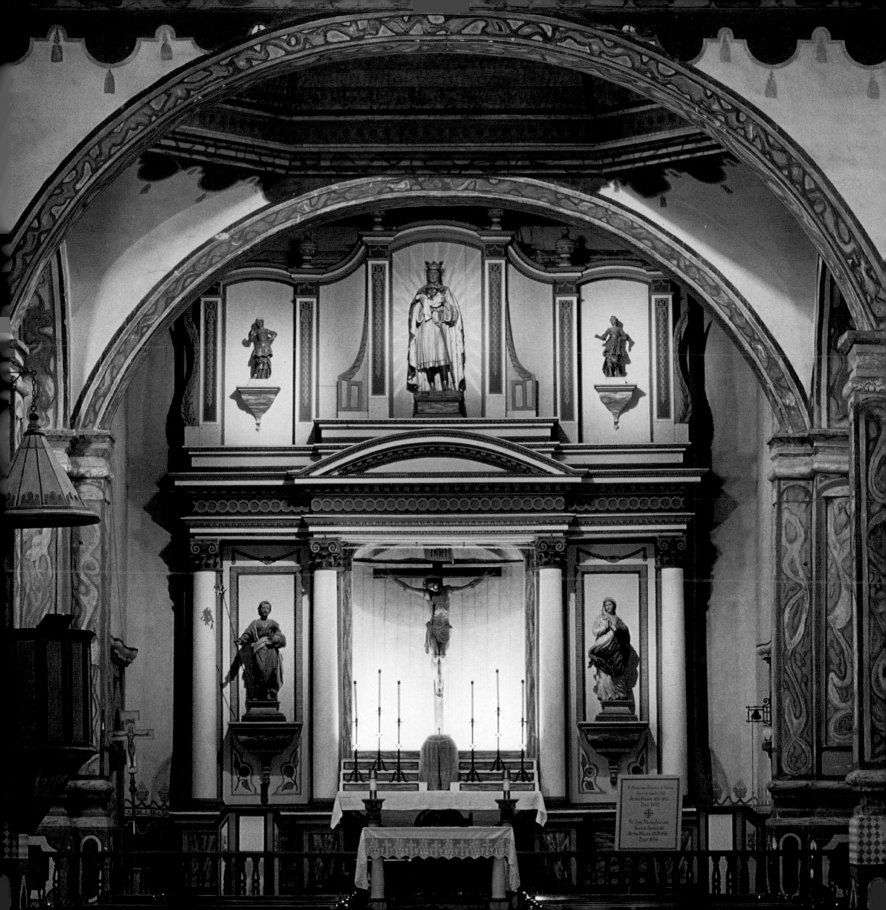

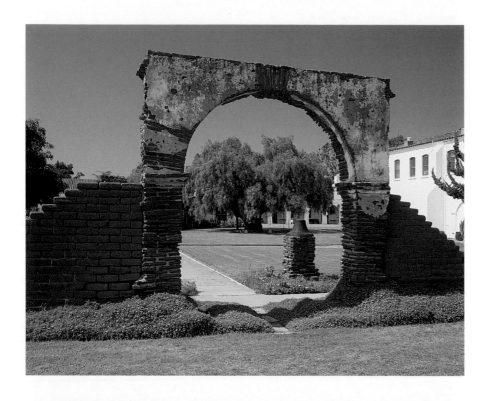

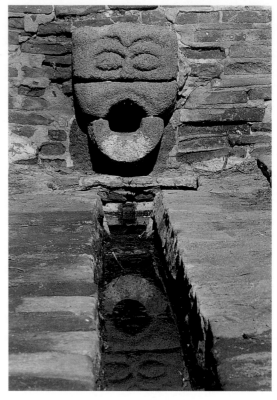

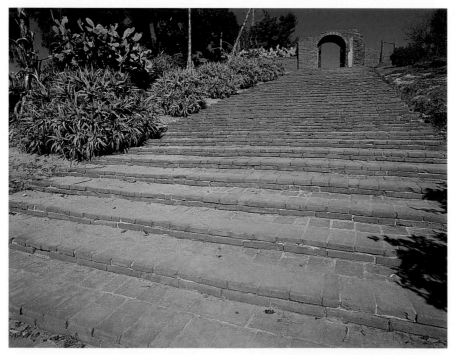

A lone survivor, the arch frames California's first pepper tree, planted in 1830.

Indian carved gargoyle waterspout from which water flowed into catch basins of the lavanderiá.

Restored arch and brick steps leading down to the lavanderiá.

Opposite: Indian-designed ceiling frescoe

Painted wall dados (Indian-style frescoes painted throughout the room are copied from pictures of original designs.)

Holy water stoup, decorated with geometric and flora designs

Decorative painted pilasters

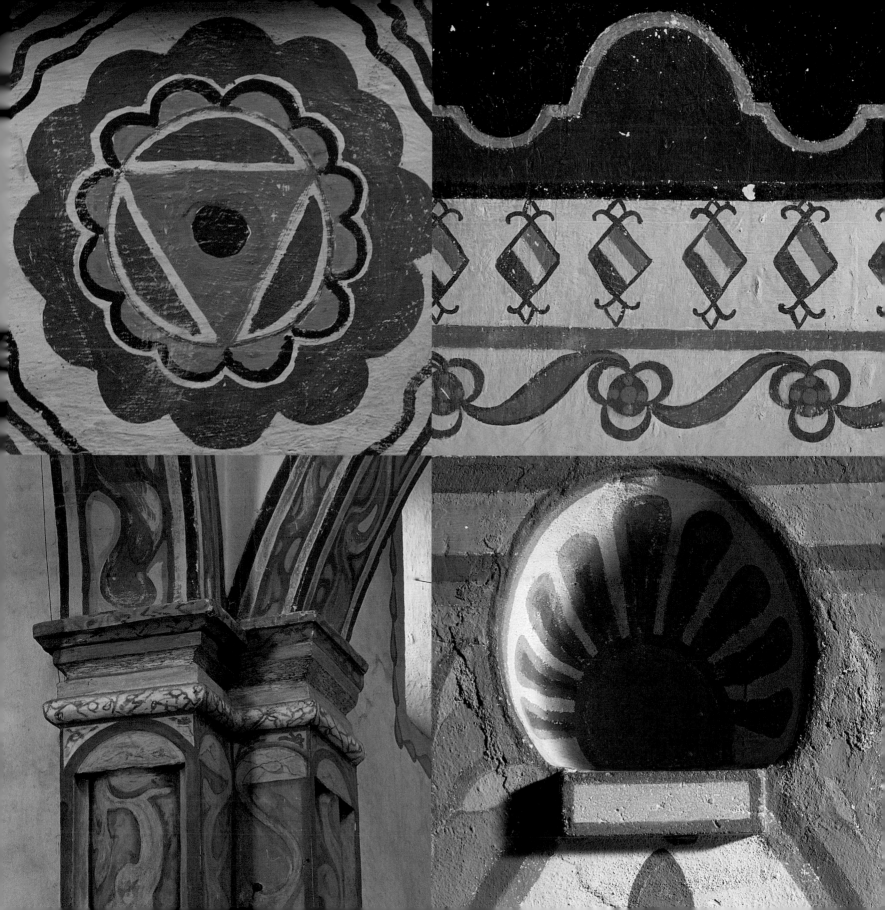

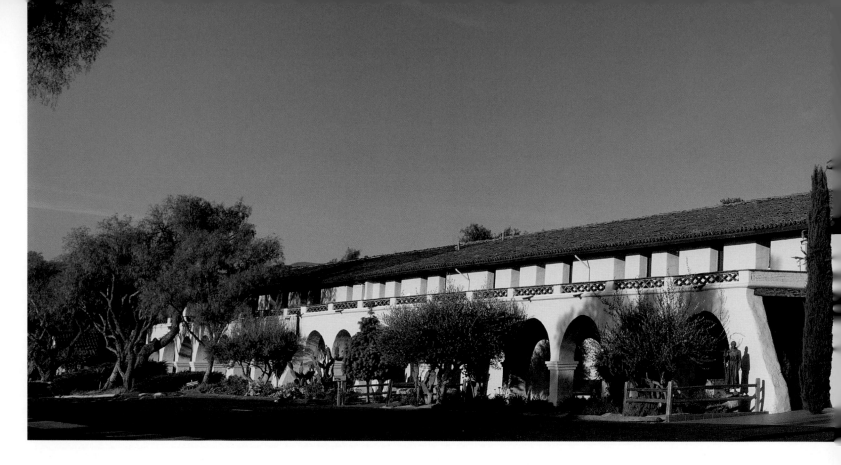

MISSION SANTA INÉS

The nineteenth mission, founded on September 17, 1804

Mission Santa Inés

Opposite:
Main entrance to the mission

Mission bell tower

The nineteenth mission, Santa Inés was founded by Fr. Estevan Tapis on September 17, 1804, between San Francisco and San Diego. The mission grew quickly with the help of other more established missions, and came to be known for its vast cattle herds and plentiful crops. Shortly following the completion of the buildings, the earthquake of 1812 demolished many of the mission structures. A new church was started in 1813. While some fighting with hostile natives occurred due to differences with the military, the most severe of the uprisings took place elsewhere. As with the other missions, the year 1834 brought secularization, followed by the sale of the property in 1846, and the eventual return of the property to the Church in 1862.

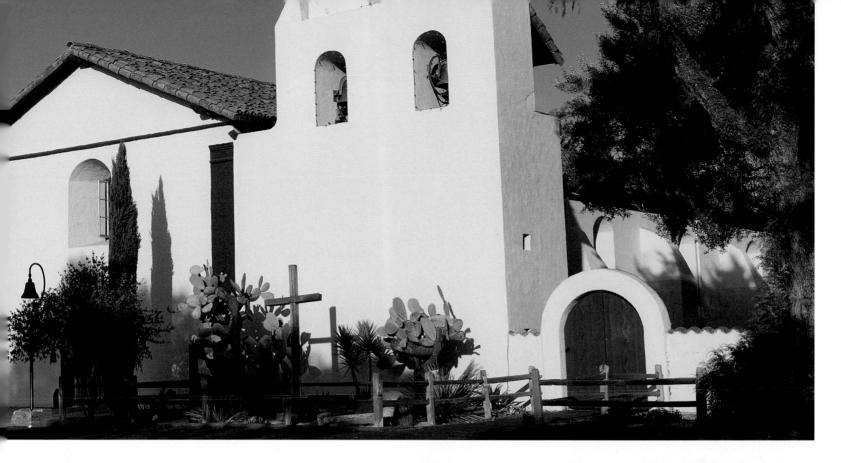

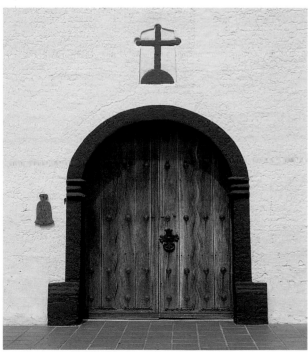

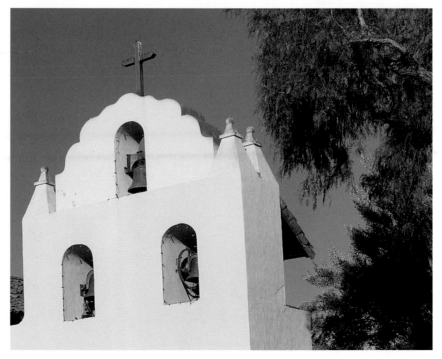

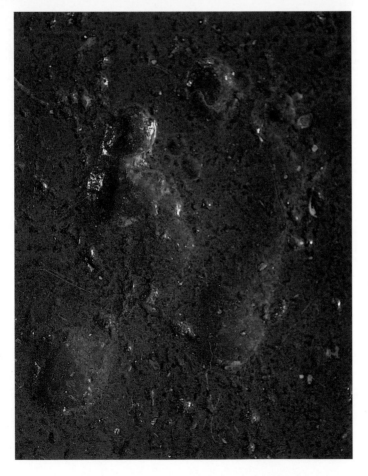

Door hinge

Mission era door pull

Indian child's footprint embedded in
a drying floor tile

Opposite: Arched colonnades

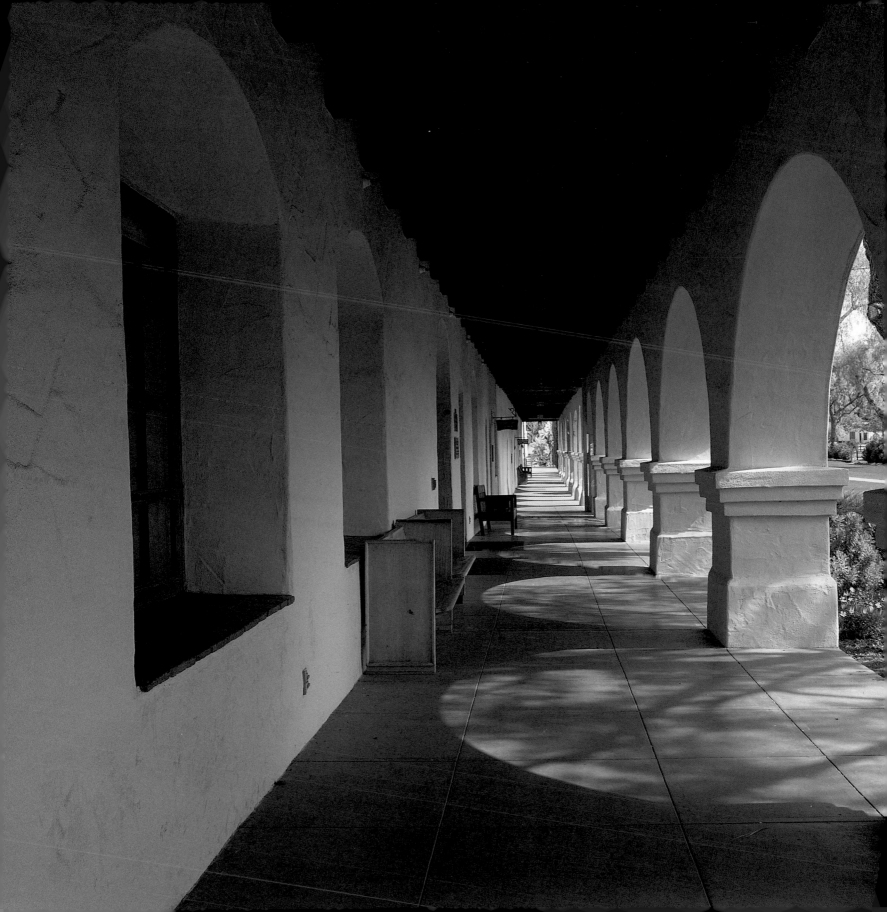

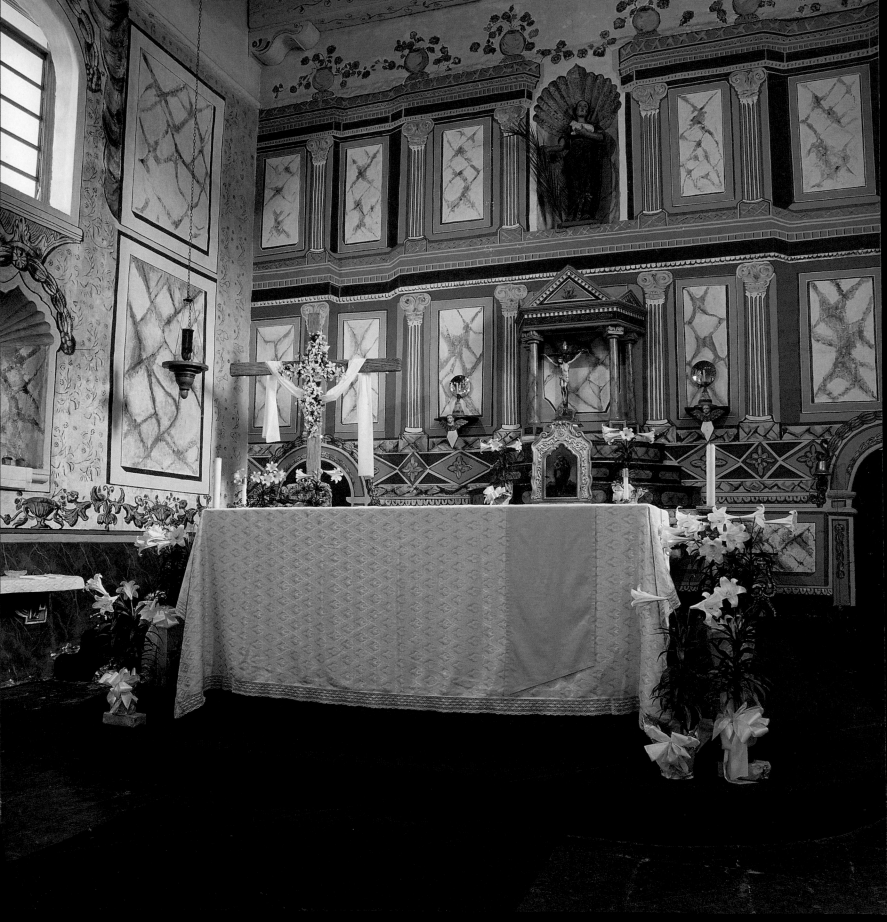

Indian wall dados, repainted to the original designs.

Statue of mission patroness, Saint Inés

Restored Stations of the Cross

Top of the reredos, mission patroness, Santa Inés

Opposite: Reredos and side walls originally painted in 1825 by the mission Indians (repainted in the 1970s and 1980s).

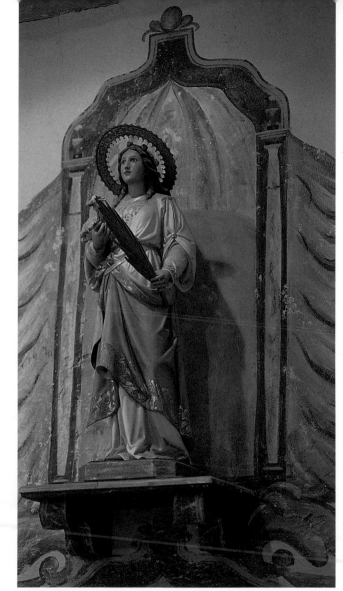

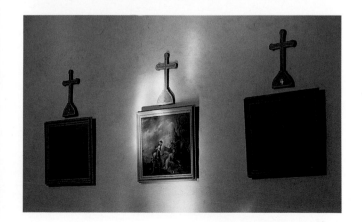

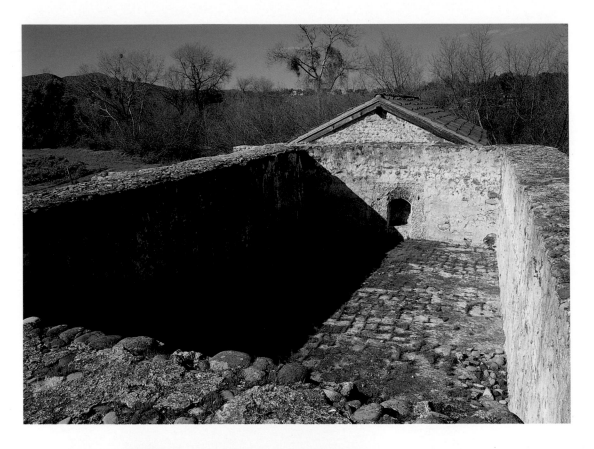

Remains of the milling complex built in the 1820s

The 19th arch is all that remains of the southern end of the mission.

Gate to the cemetery

Opposite: Old grave markers in the cemetery, decorated with tiny shells

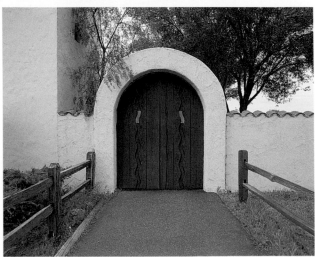

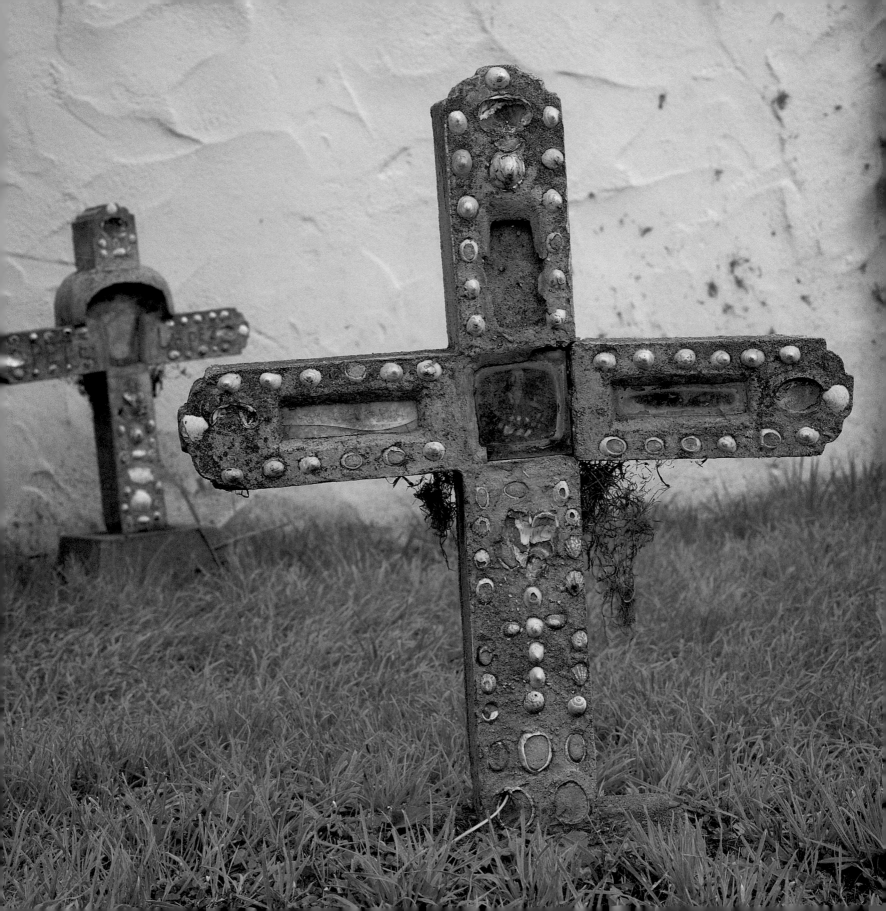

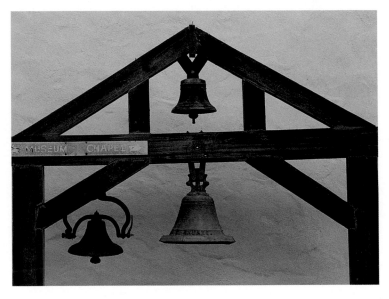

MISSION SAN RAFAEL ARCÁNGEL

The twentieth mission, founded on December 14, 1817

Sunlight highlights the arched entrance door to the mission.

Built without a bell tower, three original bells hang from a wooden frame, just as they did during mission days.

Opposite:
Star windows on the replica church and the original old chapel were copied from Carmel Mission.

San Rafael Arcángel was founded on December 14, 1817 by Fr. Vicente de Sarria as a hospital for Mission Dolores, which had suffered a high death rate for some time. The climate of San Rafael, they reasoned, would be conducive to healing. Neighboring missions all contributed to what was intended to be an asistencia, but proved to be such an asset to the mission chain that it was afforded full mission status in 1828. All of the surrounding missions sent their sick to San Rafael, where they experienced a wonderful recovery rate under the knowledgeable care of Father Gil y Taboada. San Rafael was instrumental in deterring the ever-present threat of Russian encroachment, and served as a stopover for military expeditions. After a relatively brief but successful existence as a mission, San Rafael was secularized in 1834, sold in 1846, and returned to the Church in 1855.

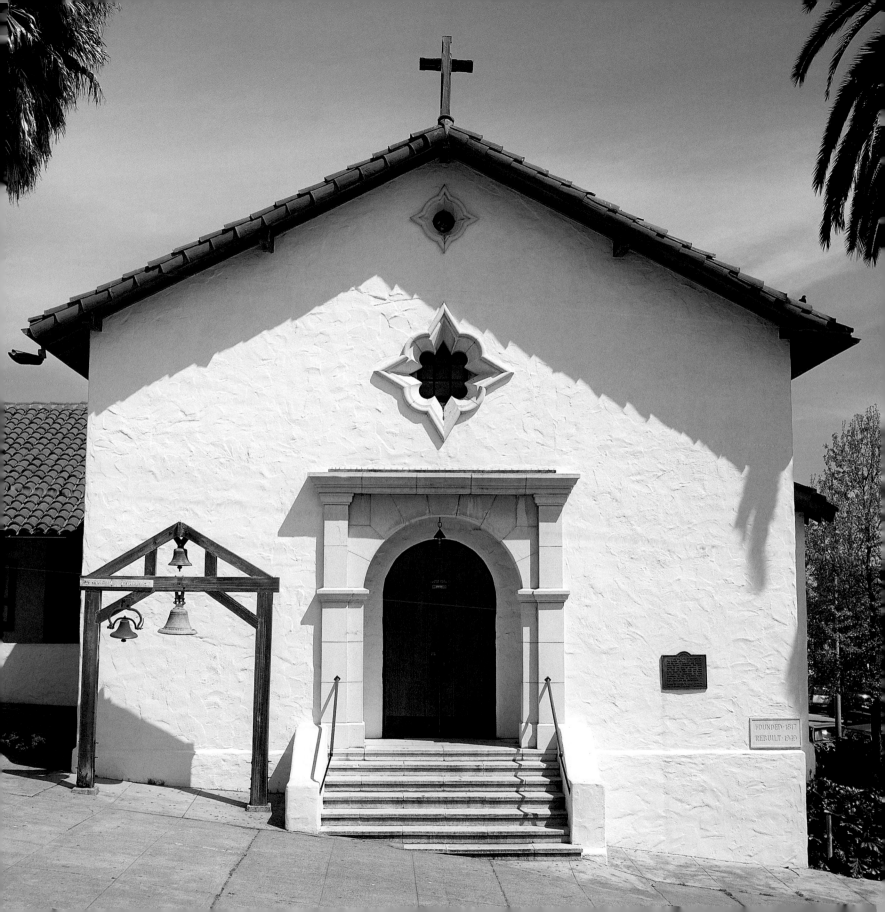

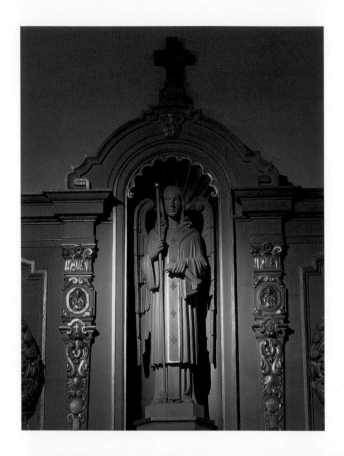

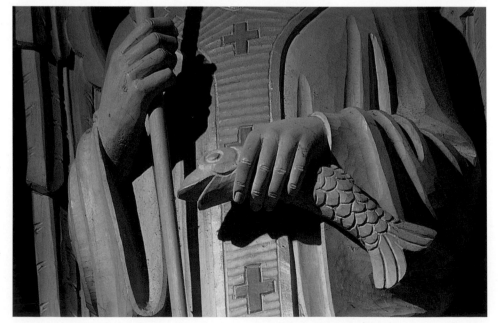

San Rafael Arcángel, patron for the mission hospital (One of three Arcangels, his name means Healer of God.)

Deep inset windows in the sanctuary

Fish detail carved into the oak bulto of mission patron, San Rafael Arcángel.

Opposite: Contemporary reredos and carved oak bultos with the Virgin of Guadalupe, Saint Joseph and mission patron San Rafael

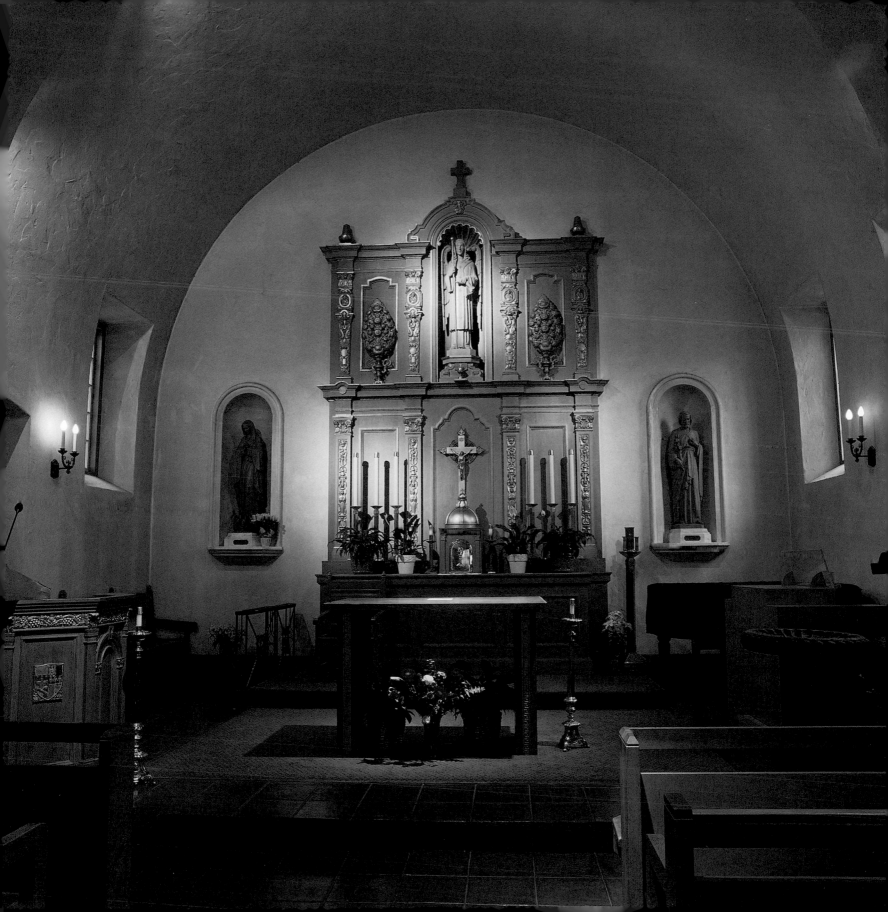

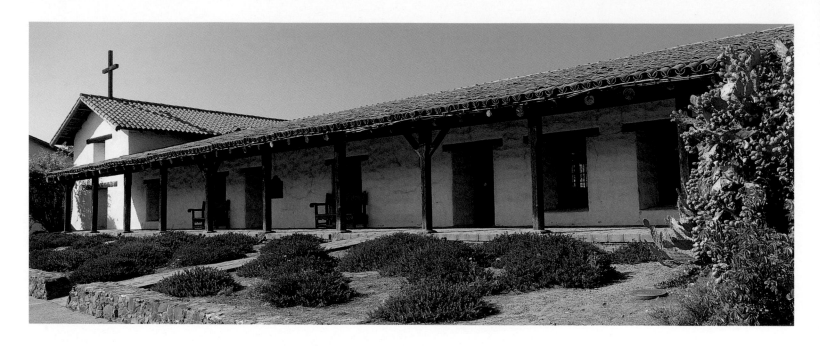

Mission San Francisco Solano

The twenty-first mission, founded on July 4, 1823

Mission San Francisco Solano, view of the long corridor supported by wooden posts instead of the usual mission adobe/brick arches

Opposite:
In front of the chapel entrance, a wooden frame holds one of the original misson bells cast in 1829.

The final mission to be established, San Francisco Solano, was founded on July 4, 1823 by Fr. José Altimira, following as much of a bureaucratic controversy as the mission chain was subject to. The padre felt conditions at Mission Dolores were unsuitable, and pressed to abandon the mission and start a new one elsewhere. Surpassing the proper church authorities, Altimira took his plan to the governor, whom he suspected would share similar ideas. Altimira and the governor tried to push their plan through, but were halted by the Church. A compromise was eventually reached, in which existing missions were to be left alone, but Altimira could build his mission. While the mission succeeded, Altimira was unfortunately not the kind and capable leader needed to run a mission, and because of his foul temper and harsh treatment of his charges, he was eventually forced to flee to Spain. Father Fortuni was left to repair the damages in 1826, a very short time before secularization.

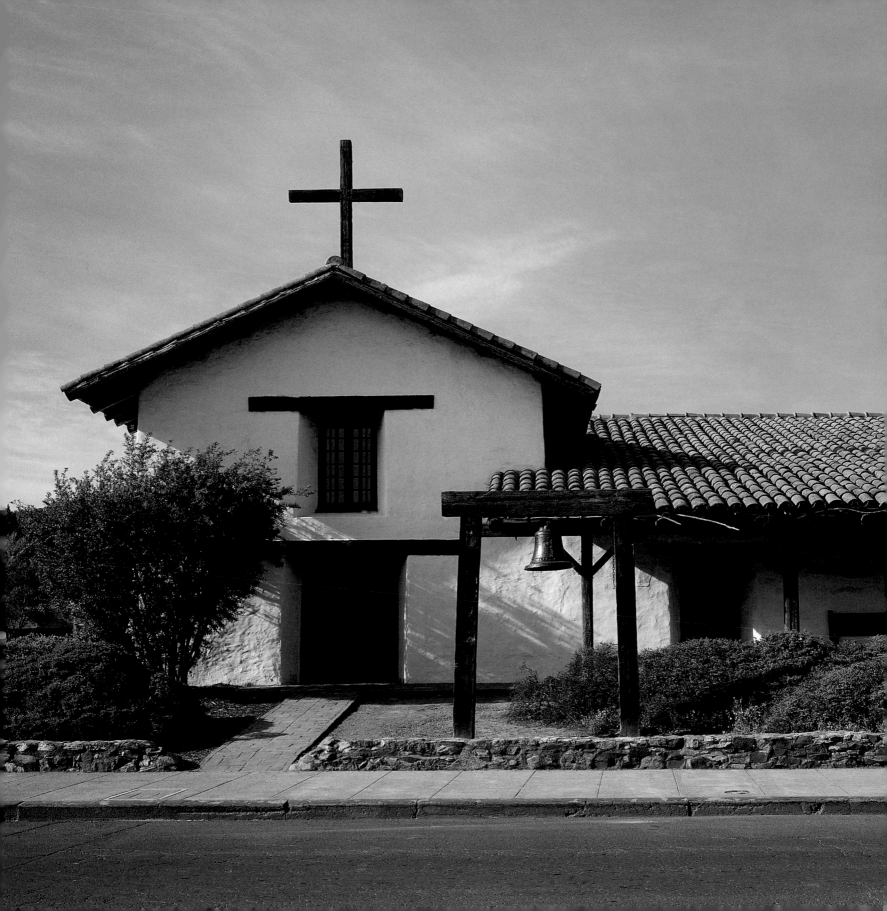

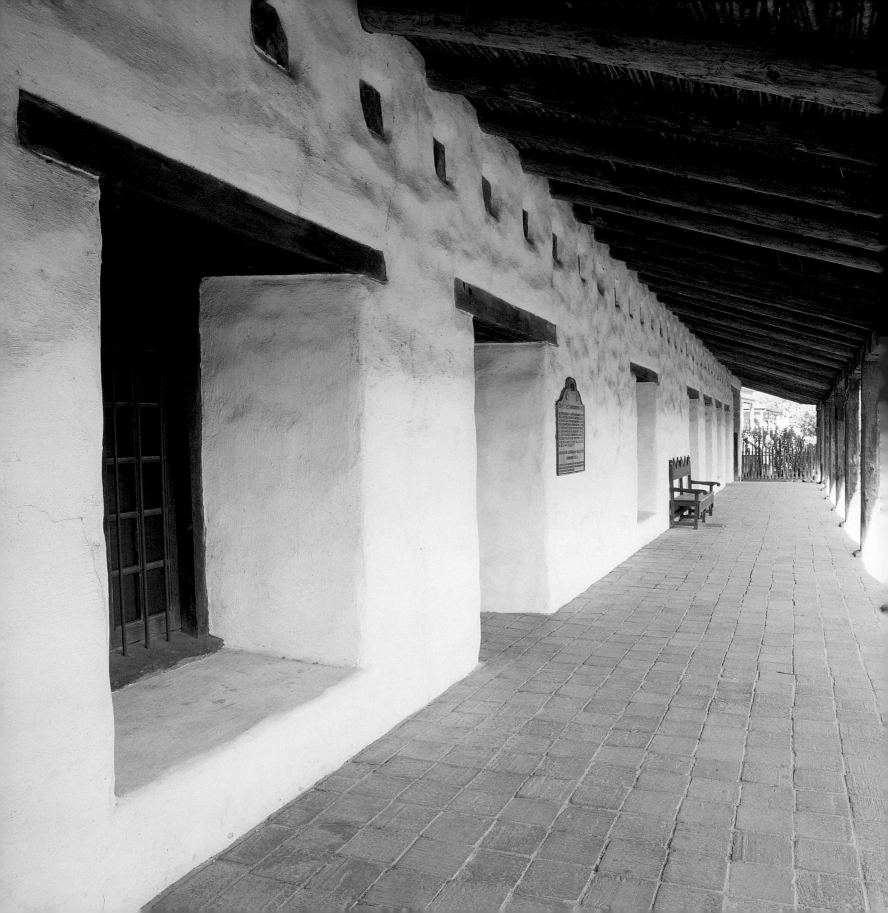

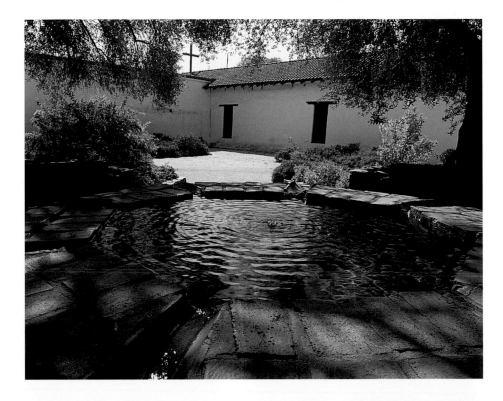

Fountain in the
courtyard area

Window shadows

Rawhide thatched roof
over the corridor

Opposite: Monastery
wing, the oldest portion of
the mission and oldest
building in Sonoma

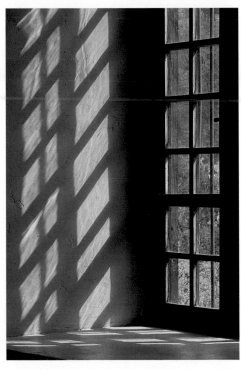

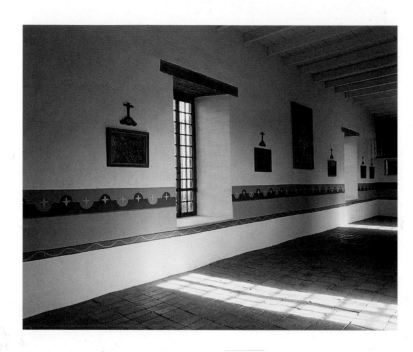

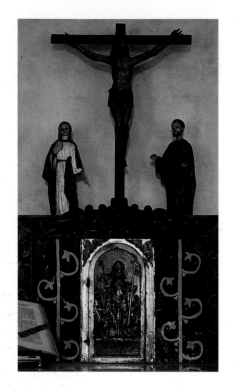

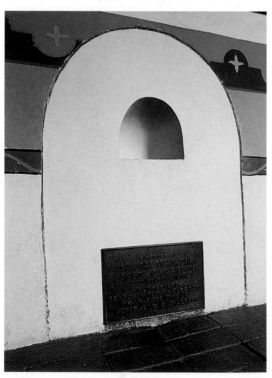

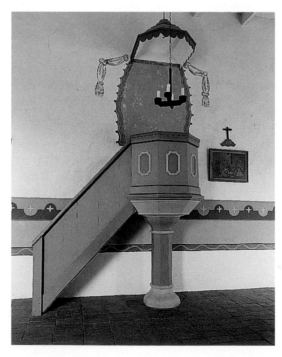

Indian-design wall dados and paintings of the Stations of the Cross

Tabernacle, Crucifix, small bultos of the Holy Mother, and San José

Pulpit and sounding board

General Vallejo's mother-in-law is buried in the chapel.

Opposite: Restored chapel with no pews (Mission Indians knelt or stood during prayer service.)

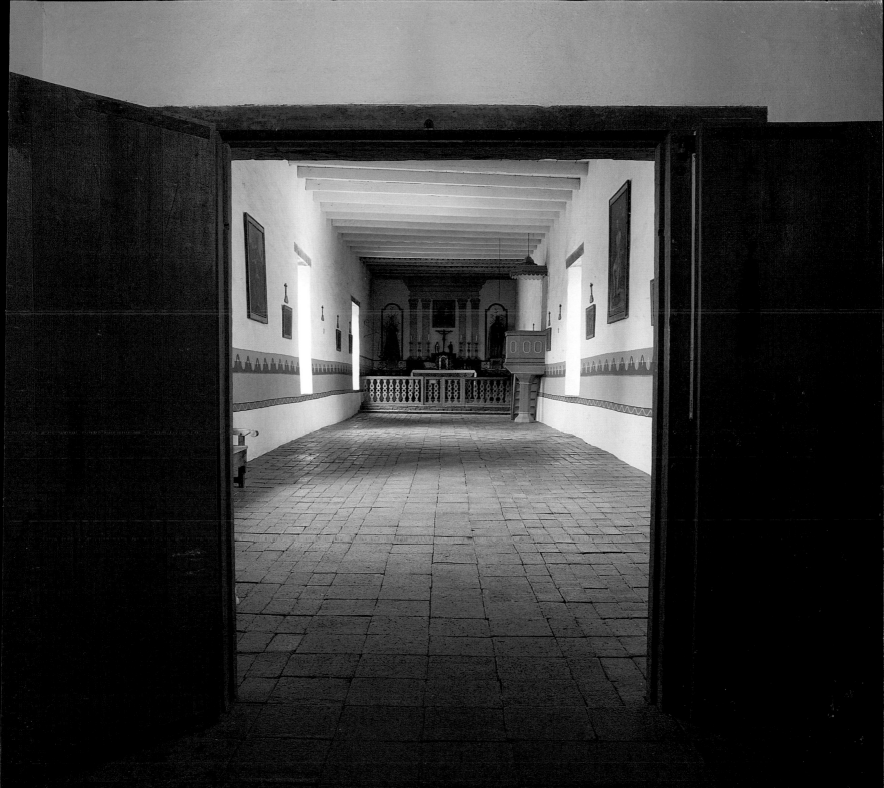

Bibliography and Suggested Reading

Beebe, Rose Marie and Senkewicz, Robert M., eds:
Chronicles of Early California 1535-1846, Lands of Promise and Despair
Heyday Books, 2001

Jackson, Robert H. and Castillo, Edward:
Indians, Franciscans, and Spanish Colonization, The Impact of the
Mission System on California Indians
University of New Mexico Press, 1995

Krell, Dorothy, ed.:
The California Missions, A Pictorial History
Sunset Books, 1979

Margolin, Malcom, ed.:
Monterey in 1786, Life in a California Mission, The Journals of
Jean Francois de la Perouse
Heyday Books, 1989

Morgado, Martin J.:
Junipero Serra's Legacy
Mount Carmel, 1956

Robinson, W.W:
Land in California, The Story of Mission Lands, Ranchos,
Squatters, Mining Claims, Railroad Grants, Land Scrip, Homesteads
University of California Press, 1948

Ruscin, Terry:
Mission Memoirs
Sunbelt Publications, 1999

Toomey, Donald:
The Spell of California's Spanish Colonial Missions
Sunstone Press, 2001

Wyman, Margaret:
Mission, The Birth of California, The Death of a Nation
Idylwild Publishing (fiction), 2002